SPANISH PAINTING

SPANISH PAINTING

GOTTHARD JEDLICKA

120 PHOTOGRAVURE PLATES
9 PLATES IN COLOUR

THAMES AND HUDSON · LONDON

TRANSLATED FROM THE GERMAN BY J. MAXWELL BROWNJOHN
© THAMES AND HUDSON LTD LONDON 1963
PRODUCED BY THAMES AND HUDSON LTD LONDON AND ATLANTIS VERLAG ZURICH
TEXT PRINTED IN GREAT BRITAIN BY JARROLD AND SONS LTD NORWICH
GRAVURE PLATES PRINTED BY ETS BRAUN ET CIE MULHOUSE
COLOUR PLATES PRINTED BY CONZETT AND HUBER ZURICH

CONTENTS

INTRODUCTION 7

El Greco 12

Jusepe de Ribéra 28

Zurbarán 31

Murillo 35

Juan de Valdés Leal 40

Velázquez 43

Goya 64

THE MONOCHROME PLATES 77

NOTES ON THE PLATES 197

INDEX OF PHOTOGRAPHERS 204

THE reproductions in this volume do not constitute a history of Spanish painting but, rather, a selection which ranges from the beginning of Spanish painting to its (provisional) end. The book is thus as fragmentary as any selection of masterpieces drawn from the entirety of the artistic heritage of an artistically well-endowed people is bound to be. At the same time, it is as rich in content as any selection of masterpieces can be. Every work of art contains, beyond that of the artist who created it, something of the character of the people to which it belongs. *The Burial of Count Orgaz* (plate 24), *The Surrender of Breda* (plate 70), *Charge of the Mamelukes* (plate 116), and *Execution of the Defenders of Madrid* (plate 117) are all instinct with the character and genius of Spain. In each of these pictures, as in so many others, we feel that we can see beyond the individual disposition of the artist and the historical and spiritual tenor of his age to the heart of the people itself. Spanish painting developed continuously from the thirteenth century to the seventeenth, during which it attained fulfilment. Discounting Greco's work, what preceded the seventeenth century seems in many respects to have been a preparatory phase, and for that reason it is represented in this volume by only a few examples, for which any number of others could be substituted. The introduction is intended merely to draw attention to a few essential characteristics of Spanish painting, give a brief sketch of the great figures who helped to shape it and, last but not least, pave the way for the pictures themselves. No rigid approach is adopted.

Christianity and Mohammedanism fought each other in Spain for centuries, but after Christianity had triumphed Mohammedanism lived on beneath the surface much as paganism and classicism lived on in Christendom. Christian Spain even erected churches, chapels, and palaces in the *Mudéjar* or Moorish style. Later, as Spanish art evolved in conjunction with that of Europe, the Moorish spirit lived on in Spain's religion, history, and culture. Her language is scattered with Arabic words, her architecture contains Moorish elements, and her folk-music has Oriental characteristics. In art and poetry the Spanish character declared itself with ever-increasing purity and richness over the centuries until the advent of that state of

artistic exhaustion which sooner or later, by a law which admits of no exceptions, besets every people. The genius of Spain found its fullest expression in a figure from the pages of fiction. Conflicting powers and forces are constantly at work in every people, and it is of this conflict —a symptom of creative vigour—that its artistic character is born. Only while these conflicting powers and forces still oppose one another will a people retain its vitality of self-expression. This can be seen more fully and in better perspective when it is viewed in conjunction with the totality of its achievements. A people's religion and poetry shed additional light on its graphic art.

One celebrated play by Calderón is entitled *La Vida es Sueño* ('Life is a Dream'), and in Spain's greatest poem life takes on a similarly dreamlike quality. *Don Quixote* is the work of a Spaniard, and Don Quixote and Sancho Panza, those antithetical but inseparable companions, personify fundamental traits in the Spanish character which appear irreconcilable and mutually restrictive. Melancholy and realism are distinguishing features of Spanish art and Spanish painting, in which many other spiritual and formal antitheses are present. The Spaniard has a pronounced sense of rhythm and grace which also expresses itself in his painting. It is because all this is manifested so strongly in the work of Velázquez that he is the greatest Spanish painter and the man who personifies Spanish painting at its richest and most unadulterated.

Religious themes predominated more universally throughout the development of Spanish painting than in any other field of European art, even though two of its greatest exponents (Velázquez and Goya) form an exception in this respect in that religious subjects rarely appear in their extensive œuvres. In Spanish painting, as opposed to Italian, Dutch, or French, the religious theme is almost invariably portrayed with an undertone of melancholy. From this source of material, which embraces all Christian motifs, two subjects emerge: the Immaculate Conception and the Crucifixion—symbols of the beginning and fulfilment of Christ's earthly career. The fervent respect which the Spaniard accords to women finds expression in his portrayals of the former subject. (Almost every Spanish painter produced an 'Immaculate Conception' or a 'Coronation of the Virgin'.) Greco, Velázquez, and Goya, not to mention innumerable others, painted the Crucifixion as though they had, in so doing, to discharge an obligation to the people and painting of Spain. The history of the latter can, in fact, be traced by studying portrayals of the Crucifixion alone. Christ's is almost the only nude male figure in Spanish painting. Spanish religious painting runs the gamut of expression between realism and spirituality, and the acceptance and mastery (and spiritualization) of the visible manifestation is imbued with a fanaticism absent in any other school.

One special feature of Spanish painting up to and including the seventeenth century is its strong susceptibility to foreign artistic influences, Italian, Dutch, French, and German. This fact, surprising in view of Spain's geographical seclusion, is discernible even in the greatest of her painters, none of whom could have reached full flower without such foreign influence. From the fourteenth century onwards, Spanish painting was enriched by foreign masters who spent years, decades, or even the greater part of their lives painting in Spain; by Spanish artists who went to look at the outside world; and by Dutch, Italian, or German pictures which

were imported by the Spanish Court, travelling merchants, or senior members of the Church —and which frequently provided indigenous artists with a model. Like that of France, Spanish painting witnessed another phenomenon: the Dutch, French, German, and Italian expatriates began by transmitting the painting of their own country to that of Spain but later modified their own style under the influence of their adopted land and, almost as if they had been fructified by it, portrayed the distinguishing features of the Spanish character more richly than native artists themselves. However many reasons one may adduce in order to render it comprehensible, this process defies explanation. It emerges at its most mysterious and unfathomable in the painting of Greco. What a marvellous phenomenon and how contrary to the natural order of things that the first in a succession of great Spanish painters, one in whom the genius of Spain achieved full expression, should have been over thirty years old when he first set foot in the country whose mind and soul he was to mirror in his work!

Like that of the rest of Europe, Spanish painting evolved from mural and miniature painting, the latter dating back to pre-Moorish times. The flattish style of the Moorish period itself is Mozarabic. Frankish elements occur in the Catalonian Bible manuscripts of the eleventh century, while mural painting flourished in the twelfth and thirteenth. Numerous frescoes of this period have survived, and Barcelona Museum houses a large and admirable collection of frescoes from the Pyrenean churches of Catalonia. The great Catalonian mural painting of the twelfth and thirteenth centuries survived in Aragón until the fourteenth. Catalonia also produced many altar-pieces of artistic and iconographic importance. A succession of extremely varied influences made themselves felt during the course of the centuries. Throughout the fourteenth and the first few decades of the fifteenth century, Italian influence predominated. Italian painters such as Gherardo Starnina, Nicolás Florentino, and others worked in Spain and prompted Spanish artists to visit Italy. The work of Ferrer Bassa, Pedro and Jaime Serra, and Luis Borrasa frequently recalls the Sienese school.

Fifteenth-century Spanish painting was universally affected by Dutch painting. Not only were many works introduced into Spain from the Netherlands during this century, but the whole of the painting of this period was exposed to Dutch influence. Luis Dalmau's altar-piece for the Chapel of Barcelona's Town Hall is reminiscent of the Ghent Altar, even though its Dutch garb conceals the spirit of Catalonia. While Dutch influence predominated in the Barcelona school, German, Italian, and French influence can also be detected. Jaime Huguet, the brothers Vergos and Vermejo of Córdoba were the leading artists of this period. Painting had not yet begun to flourish in Aragón at this stage, and compared with contemporary Valencian painting it creates a dry, hard impression. Dutch influence also prevailed in Castile. Among the important Dutch artists who were active in Spain during the latter half of the fifteenth century were Juan de Holanda, Juan de Flandres (Court Painter to Isabella the Catholic), and Francisco de Amberes (Antwerp), who worked in Toledo. Juan Sánchez de Castro (1454-1516), the earliest-known Sevillian painter, is linked by an unbroken tradition with Murillo. His panel painting *The Virgin with St Peter and St Jerome* from the Church of San Julián, betrays Flemish influence. His successors were Alejo Fernández and his brother Jorge Fernández Alemán of Córdoba.

9

The two most gifted exponents of Castilian painting in the second half of the fifteenth century were Fernando Gallego and Pedro González Berruguete. The surname of Fernando Gallego, who signed himself 'Fernandus Gallecus', reveals that he came from the province of Galicia. It is assumed that he was born a few years before the middle of the century (his great altar-piece in Zamora Cathedral, which cannot have been painted later than 1467, is a youthful work), and he probably died shortly after completing the tribune in the University Chapel at Salamanca in 1507. His painting was influenced by Dutch masters such as Dirk Bouts and Petrus Christus. Among his other works were a *Martyrdom of St Ursula* in San Esteban's at Salamanca and a large retable depicting fifteen scenes from the life and Passion of Christ for the Parish Church of Arcencillas. Pedro Berruguete came from Paredes de Nava. His date of birth is unknown, but between 1483 and 1495 he was engaged on murals for the Cathedral, and from 1499 until the end of 1503, the date of his death, he resided at Avila, doing work for the Cathedral and the Convent of San Tomé. It was for this monastery that he painted ten panels depicting scenes from the life of San Domingo de Guzmán. Berruguete's painting displays Flemish and Italian influence held in check by a forceful personality. It is stronger and more intelligent than Fernando Gallego's and contains more genuine expression. *The Court of Inquisition* (plate 8) from the Convent of San Tomé at Avila deals with a subject (*auto-da-fé*) whose important place in the religious and spiritual history of Spain makes it an ever-recurring theme. There is, for example, a link between this picture and Goya's *Tribunal of Inquisition*. Like all Spanish painting until almost the close of the fifteenth century, this work betrays its descent from miniature painting. The picture's perspective plane is partitioned by the dais on which the Court of Inquisition, presided over by Domingo de Guzmán, has taken its place. The composition of the Court is depicted, as in one of Jean Fouquet's miniatures in Etienne Chevalier's Book of Hours, with meticulous attention to detail, so that the picture can also be studied as an historical document. The burning of the heretics is subordinated to the court scene and forms a subsidiary episode which takes place in the right foreground. The two heretics who have been sentenced to die at the stake seem mainly ashamed of the fact that they have had to mount the pyre in the nude. The solemnity of the court proceedings is set off against the bustle of activity in the foreground, where preparations for the *auto-da-fé* are taking place.

Peter de Kempeneer, called by the Spaniards Pedro de Campaña, was born in Brussels in 1503. The scion of a large and respected family of artists, he travelled as a young man to Italy (then in her golden age of painting), where he stayed at Bologna in 1529 and later in Rome. The earliest traces of his presence in Seville date from 1537, but he later worked in Córdoba, Carmona, and Ecija. Some time before the year 1547 he completed the San Bartolomé Altar in the Church of Santa Cruz in Carmona, and from 1547 onwards he was again resident in Seville. In that year Hernando de Jaén commissioned him to produce a *Descent from the Cross* for his family chapel in Santa Cruz Cathedral—a painting regarded as a variant of the one which he had produced prior to July 1547 for Luis Fernández's funerary chapel in Santa Maria de Gracia, now in the Musée Fabre at Montpellier. Pacheco, who made a drawn portrait of Pedro de Campaña, calls him 'benevolent, kind-hearted and chaste'.

He was a man of wide education, an astronomer, geometrician, expert on perspective, architect, and sculptor, an open-hearted individual who enjoyed a joke, a sober and temperate man who was popular with the aristocrats of Andalusia but seems to have been dogged by the envy of others. In the year 1555 he collaborated with Antonio de Alfián on the *Retablo del Mariscal*, which had been commissioned by Diego Caballero. In 1562 he returned to Brussels, where he died, greatly esteemed by his fellow-citizens, in the year 1580. The self-portrait which he had painted on his return was exhibited in the Town Hall.

Just as the Spaniard Ribéra became the greatest exponent of the Neapolitan school, so the Dutchman Pedro de Campaña became one of the early masters of Spanish painting. Even though he did not remain in Spain until his death, he left his mark on Spanish painting for a considerable period. His *Descent from the Cross* (plate 11) was influenced by one of Marc-antonio's engravings, but this matters little in view of its own strongly individual content. There is a freshness of vision about it which seems like a simplification and enhancement of the earlier *Descent from the Cross* in the Musée Fabre. Campaña's colours gain vitality from a juxtaposition of blue-green and red, and his composition reveals great experience in dealing with such subjects. The two ladders are deliberately placed so as to project like a wedge into the centre of the picture's upper margin. It is also noticeable that Pedro de Campaña used to paint from clay models. There is power of conviction in the way in which the garments of both men and women have been employed to create decorative equivalents of the feelings which animate their wearers, and the figures of John, the Virgin, and the three Marys which convey profound emotion, are disposed at Christ's feet with a skill which transcends mere technical routine. The scene is laid in a hilly landscape beneath a cloudy sky. Pedro de Campaña himself produced large and small variants of the *Descent from the Cross*, which was one of Murillo's favourite paintings, and it was much imitated by others.

Luis de Morales was christened 'El Divino' by his contemporaries, less because of his painting than his choice of subjects. He appears to have been born at Badajóz in Estremadura at the beginning of the century, and may have learned his craft in Valladolid or Toledo. Palomino calls him a pupil of Campaña, but this is impossible. His son Cristóbal was baptized in Badajóz Cathedral on 22 November 1554. Many of his paintings, which are housed in Salamanca, testify to his having lived in Castile. He was one of the few native artists whom Philip II appointed, in addition to Italian painters, to decorate the Escorial. However, he failed to satisfy his royal patron. The King, who did not care for his test-piece, a *Christ Bearing the Cross*, sent him home with a sum of money in compensation and had the picture hung not in the Escorial but at San Jerónimo's in Madrid. Luis de Morales was destined to meet the King once more. When Philip II was passing through Badajóz after the subjugation of Portugal in 1571, Morales stationed himself in his path. 'You are very old, Morales,' the King remarked. 'Yes, noble sire,' replied the painter, 'and very poor.' When the King proposed to grant him a pension 'for the midday meal' the painter asked what he was supposed to eat for supper—whereupon the King raised his pension to three hundred ducats. Luis de Morales died fifteen years later (in 1586) at the age, according to Palomino, of seventy-seven.

Luis de Morales's painting often contains an absorbing degree of formalization, a feature on which the numerous copies of his works depend. In his figure-work he frequently evolved

convenient formulae for Mary's sorrow and Christ's suffering which he himself was capable of exploiting with great facility. His painting represents a blend of the essential artistic influences which affected Spanish painting during the fourteenth and fifteenth centuries. His draughts-manship and use of colour recall the Dutch masters, and his structural technique cannot be dissociated from Italian (Milanese) painting. Despite the fact that both influences are clearly identifiable even in his finest pictures, the originality and strength of his personal vision are never obscured. Though an expression of Spanish Romanesque and occasionally evocative of Pedro de Campaña, his work nevertheless discloses the Spanish character—at least in its strongest examples—with a force which is seldom present even in artists who expressed them-selves with greater purity and consistency. These few pictures are among the great works of Spanish art, and Luis de Morales has been immortalized by them. That is why he has been called (with Greco) 'the foremost Spanish devotional painter of his century'.

There is a deep and readily discernible emotional content in these pictures which lends the figures in them, even now, a vitality from which the man in the street can derive inspiration. This applies equally to the seated *Ecce Homo* in the Principe Drago Collection in Rome and to the *Pietà* in the Madrid Academy. Mary and Christ are drawn together into a steep per-pendicular, yet the two figures seem to be sinking ever further down the vertical axis. Like all great artistic achievements, this one is capable of various interpretations. It not only points backward in time but indicates the course of future development. The picture looks as though it were based on a Gothic sculpture. Its power of expression reminds one of Grünewald and recalls sculptures by Michelangelo, just as it also contains a hint of the emotional warmth of Baroque.

EL GRECO

Greco's painting is the most enigmatic of all Spanish painting, and it has always been re-garded as mysterious and uncanny by the Spaniards themselves, who have alternately admired it and rejected it with cool distaste. The history of its reputation has been subject to a rhythm which veers between passionate admiration and violent dislike. We can discern such a 'swing' even when reviewing Greco's posthumous reputation during the past three-quarters of a century, for it was only in the latter half of the last century that people recognized his great importance, previously guessed at only by Théophile Gautier and Captain Cook. Greco is one of the most individualistic artists in the entire history of European art, and if we under-stand him better today than he was understood a few generations ago it is partly because we have acquired a better understanding of the Mannerism from which he evolved. His painting, it has been said, is 'old man's' painting (which in itself implies elements of Mannerism) in a more pronounced sense than the late painting of Titian or Rembrandt. It is precisely when we compare it with the latter two that we realize why it is always liable to meet with incom-prehension. Late Titian and late Rembrandt are founded upon a broad human and spiritual approach. The older Greco, by contrast, seems to have excluded a great deal from the outset in order to attain the spiritualization which he needed for self-fulfilment but which also endangered his mode of artistic expression.

I EL GRECO. ST MARTIN

Doménico Theotocópuli, called by the Spaniards *el Greco*, 'the Greek', was born in the year 1541 at Fódele, the small Cretan village where his great career began. We do not know exactly when he reached Venice, but we know that he worked in Titian's atelier. He is referred to as '*un giovane*' in a letter dated 16 April 1570 from Giulio Clovio to Cardinal Farnese at Viterbo. We learn in this letter that he had recently painted a self-portrait which had won the admiration of all the artists in Rome. He assimilated a wide variety of influences, including Titian, Tintoretto, and Bassano, but his own strong temperament impelled him to bend them to his will. Six years elapsed between his arrival in Rome and his departure for Toledo, though the first documentary evidence of his presence there dates from June 1577. His stay in Toledo was bound up with a contract to decorate the Monastery Church of San Domingo el Antiguo. Greco arrived in Toledo with two companions: a young Italian who had probably accompanied him throughout his journey and who remained his aide, representative, and business agent until his death in 1607; and a relative of the painter referred to as 'Manusso Theotocópuli Griego'.

In Toledo, Greco soon met Doña Jeronima de las Cuevas, the Toledan woman whose por-trait is in the Stirling-Maxwell Collection and whom he used as a model for his most important female subjects. She lived in his house and in 1578 bore him a son, Jorge Manuel Theotocópuli, whom he legitimized. Jorge Manuel, who became an architect and painter, acted as his father's accredited representative toward the end of his life but later got into debt and went to gaol —a fate not uncommon among sons who live in the shadow of a celebrated father. Something of the atmosphere in which Greco lived, felt, thought, and painted, which many have endeavoured to portray, emerges from Maurice Barrès's *Greco ou le secret de Tolède*. In 1611, three years before his death, he was visited by Pacheco, later Velázquez's father-in-law, who wanted to do a portrait drawing of him for his collection of famous painters. Pacheco has described this visit and the remarks of the old man, whose son Jorge showed him round the palace. He asked him, for instance, which was more important, line or colour, to which Greco replied 'colour' and declared that although Michelangelo was a capital fellow he knew nothing about painting.

From 1585 onwards (except for a break of four years at the beginning of the seventeenth century) Greco lived in the Marqués de Villena's palace in the old quarter of the city. He occupied the twenty-four best rooms in the building, probably using them as a means of self-escape. He behaved like a *grand seigneur*, indulging in the frivolity and extravagance which often characterizes fundamentally melancholy artists. It was his custom, at the banquets which he frequently gave—and which may have provided a necessary counter-weight to the essential loneliness of the creative mind—to employ the services of an orchestra. He was also fond of consorting with the great men of his day, whom he treated as his equals. All these outgoings compelled him to accept commissions of any kind and exploit them to the full, which he did with considerable acumen. If commissions in Toledo and the district of New Castile were insufficient or had grown scarce he used to send his assistant Preboste on a tour of the country to collect some more. He also maintained a sales outlet in Seville, at the establishment of the celebrated embroiderer Pedro de Mesa. 'He was not only a man learned in his craft,' writes Palomino, 'but a great worldling and a man of humorous conceits. He

wrote of painting, sculpture, and architecture, for he became not only a great painter but a consummate architect as well.'

Greco's book, which must have been on the lines of Leonardo's treatises, has disappeared, but we know the principal dates in his career. Towards the end of 1579 he received a trial commission from Philip II, probably through the good offices of Pompeo Leoni, to paint a picture in worship and glorification of the name of Jesus. This offered Greco a prospect of advancement. The King seems to have been pleased by the small trial picture, for in the spring of 1580 he ordered a large altar-piece depicting the martyrdom of St Maurice for the Church in the Escorial. When the work was delivered, however, it was not placed on the Saint's altar, and this being a reflection on Greco's painting, marked the end of the association between the King and the artist. One hardly ventures to think how fruitful it could have been if the former had recognized the latter's importance.

For all that, Greco's genius did not fall on stony ground. He remained in Toledo, where he found employment enough. The city's parish churches, public benefactors, aristocrats, bishops, other ecclesiastical dignitaries, and lawyers all gave him orders for group pictures and single portraits. Within a few decades his mental attitude and artistic approach were moulding the atmosphere and appearance of the city, but a whole decade passed before he received his crucial commission. In March 1586 he committed himself to spend the rest of the year until Christmas working on *The Burial of Count Orgaz* (plate 24) for the Parish Church of San Tomé. The result was one of the greatest and most celebrated examples of Spanish painting. Greco's last commission of any size, for which the contract was drawn up on 16 November 1608, was the interior decoration of the Hospital Church of San Juan Bautista. On 31 March 1614 he gave his son authority to draw up a will on his behalf. He died on 6 or 7 April of the same year, heavily in debt, and was buried on 8 April in the presence of a large gathering of knights, priests, scholars, and artists. His body was laid to rest in a porphyry sarcophagus which, like all else that was mortal in Greco, has since disappeared.

A black stone tablet beneath *The Burial of Count Orgaz* bears the following inscription in gilded capitals: 'And even if you are in haste, O traveller, linger a moment and hear in few words an old tale of our city. Don Gonzalo Ruiz of Toledo, Lord of the township of Orgaz, Protonotary of Castile, who has bequeathed us many tokens of his piety, made it his concern that this church of the Holy Apostle Thomas, which was earlier in want, but in which the noble lord desired to be buried, should once more be richly appointed at his expense, and he made this church rich gifts of gold and silver. At the very moment when the priests were preparing to bury him—O singular and wonderful occurrence!—St Stephen and St Augustine descended from Heaven and buried him with their own hands. It being out of place to relate here the reason which impelled the Saints to do what they did, go, if you can, to the Monastery of St Augustine which stands not far hence and inquire, and the pious men will tell you of it. He died in the Year of Our Lord 1312. You know now what sort of miracles the gratitude of the Celestial Ones can perform. But now hearken to a word of the inconstancy of mortals. The said Gonzalo made a bequest of two sheep, sixteen hens, two skins of wine, two wagon-loads of wood, and eight hundred pieces of the sort which are called *maravedi*, all of which things were to fall due each year from the inhabitants of the domain of Orgaz

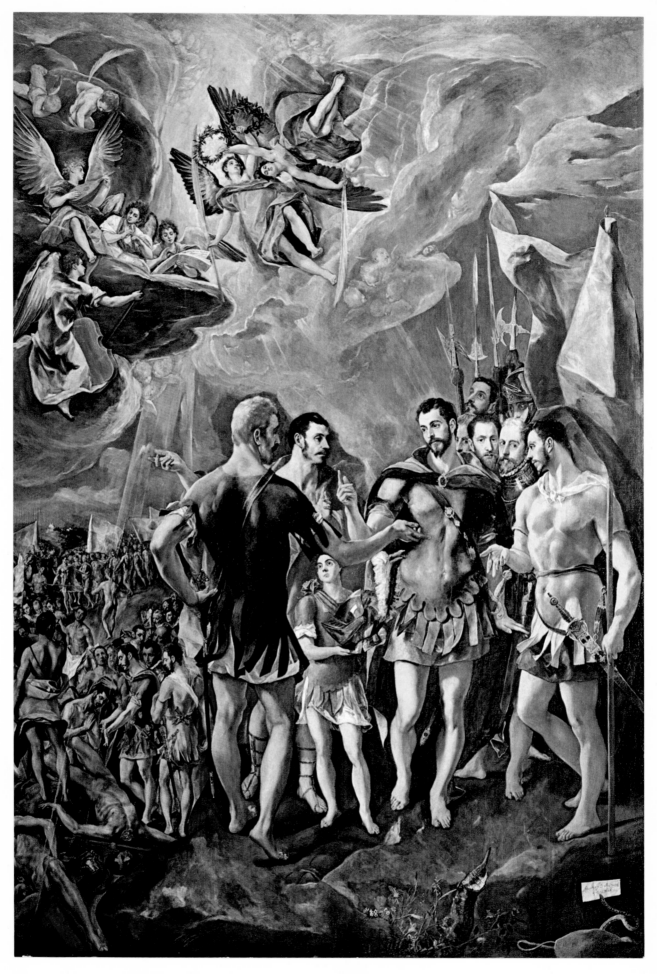

II EL GRECO. THE MARTYRDOM OF ST MAURICE

Theattans

visible from above or from the side, large or small as the case may be, drawn and executed as a piece of simple or elaborate decoration, dazzlingly white or shrouded in varying depths of shadow. (The primer gleams through the over-painting, acts as paint in its own right or is visible only in places.) Greco uses the ruff to give a face homogeneity or contrast. If it was the model's own choice and thus had a latent or overt bearing on his character (even the austere male fashions of the period allowed of small variations), he fully exploited the opportunities for characterization afforded by it and used them not only in the ruff but in the face as well. Velázquez and Franz Hals used a similar technique, the former having learnt from the latter, but with Velázquez the painting of such a ruff seems to be based more on observation and with Franz Hals on brilliant improvisation. The imagination and artistic planning present in Greco's treatment of the ruff becomes evident when one scrutinizes the extensive retouching in any particular spot. As soon as one compares the final version with the original, which is often still visible beneath, one realizes that the retouching constitutes a substantial enhance-ment and strengthening of the overall spiritual and artistic effect.

Greco probably painted the picture known as *Portrait of a Nobleman with Hand on Chest* (plate 26) between 1577 and 1584. It is assumed to portray Juan de Silva de Toledo, Marqués de Montemayor, though the name matters little in the case of a portrait such as this. The white ruff of costly lace endows the narrow face above it with wonderful poise. The yellow skin of the face, like the yellow skin of Titian's portraits, is alive with many other colours and shades, vibrant with all the colours which emerge separately in the picture around it. Anyone looking closely at the portrait will discover enhancing touches in the velvet of the man's clothing, as there are in a jacket painted by Titian or Rubens. The man's hand is expressive of his inward and outward disposition. It is extended flat against his chest, the fingers slightly but neatly splayed, and its power of expression reminds one—even though it is worlds apart—of Dürer's hand in his idealized self-portrait in the Alte Pinakothek in Munich or of St John's hand in the Crucifixion on the Isenheim Altar. Although it forms a contrast to the richly ornamented sword-hilt, its fan-like spread provides a link between the latter, which protrudes into the picture from beneath, in apparent isolation, and the earnest face. It is as though Greco has concentrated in this one hand the emotional and spiritual expression which in other portraits is sustained by the attitude of both hands—this etherealized hand which seems to pulsate like the heart of the man himself and lies on his breast as though over an abyss. There is something slightly precious about the obviousness of its pose (visible evidence of social ceremonial), and this lends the knightly figure a delicate hint of effeminacy which is accentuated by the lace at throat and wrist. The sword-hilt is set vertically, while the hand rests almost horizontally on the chest. The fact that the sword-hilt is shown unconnected to a hand makes it look like an inexorable reminder of duty, of human obligations. The hand, by contrast, lies on the chest as though it were covering the heart, seat of human life. It is as if Greco had recognized a kindred spirit in this nobleman with the ethereal face and slightly twisted body (the right shoulder is raised whereas the left shoulder droops). It is one of the most important male portraits ever painted by Greco and, consequently, one of the most brilliant examples of Western painting.

However, not all Greco's portraits contain the same measure of spirituality. One gets the

impression that he saw through the people whom he portrayed more quickly than he was able to reproduce them in paint. In Velázquez and Goya, elements of spiritual, mental, emotional, and physiognomical understanding are combined with a human account of the sitter, so that in their work, as opposed to his, there is evidence of a striving to understand human beings primarily through their physiognomy. For this reason Greco's portraits, even when their emotional and spiritual content leap to the eye, create a more abstract impression —and one sustained by less detailed drawing and painting—than those of Velázquez and Goya. Greco says everything that intuition and power of artistry can express about a human being, it is true, but he sometimes says it in a way which seems arrogant and hurtful. In many cases his portraits are less portraits than brilliantly painted assessments of the people they represent. Greco captures and reproduces them as deliberately from the point of view of inner character as Velázquez does from that of pure appearance and Goya from that of background.

Like many Spanish painters before and after him, Greco painted a *Coronation of the Virgin* (plate 22). In this, Mary sits with hands folded in prayer and gaze directed upwards, dressed in a red robe and blue-green cloak, on a crescent borne by three winged angels' heads. God the Father and Christ sit enthroned on banks of cloud, holding the crown above her head, God the Father in a white robe and Christ in a red robe and blue cloak. Greco's painting, in this as in all his religious pictures, is not only ethereal and pregnant with faith but also emotional and rich in mutual relationships. The three figures in the *Coronation of the Virgin* are a representation of a religious and spiritual hierarchy which finds purest expression in the faces. These portray youthful femininity and chaste maidenhood, manly maturity and responsibility, and the experience and enlightened kindliness of old age. In this picture, Mary who gave birth to Christ, is, as it were, cradled between Christ, God the Father, the crescent, the clouds, and the dove representing the Holy Spirit.

Another picture in which Greco's painting shows itself the equal of Titian's is *The Vision of St Ildefonso* (plate III), of which one writer on art has said: 'It is worth visiting Spain for this picture alone.' This is one of Greco's best-preserved works. St Ildefonso sits, dressed in a dark brown habit, at a table draped in dark red, his raised right hand holding a pen, the fingers of his left spread upon a book and his face raised in ecstasy to the Madonna who is appearing to him in his vision. The lean face and sparse white hair, the white moustache and beard—all are ennobled and etherealized by prayer and meditation. It is the expression not of a man who sees Heaven before him but of one who carries it within himself. The objects on the writing-table form a still-life in themselves, while the painting of the habit rivals the perfection of Titian's finest work.

In the 1590s Greco painted a *Baptism of Christ*, a *Crucifixion* (plate 28), and a *Resurrection* for the Collegio de Doña Maria de Aragón in Madrid. The *Baptism of Christ* (plate 32) is an example of subtle planning which finds expression in the drawing and painting of the figures and their attitudes. The work, whose height (twice that normal for a picture of this format) lends it a slightly Gothic quality, is divided at the half-way mark by the carmine cloth which two slender angels are holding above Christ's head, forming a vivid horizontal central axis. The angel on the left is wearing a blue robe, the angel on the right (in front of Christ) a yellow-green robe. John the Baptist, whose loins are swathed in brown fur, is pouring baptismal

water over Christ's head from a small shell, and fine threads of water are falling down the vertical central axis. Christ has raised his hands before his breast in prayer, and John the Baptist's whole attitude and expression denote prayerful concentration on what he is doing. Above the hand holding the shell hovers the Sacred Dove. God the Father sits in majesty in the vertical centre of the upper half of the picture, enclosed by a semicircle of angels and *putti*, and the two huge angelic figures to his left and right border the top of the picture like a Gothic arch.

The mature Greco's vision achieved even purer fulfilment in a painting like *Pentecost* (plate 33) than in the *Baptism of Christ*. Simple though the composition at first appears, it embodies in refined terms almost all the formal themes employed by Greco. The picture takes the form of a massive, upright oval traversed by horizontal and vertical axes which develop or break up the oval arrangement and themselves embody a triangular structure. The two Apostles standing in the foreground (seen from the rear and side) provide a base for the figure which gazes raptly up at the Sacred Dove with hands folded in prayer. The attitudes of the various figures are all interrelated. Bodies, limbs, and gestures are disposed throughout the length and breadth of the picture in horizontals, verticals, and diagonals as though it were not so much painted as woven out of these components. Yet the figures' external relationships, which seem to be the result of planning (as indeed they can be proved to be) are only a crude reflection of the inner relationships engendered by the emotional impact of a shared experience. The eye is led upwards from left and right along a predetermined path, yet it could just as well arrive at the Sacred Dove without passing through any intermediate stages.

Greco's *View of Toledo* (plate 36) is one of the most inspired landscapes in Western painting. This view of Toledo beneath a stormy sky afforded the artist an opportunity to give us a glimpse of his inner self. The reddish brown of the ground does not merely emerge throughout the picture's surface but is introduced into the general colour-scheme as a colour in its own right, and as a contrast to the green. The two colour complexes which dominate the upper portion of the landscape are the lilac-grey of the city of Toledo, its ramparts and the buildings in their vicinity, and the leaden grey of the stormy sky. Everything in the picture is an expression of personal solitude. The atmosphere of loneliness which emanates from it derives partly from the way in which it depicts human figures. These are less human beings than insects in human shape. They look tiny, not because Greco reproduces them on such a small scale but because he sees them as minute creatures: pins with pin-heads, which he inserts —only when pictorial unity demands it—as harsh points of light. In this picture there is more soul in a tree, a house—even in an expanse of water—than in the human figure. This tragic landscape occupies as lonely a place in Greco's œuvre as *The Naked Maja* does in Goya's.

Four Laocoon pictures, two large and two small, are mentioned in the inventory of Greco's estate, but only one large Laocoon picture still exists. The theme: Laocoon, priest of Apollo, warns the Trojans against dragging the huge wooden horse left behind by the Greeks into their city. While sacrificing on the sea-shore with his two sons, he is attacked by two immense serpents, who crush all three men to death. Greco's picture was painted in commemoration of the rediscovery of the famous Laocoon group in Rome in 1506. The main theme of the classical group is the priest and his two sons being crushed by the serpents. The

main theme of Greco's group is one snake biting the head of the reclining priest, the other biting the left hip of his standing son. This is another 'storm picture', and contains a 'View of Toledo' framed by the reclining and standing figures. It is one of the boldest examples of composition in Western painting. The train of movement depicted by the five male subjects develops not from left to right, in the traditional manner, but from both left and right towards the centre, where utter despair and death are portrayed in direct proximity by the prostrate figures of the priest and his dead son. The disjunction and obscurity peculiar to Mannerism are carried through with such spiritual and formal consistency that *Laocoon* (plate 34) creates the effect of a new system dictated by a tragic approach to life.

The Opening of the Fifth Seal (plate 30), which is not mentioned in the inventory of Greco's estate, was previously known as *Earthly Love*. M. B. Cossio suggested that it might depict a scene from the Revelation of St John the Divine, and Hugo Kehrer supplied the most plausible interpretation, namely 'the opening of the fifth seal' in Revelation vi. John, represented by the huge figure kneeling with outflung arms in the left foreground, sees the dawn of the Day of Wrath. The two nude figures kneeling opposite one another with raised arms are 'the souls of them that were slain for the word of God'. The naked figure on the extreme right with two angels hovering above him holding a cloth personifies the words: 'And white robes were given unto every one of them.' The idea of the persecuted community of Jesus which had to lay down its life is thus captured by the brush, demonstrating that the coming of Christ's heavenly exaltation does not at first bring peace, joy, and glory, but death, want, and suffering' (Hugo Kehrer). There are symbols of transition throughout this picture, in the general mood, in the figures' attitudes, in the line and colour, which have a will-o'-the-wisp quality. All the figures have been transformed into vehicles for movement, weightless like blazing torches of the spirit. The picture resembles the beating of time to music.

Greco's development was one of the strangest in the history of Western art. He started in Venice, where he was influenced by Titian, Tintoretto, and Bassano. Not until he was past the age of thirty and in full command of his intellectual and artistic powers did he arrive in Spain. It was as though a foreigner had undertaken to fulfil a task on behalf of Spanish painting, as so often in its history (cf. Pedro de Campaña), because the requisite man of genius had not come forward in Spain itself. In Greco, who had to travel farther than all the other foreigners to reach Spain, the Spanish genius triumphed over alien origins. Many related traits can be distinguished in Greco's early, middle, and late periods. His later painting is an organic development, both intellectual and artistic, of his early work, yet the journey from the young Greco to the old represents not only a development but a transformation. *The Burial of Count Orgaz* is the major achievement of his prime, but it also (like Rembrandt's *Night Watch*) forms a link with his late work. For all the spirituality of his painting, his line and colour, the young Greco is a shaper of the world about him. The old Greco seems to be depicting his inner vision, which constantly deviates from the world of outward appearance and which he expresses in hieroglyphs. He paints 'with tongues' just as other men 'speak with tongues', but his 'painting with tongues' is an expression of robust faith, artistic deliberation, and mental discipline. Anyone who wants to appreciate Greco's early painting can rely on his eyes alone. The beauty which it portrays is the beauty of line and colour, the spiritual and

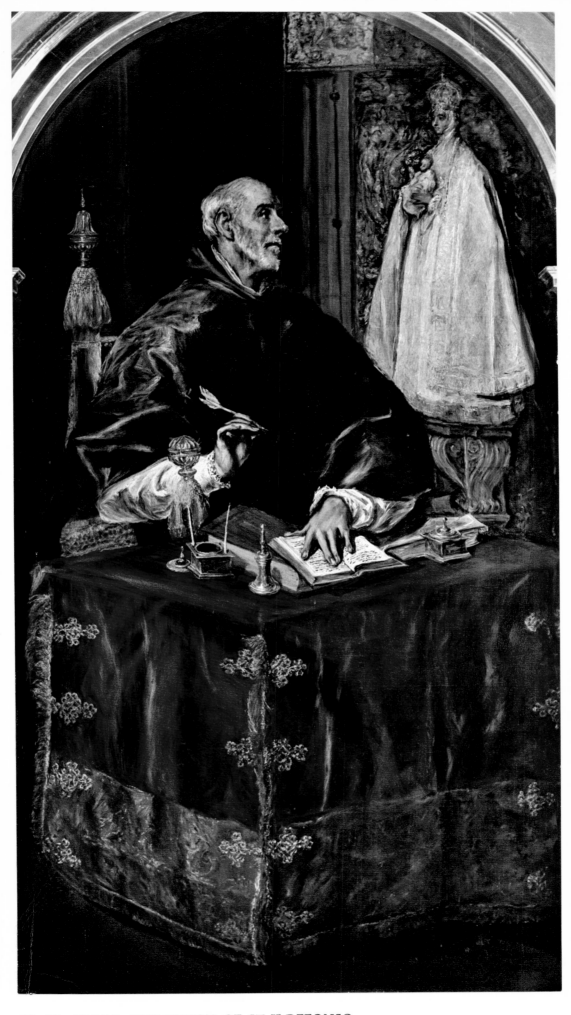

III EL GRECO. THE VISION OF ST ILDEFONSO

intellectual beauty of a world to which, for all the individuality of Greco's composition, access can be gained from outside. Anyone who wants to appreciate Greco's late painting must be inwardly prepared, relaxed, detached. Having achieved this state of mind, he will be led to intellectual, spiritual, artistic, and religious experiences which cannot, for all that, be dissociated from the painter's early work. He will also recognize in it a pattern which is related with but on a higher plane than that of his early painting. Greco's late work is a formalized language for initiates, his composition that of a Late Gothicist and a Mannerist—though it points back even beyond Gothic to Byzantine painting. The fanaticism which persistently recurs in Spanish painting appears in Greco's late work in its most mystical form. Spanish power of faith is present—together with the melancholy in which it is often rooted—experienced, captured, and reproduced in terms of line and colour by a foreigner with an uncanny degree of insight and all the fanaticism of a proselyte.

However, Greco's painting must also be viewed in conjunction with contemporary Western painting. It is an expression of a Mannerism from which, in the last analysis, it cannot be dissociated. Greco is the greatest Mannerist in Spanish painting and European painting as a whole. The chief characteristics of Mannerism have been defined as 'conflict' and 'alienation'. But in our delight at having recognized Mannerism, long a source of confusion and perplexity, as a thorough-going style intermediate between Renaissance and Baroque and possessed of its own stylistic features, we forget that it also represents the bridge between Renaissance and Baroque—that it owes something to the past and contributes something to the future. Greco's work contains elements of Italian Renaissance painting, and contemporary Venetian painting in particular, in an exaggerated and in many cases, even, a brutalized and degenerate form. Where composition is concerned, even his latest works disclose a relationship with that of his Italian masters and contemporaries (Tintoretto, Palma Giovane, Jacopo Bassano, Parmigianino). As regards use of colour, his late work reveals his debt to Titian, Veronese, and Venetian painting in, for example, his predilection for luminous blues, glowing yellows, and rich reds. But for all its perfection—and this is precisely why it is inseparable from Mannerism—his work is full of enigmas. No other paintings illustrate so forcibly the conflict between actuality and appearance, mind and matter, vivacity and formality—and this applies even to pictures which are numbered among his finest works. Greco portrays the world of outward appearance in all its richness—and simultaneously negates it. He often goes to the lengths of reproducing it in a form which hints at future decay, as if he wanted to indicate his permanent awareness of its ephemeral nature. In his late work he extracted from its variety of shapes and objects only as much as he needed to render his pictures comprehensible—and sometimes not even that. It is as though in his final period he were searching by methodical, demonstrable, and generally valid artistic means to express the least expressible thing in the world—religious ecstasy—and, by using a new formal language, to induce a state of grace in the beholder.

The seventeenth century is frequently described as the 'golden age' of Spanish painting. It was, in fact, the golden age of Spanish art, Spanish poetry, and Spanish genius, an age which had been heralded and rendered possible, in every domain and in a variety of ways, by the

centuries that preceded it. However, the century of spiritual and artistic fulfilment was not the century of greatest material power. The creative spirit of a people which had so often made use of the artistic heritage of others did not come to full flower until the Spanish Empire was showing signs of decay. Many powers and forces contributed to its fulfilment. The seventeenth century created conditions in European thought in which the genius of Spain could attain a peak of development, just as it did in the case of Holland. The outlook on life which had been made possible by the Renaissance could never have provided the prerequisites for a spiritual and artistic flowering of the Spanish genius. But, just as it first began to materialize along with the Mannerism in Greco's painting, so it developed its full potential during the Baroque period, whose basic mental attitude met the needs of the Spanish character.

Baroque art not only tolerated passion and fanaticism: it demanded them. One universal characteristic of passion being to abolish moderation and induce exaggeration, this process transmitted itself to art and painting in particular. The Counter-Reformation, too, with its bellicose excess of faith, played an important role in Spanish painting. Spanish art during this century of fulfilment exhibits all the contradictions which subsist together—and militate—within the Spanish character. Even the border-line examples of this style belong to the realm of religious themes: ugly old men invested with the names of saints cheek-by-jowl with graceful young girls representing female saints, martyrdom alongside courts of inquisition, dwarfs, cripples, and imbeciles contrasted with dignified kings and grandees, inward contemplation with brazen clamour, pretty little *putti* with beggar-urchins at play or delousing each other, bare monastery walls with the infinity of Heaven, ladies of the Court with manual workers, devout monks with imperious infantes, old crones with sweet young infantas. Seventeenth-century Spanish painting dealt with every conceivable antithesis in the external world because it excluded nothing, and during this period, like Dutch painting, it spent its energies for a considerable time to come.

JUSEPE DE RIBÉRA

Jusepe de Ribéra's painting is a fulfilment of the promise contained in that of his teacher, Francisco Ribalta. His exact date of birth is unknown, but he first saw the light in about 1588 in the neighbourhood of Valencia. His father, who belonged to a prominent family and held high military rank, was posted to Naples about 1600. Jusepe de Ribéra received his preliminary instruction in painting from Francisco Ribalta, but he left home at an early age and went to Italy, where he spent some time in the north. The first sign of his presence in Naples dates from 1616, in which year he married Catarina Arzolino, the fifteen-year-old daughter of a fellow-painter. The Duke of Osuna, at that time Viceroy of Naples, made him his Court Painter, so that from then until his death he never had to contend with financial worries. He retained his popularity in Naples under subsequent viceroys (Alba, Alcalá, Monterey, and Medina de las Torres), and his patrons, apart from the Spanish viceroys, included Spanish monasteries and collectors in Italy and Spain. He won fame and numerous honours during

his lifetime. Velázquez called on him during both his visits to Italy, Rome's Accademia di San Luca elected him a member as early as 1626, and twenty years later the Pope invested him with the Order of Christ. He died in Naples on 2 September 1652.

In an account of a journey made in 1625, the painter Martínez of Zaragoza described Ribéra as follows: 'I received much kindness from him. He showed me sundry chambers and galleries in the large palaces, which gave me great pleasure. But, because I came from Rome, much of it seemed small to me, for in this city all revolves about soldiers and cavalry rather than art. When I remarked on this to my fellow-countryman he confirmed it . . . I asked him if he had no desire to come to Rome in order to see the originals of his earlier studies, whereupon he sighed deeply and said: "I yearn not only to see them but to study them afresh. For they are works which should be studied and pondered very often. It is true that the course and mode of painting have now changed, but if it is not founded on such a study it will likely come to a bad end, especially in the narrative pictures which are the Pole Star of perfection. And in this we are instructed by the immortal Raphael's narrative paintings in the Sacred Palace. The man who studies these works will mould himself into a true and accomplished narrative painter." '

Partly because of his small build and partly out of envy at his success, Ribera's contemporaries called him 'lo Spagnoletto', a nickname which eventually became an honorific. Even in Italy, his whole approach remained Spanish, and his influence radiated from Naples to exercise an effect on Italian and Spanish painting at large. He was the first great, free Spanish painter of the seventeenth century, and the significance he held for his chosen home, Naples, can only be compared with Greco's for Toledo. His early painting betrays the influence of Titian, Correggio, and Caravaggio, but he soon threw it off and evolved a style of his own which made a vital contribution to the development of seventeenth-century Spanish art. Even though he scarcely ever left Naples, his work was represented in all the important centres in Spain and had great repercussions there because Spanish viceroys sent many of his pictures home. His impact on contemporary European painting was thus greater than that of Velázquez or Greco, whose contemporary influence was confined to Spain (and even there to a limited circle) and only exercised an effect on European painting in the nineteenth and twentieth centuries respectively. Ribéra's artistic technique lends splendid expression, within Spanish painting, to the problem of chiaroscuro, to which Caravaggio in Italy and Rembrandt in the North found a classical solution.

The painting which depicts the martyrdom of St Bartholomew (an extremely popular subject during the Baroque period) is dated 1630 and signed. It is a work of middle-life. Two years earlier he had portrayed the same subject in a less rich, almost diffident style. The Apostle (the bridegroom of the wedding in Cana) suffered martyrdom at Albanopolis in the year A.D. 70 by being flayed alive. Ribéra shows Bartholomew, his hands lashed to the ends of a horizontal beam, being hauled up a pole by two herculean executioners. Pole and spar combine to form the sign of the Cross (the symbol of all martyrdom). Two assistants are hauling on the ropes and tackle while another, staring avidly into Bartholomew's face, is helping them by grasping his leg. Groups of people to left and right look on with expressions of sympathy, curiosity, or indifference. This picture won Ribéra a reputation for painting

horror-scenes, even though it depicts the preparations for martyrdom—admittedly suggestive of all the horrors to come—rather than the martyrdom itself. Bartholomew is still standing, supported by his bent right leg, and his left foot is still in contact with the ground, but his manly face, tilted upward between his outspread arms, betrays frightful agony (plate 46).

The action of the picture, which is set in a square format, is clearly articulated. The martyr's naked body is arranged in a diagonal, his left foot pointing at the bottom right corner of the picture and his raised right arm at the picture's opposite extremity. His face is almost in the centre of the picture and the people surrounding him are compressed into groups which are focused on his figure, so that his countenance forms the picture's spiritual and emotional fulcrum. In general, Ribéra's faces are endowed with more physiognomical elabora-tion than spiritual or emotional content. (His *St Andrew* (plate 50), for instance, looks less like a saint than like a splendid old man whom he may have come across in Naples Harbour and used as a model.) Looking at many of his pictures, one forms the impression that he modelled them rather than endowed them with life. However, Bartholomew's features convey a strong man's acute physical torment with a vividness which banishes all sense of physio-gnomical elaboration, and the interplay of light and shade is an expression of the agony implicit in every muscle, though it never degenerates into a mere grimace and is kept under perfect control. In this way, Ribéra has ennobled the face of the fisherman or dock-worker who acted as his model. He gazes upward with pain-filled eyes and lips parted in suffering, and his agony conveys a hint of the ecstasy which formed a recurrent theme in Spanish painting and in the portrayal of which it so often achieved perfection.

Earlier writers on art frequently referred to Francisco Herrera the Elder as the father of the great school of Sevillian painting, though Juan de Roelas was the more important figure artistically. It was de Roelas who introduced the Sevillian school to the real problems of paint-ing and gave it a fillip by infusing some of Tintoretto's influence. Francisco Herrera the Elder was born at Seville in 1576. Palomino states that he was a pupil of Pacheco, while Bermúdez refers to him as one of his fellow-pupils under Luis Fernandez. He was a skilled engraver, and exploited his aptitude by forging coins. After his activities in this field had come to light he took refuge in the Jesuit College of St Hermengild, for whose church he painted an altar-piece depicting its patron saint. When Philip IV saw the picture during a visit to Seville and inquired about the painter, he was told of Herrera's misdemeanours. 'I am both judge and plaintiff here,' declared the King. 'Does the man who possesses such ability need to make gold and silver as well?'—and he pardoned the painter. In 1629 Herrera collaborated with Zurbarán on a cycle of paintings depicting scenes from the life of St Bonaventure. In 1647 he painted four large pieces for the *salon* in the Archbishop's Palace at Seville (*Gathering Manna, Moses Smiting the Rock, The Wedding in Cana,* and *Jesus feeding the Five Thousand*), none of which exists now. In 1650 he moved to Madrid, where he died six years later.

Francisco Herrera the Elder was a violent and impetuous man whose pupils never stayed with him for long. His daughter fled to a convent and his eldest son, having robbed him, made for Rome, where he soon became known as '*lo Spagnuolo degli peschi*' because he special-ized in painting genre pictures of fish. Herrera the Elder's volatile nature is apparent in his thick

and liberal application of paint and in his pen-drawings. We are told that when he ran out of assistants he made a servant-girl prime his canvases and then set to work on the damp ground without more ado. Although his *Vision of St Basil* (plate 44) is among his most mature works, we can detect a close affinity with Roelas. The picture is a definite example of chiaroscuro painting, and the original clarity of its construction seems cramped by the arrangement of the figures round the Saint. It contains more bravura than convincing stature. In his own day Francisco Herrera the Elder was known principally for his *bodegones* or still-lifes, few of which have survived. Being an expression of genuine observation, they are purer painting.

ZURBARÁN

Francisco de Zurbarán was christened at Fuente de Cantos, a small town in Estremadura (Badajóz Province), on 7 November 1598. His father's name was Luis Zurbarán, his mother's Isabel Marquéz. At the beginning of the seventeenth century several talented painters lived in Seville whose names only appear in written records. On 19 December 1613, one of these artists (Villanueva) contracted with Luis Zurbarán to teach his fifteen-year-old son all he knew about painting in three years, in settlement of a debt of ten ducats. Zurbarán's first signed and dated work, painted at the age of eighteen, was an *Immaculate Conception*. Not a single document or picture dating from the ensuing nine years has come to light, but it is probable that Zurbarán produced a good deal of work. Palomino relates that the city fathers of Seville requested the painter to take up residence there again, but this does not accord with the true facts. On 24 June 1629 Rodrigo Suárez proposed to the Sevillian authorities that Zurbarán should be asked 'to live in the region, and that the city take it upon itself to patronize and assist him at every opportunity which may present itself'. Alonso Cano and various other Sevillian painters felt affronted by Zurbarán's conspicuous preferment, however, and made the counter-proposal that he should be compelled to pass his master's examination, a suggestion to which Zurbarán took exception in a letter dated 24 May 1630.

Zurbarán's fame soon spread beyond Seville. Numerous monasteries and churches in the immediate neighbourhood and farther afield entrusted him with sizeable commissions, all of which he performed to their satisfaction. His name came to the ears of Philip IV, who commissioned him (while still in his thirties) to paint a *Labours of Hercules* for the Grand Chamber of the Realm in the Palace of Buenretiro. Only a few verifiable dates in Zurbarán's personal life are known, and these are not such as to help one form a significant picture of the man himself. In the year 1638 his wife Beatrix Morales was buried at the Church of Santa Magdalena in Seville. In the same year Zurbarán did some work for the Carthusians of Jeréz. On 8 October 1639, in his capacity as a confidant of the Court, he notified the Marqués de Casa Torres of the dispatch of some gilders. A *Dream of St Joseph* is dated 1642, but no dated picture is extant from the next twenty years and no large contracts seem to have come the artist's way during these two decades.

A daughter by Zurbarán's second marriage to Leonarda de Tordera was christened on 24 May 1645. On 14 December 1657 the City Council of Seville voted to allot her a house,

which may convey something of the esteem in which her father was held by the city fathers. On 23 December 1658 Zurbarán gave evidence on behalf of Velázquez, whom he had 'known for forty years', in proof-of-ancestry proceedings at Madrid. The records made on this occasion state that he had been staying in Madrid for seven months. On 28 February 1664 he undertook a picture valuation with Francisco Rizi. This is the last known date in his life, his precise date of death being unknown. We know equally little about his personality, views on art, and material circumstances. Even Palomino, who can generally be relied on to supply a wealth of anecdote, finds scarcely anything to tell us about him. His intellectual and artistic development can be traced only in broad outline in his dated pictures. In general, his painting is the expression of a vigorous artistic personality. His earlier pictures reveal an affinity with the painting of Herrera the Elder and Ribéra, while his last works betray the influence of Murillo. From Ribéra he adopted types and representational formulae, notably compositions constructed of large, serene planes. Basing his technique on the chiaroscuro painting which dominated Spanish and European art in his youth, he employed violent contrasts between light and shade—in heads, hands, clothing, and spatial representation—applying his paints in direct juxtaposition. From his mid-thirties onwards these contrasts grew milder and were accompanied by a refinement in tonal gradation and enrichment of Zurbarán's palette by the addition of blue and light red.

Carl Justi was the first to interpret the picture *St Thomas Aquinas visiting St Bonaventure* correctly (plate 39). Twenty years after writing a piece dealing with stories about Bonaventure, he quoted from it in an appendix to his book on Murillo. 'The youthful Franciscan monk with the dark curly hair is Bonaventure, then a teacher of theology at Paris University; the Dominican monk on whom the sight is making so deep an impression, Thomas Aquinas. The latter, who, so Pietro Galesini tells us, was astounded at the power and richness of Bonaventure's mystical theology, visited him in Paris and asked him to show him his library so that he could acquire for himself the works from which Bonaventure had culled such a many-sided and comprehensive store of knowledge; whereupon the monk pointed to the figure of the crucified Lord Christ and confessed that he had acquired all he had read and written from that most abundant source.' Justi goes on: 'The pictorial translation of this cele-brated remark is distinguished by clarity, simplicity, and dramatic force. It provided a parti-cularly edifying story for use in Franciscan courses of instruction. The great Father of the Church and pride of his Order, the Dominican, looks for the secret of theological instruction in a large library, but bows in humble acquiescence when the Franciscan proclaims a superior, spiritual source of knowledge, echoing the words of St Paul: "For I determined not to know any thing among you, save Jesus Christ, and him crucified."'

'The fourth scene,' writes Justi (and we again quote his account of the death of Bon-aventure because of its classic simplicity), 'named *Funeral of a Bishop* and previously associated with the story of Pedro Nolasco, shows us Bonaventure lying in state [plate 42]. He died suddenly on 15 July 1274, during the Council of Lyons, at the height of his fame and after the object of that ecclesiastical gathering—the union of the Greek and Roman Churches (including the *Filioque*)—had been achieved, due to his influence. Tradition has it that those present at this Council included Pope Gregory X, Emperor Michael VII Palaeologus (accord-

ing to Galesini), the Patriarch of Constantinople, and "Scythian envoys". The Cardinal Bishop of Ostia, Peter of Tarantasia, delivered Bonaventure's funeral oration. The Emperor is said to have formed a particular liking for Bonaventure, and "the Pope declared that the Church, which had derived such marvellous benefits from the knowledge of such a man, had suffered a grievous loss by his death. Priests and laymen, Latins and Greeks alike, mourned him whose like they sought in vain among the living. . . . That a Pope and a Greek Emperor, together with numerous cardinals and bishops, should add lustre to the funeral of a great man by their presence is probably unexampled in the entire annals of ancient times." Zurbarán's portrayal appears to be wholly artless, yet it achieves its object perfectly.'

Zurbarán injected ideas into his compositions and group portraits and carried them out with consistent vigour and sureness of touch. This is apparent in *The Death of St Bonaventure* (plate 42), a scene from the series on the Saint's life which he painted as a group portrait at the monastery's request. He did justice to the two tasks which were combined in the one commission, extracting great results from his narrative material. Each of these pictures embodies a different connecting idea to which Zurbarán gives powerful effect and predominance over all else. The bier bearing St Bonaventure, at whose feet a monk is kneeling, draws the gaze diagonally from the picture's lower left corner into its perspective depth. The monks who surround the bier on every side are knit into groups of varying compactness. They kneel in the left and right foreground and surround the bier in an unbroken semicircle which recedes into the background. The Pope's left hand forms a counter-diagonal to the bier, describing a gesture which sums up the expression on every face. Even within the closed groups, the individual figures are mobile, expressive, and linked together by strong emotional ties. *The Death of St Bonaventure* has reminded some people of Rembrandt's *Anatomy Lesson of Dr Tulp*.

The *Cloaked Madonna* (plate 40) in Seville Museum comes from the Cartuja in the same city and probably dates from the period when Zurbarán was painting for the Court, Cádiz, and Guadalupe. The figures are slender-proportioned and have attenuated faces. The composition itself, which seems to have been hurriedly though skilfully put together, testifies to the artist's great experience in dealing with multi-figurative subjects. The Virgin's protective cloak recalls the roof of a pavilion and is spread like a baldachin above the monks who kneel with folded hands to right and left of her in groups of six. It seems to act less as a protective covering than as a line of demarcation between Heaven and earth: Mary stands on earth but looks down as though from Heaven. The symmetry of the composition, which is accentuated by the winged angels to left and right, is counteracted by the internal arrangement of the two groups of kneeling men. Mary's hands are laid in benediction on the heads of the foremost monks. They rest differently on the two heads, and each man's face is animated by a different expression. Despite the limited opportunities at his disposal for varying their poses, Zurbarán has managed to heighten the monks' expressions by the arrangement of their cowls.

The Miracle of St Hugo (or *The Miracle of the Sacred Offering*) (plate 41) in Seville Museum, one of the three great pictures which he painted for the Cartuja de Santa Maria de las Cuevas, is yet another characteristic example of Zurbarán's capacity for narrative and formal enhancement of simple subjects. The picture shows St Hugo surprising some monks who are just

about to eat forbidden meat in the refectory of a newly-founded Carthusian monastery dedicated to St Bruno. The seven monks are seated at a laden table and the Prior has just said grace (note his still folded hands with the crossed thumbs), when St Hugo comes in from the street, a bent, bare-headed figure with one hand resting on a stick and the other indicating the aristocratic-looking youth in the foreground. The picture is strictly articulated and combines archaistic features with artistic piquancy. The short distance between the foreground and the back wall, which is precisely suggested by the perspective shortening of the table-top at the left-hand edge of the picture, is set off against the open space visible through the archway on the right. The composition is further enhanced and its symmetry relieved by the delightful asymmetry with which bare-headed monks alternate with monks in cowls. Similarly, the picture hanging on the wall above the monks' heads (John the Baptist and Mary with the Child at her breast) lends the austere refectory an illusory pictorial depth complete with low hills and trees. The still-life on the table (earthenware, bread, and fish) is painted with the same austerity as the group of monks.

Zurbarán, who once painted himself, palette in hand, before a crucifix, is a classic exponent of Spanish Baroque. He paints with sober pathos, and his severity and objectivity make him a spokesman for Spanish monasticism and asceticism. Many of his works are constructed with a brutal audacity which shrinks at nothing, but even they are pervaded by a fundamental coolness. Almost all his pictures are perfectly composed as regards the arrangement of figures in perspective and the treatment of light and shade. Some contain elements which strike one as archaic, while others have a modernity reminiscent of Degas. Zurbarán transformed the draping of monks' cowls into a formal idiom in its own right and one which recalls his French contemporary Georges de Latour. He appears to have taken the external world exactly as it was (just as he always fulfilled a particular aim in each of his works) and transmuted it into his own formal idiom—whether he was dealing with a monk's habit, a face, a crucifix, or a chair. His painting contains everything—not only genius, and we can only marvel that some people refuse to credit him with the latter. Most of his works give the impression of having been painted to order, but perfectly to order. The action is conveyed with exemplary clarity, as though on a stage.

Zurbarán was one of the greatest colourists in the history of Spanish painting. 'With a conscientious lack of imagination he paints drapery from models and flesh from life, taking as his example Caravaggio, for whose works his own are mistaken,' observes Palomino. He became famous for the serial paintings in which, as in those depicting St Bonaventure, he told the story of various monastic Orders with simple effectiveness. However, his purest achievement does not consist of them, even though their structural technique puts them on a plane with the greatest works of all time and even though they show him to be one of the finest Spanish narrative painters. His gifts achieved their fullest realization in individual monks' figures and portraits of female saints. No one ever created such austerity, spirituality or grandeur out of a monk's white cowl and no one ever avoided the subject's inherent monotony with such consistent success. However, Zurbarán did not confine himself to stern and ascetic monks in simple cowls, their faces pregnantly expressive of human destiny. He also painted graceful female saints (e.g. Agatha, Margaret, Casilda, Apollonia, Matilda, and

Elizabeth) dressed in gorgeous robes and conveying the youth, freshness, elegance, even the coquetry of the girls who, attired in the saints' garments and identified by their attributes, so charmingly personify them.

MURILLO

Bartolomé Esteban Murillo, son of Gaspar Esteban Murillo and his wife Maria Pérez, was christened at the Parish Church of Santa Magdalena in Seville on 1 January 1618. He lost his father early in life and his mother died on 8 January 1628, so that by the age of ten he was an orphan. In view of his outstanding artistic gifts, his uncle and guardian, the surgeon Juan Agustín Lazares, sent him to the house of the painter Juan del Castillo, a relative of his. When the latter moved to Cádiz in 1639, Murillo, who remained behind in Seville, began to paint for various art dealers and for export to the West Indies. The painter Pedro de Moya persuaded him to go to Madrid to study the great masters. On arrival Murillo sought out Velázquez, who welcomed him cordially and gave him an opportunity of inspecting pictures by Titian, Rubens, Van Dyck, and Ribéra, as well as some of his own work. The young Sevillian stayed in Madrid for two years. Returning to the city of his birth, Murillo began to be influenced by the painting of Zurbarán, a process which was reciprocated in later years. In a very short time he became the most sought-after painter in Seville. Between 1645 and 1646 he painted a series of eight pictures for the Convent of San Francisco (among them *The Angels' Kitchen* now in the Louvre). These are among his most important works and reveal his talent for narration, skill in portraiture, and aptitude for still-life painting. By the mid fifties he had already evolved a characteristic style of his own.

Despite the great fame which soon surrounded him, few of Murillo's dates are known. On 9 May 1646 he took the fourteen-year-old boy Manuel Campos into his house as a pupil. His wife, Doña Beatrix Isabel y Sotomayor, came from Pineda. Murillo was probably a pious man. In 1648 he had a daughter, Isabel Francisca, who became a nun in the Dominican Convent of Madre de Dios, and two years later his son Gabriel, who entered the Order of Friars Minor (and whose portrait was painted by his father), was baptized. A second son, Gaspar Esteban Murillo, who became a painter, died in America at an early age. In about 1656, supposedly on instructions from Canon Don Justino de Neve, Murillo executed the two large lunette paintings for the Church of Santa Maria la Blanca which depict the founding of Rome's Santa Maria Maggiore and are among his most celebrated works. He won high honours very early in life. Seville Academy, for which he did a great deal, elected him its first president in 1660. On 4 June 1665 he joined the Brothers of Charity. From 1671 onwards he worked for the Brotherhood, as did Juan de Valdés Leal, under instructions from Don Miguel de Mañara, Knight of Calatrava. It was for them that he painted the *St Elizabeth* which is now in the Prado. Between 1667 and 1668 he painted an *Immaculate Conception* for the Cathedral Chapter-Room. In the year 1671 he and Valdés Leal were both enlisted to help to decorate the Cathedral for the celebrations held to mark the canonization of King Ferdinand. His self-portrait probably dates from the seventies, which also saw the appearance of his large pictures for the Capuchin and Augustine Monasteries and for the Venerables Sacerdotes.

His last work of any magnitude was the decoration of the High Altar in the Capuchin Monastery at Cádiz. When starting work on the main picture, a *Marriage of St Catherine*, he fell from some scaffolding and sustained a fracture which he apparently concealed. We are told that he spent his last days contemplating Pedro de Campaña's *Descent from the Cross* in the Parish Church of Santa Cruz, which stood near his lodgings. 'I am waiting until those holy men shall have removed the body of the Lord from the Cross,' he is said to have told the door-keeper. He died on 3 April 1682, before he could finish dictating his will, and was buried near Pedro de Campaña's *Descent from the Cross* in Santa Cruz. His tomb bears the words: '*Vive moriturus*'.

St Isabel of Hungary tending the Sick (plate 90) is a characteristic example of the way in which Murillo combined religious and genre painting. Since he painted the picture as a component of the wall decoration in the church attached to the Hospital de la Caridad in Seville, which was not finished until 1664, he could only have begun it after completing his work for Santa Maria la Blanca, which in many respects represents a peak of fulfilment. The founder of the Hospital had commissioned him to decorate the upper walls of the nave with paintings depicting instances of charitable work in the Bible. He was also asked to paint pictures for two side altars, as well as a number of smaller pieces. This is yet another proof that Murillo's painting could vary considerably within the same year. Far from being entirely subordinate to the laws of his own development, his artistic methods and technique were largely independent of his deliberate control—a phenomenon which never occurs among the greatest artists but is frequently to be found among virtuosi. St Isabel is portrayed as a beautiful woman engaged in cleansing and healing wounds. She is standing behind a large basin set on a low chest, washing a suppurating sore on the head of a beggar-boy, who is bending over the basin.

Murillo enhances his pictorial treatment by stratifying the figures socially. As befits a lady of high degree, St Isabel of Hungary is being assisted in her charitable work by serving-women. One of them is standing beside the Queen with a ewer of water so that she can wash her cloth out, while the other, who has averted her face from the distressing proceedings, is carrying a jar of ointment on a tray. Between the two servants a bespectacled woman peers out at the goings-on in the foreground with an avid curiosity shared by the old woman seated in the foreground and the cripple on the right, who has propped himself on his short crutches and is watching the Queen at her noble work. These figures supply the scene of compassion with a grateful audience. Beneath the lofty portico in the background on the right can be seen the banquet at which the sick are regaled after being treated. The work is notable for its narrative power, construction, and perfection of line and colour. Its anecdotal content is as clearly defined as its construction is fully realized. Murillo's theme allowed him to include in his treatment some of the beggar-boys who were such a favourite subject of his, perhaps because he himself was orphaned so early in life.

It is easy to account for Murillo's rapid rise to fame but harder to define why he is not one of Spain's greatest painters. His painting contains much that endears it to the beholder. It has a narrative and thematic richness which gives it an affinity to that of Rubens. In his mature pictures, Murillo possesses a rare facility for thematic invention, a perfection of line and colour

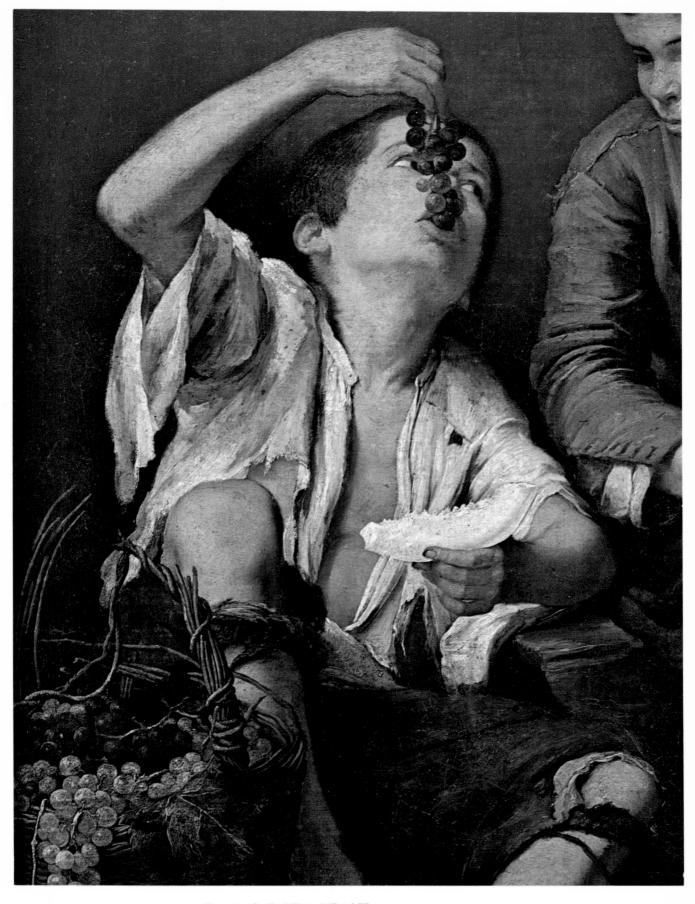

IV MURILLO. TWO BOYS EATING FRUIT. DETAIL

and an innate charm reminiscent of Correggio or Raphael—hence his nickname, 'the Spanish Raphael'. He has the ability to captivate his audience swiftly by means of pictorial narration, figurative poses, and chromatic mood and lure their minds away from the pictures themselves. He tempts one to day-dream in front of his work. He paints precisely what will give pleasure with a natural talent rivalled by few other painters. He senses what will titillate and knows how to convey it in his painting. One's initial impression is that he wants to be a painter both for the great majority, who only look for excitement in painting, and for the select few to whom it signifies a crucial experience. He was a master of artistic technique and knew better than almost all his contemporaries how to give a picture clarity and impact. He even managed to avoid exaggeration, and served the needs of the Spanish Church—principally in the region of Seville—with the same exuberance as Rubens, who was born forty-one years before Murillo and died forty-two years before him at Antwerp.

It is when we compare Rubens's painting with Murillo's that the Spaniard's weaknesses emerge. All great painting ultimately owes its vitality to spiritual substance, which is the source of all else and which alone can sustain it in the long term. The great painter shows his greatness in every brush-stroke. This goes for Rubens, but not for Murillo. Every facet of Rubens's work is abrim with substance, observation, imagination, sensuality, alertness, and decorative talent—all of which features of his creative nature are inherent, from the first brush-stroke to the last, in the pictures which he painted alone and unaided by his numerous and often gifted pupils. The longer one looks at such a painting the further one travels from pictorial treatment, subject, and narrative content to the brush-work and paint itself, to the basic structure of line and colour. To examine this in terms of the entire picture and its treatment, the entirety of figures and objects, is like gazing down through the waters of a deep, clear spring and finding the secret of life itself.

Anyone who goes as far as this with Murillo is doomed to disappointment. The more one examines his pictures the more they begin to pall. The soul-stirring charm of their strong initial impact does not increase in intensity, as with Raphael, Rubens, or Watteau, but wanes, leaving behind a faintly insipid flavour. Even the magnificent composition *Dream of a Roman Senator* is subject to this law of disillusionment, and if one looks beyond the general chromatic effect to the individual paints which do, or should, determine it, one comes upon hurriedly applied, bright or chalky coloured matter devoid of the substance and inner structure which alone can invest it with lasting vitality. Murillo is one of the greatest charmers in the field of painting. Charm means a great deal, but it only becomes of paramount importance when it clothes flesh like a bloomy skin and is sustained by underlying strength.

The virtues and defects of Murillo's religious painting become evident when one compares his *Mater Dolorosa* (plate 89) with that of Greco. Greco and Murillo painted for different classes of people: Murillo for the simple devout man in the street and Greco for the aristocrats of his day. The content of their painting is not, however, dependent on this and has nothing to do with it. Murillo captures the beholder's attention more swiftly but relinquishes it sooner. Grief is vividly conveyed by the Virgin's bowed head, by her wide, sad, tearful eyes, by her sorrowfully parted lips and the draping of her shawl. Murillo's pretty young girl is weeping and lamenting, and her lamentation touches one because it is somehow melodious. Greco, on

the other hand, portrays the Virgin as a young girl who gazes out at the beholder as though her shawl were a veil, wearing a halo which marks her unmistakably as Mary the Mother of God. The longer one looks at this picture the more its drawing, colour, and emotional content begin to live, the richer its nuances and the more genuine its sorrow become, because it avoids all theatricality. Murillo's *Mater Dolorosa* degenerates ultimately into a graceful pose, while Greco's discloses the underlying existence of a complex personality.

Murillo's painting touches us most closely in his unpretentious genre scenes, for example, *Two Boys eating Fruit* (plate 94 and plate IV) and similar pictures, in which everyday life is observed and portrayed dispassionately but with an enchantingly individual touch. These pictures also reveal Murillo's sympathy for poor folk in the streets, his love of youth, and his closeness to life. And this is where his painting carries power of conviction. The two boys, one chewing with a slice of melon in his hand and the other holding up a bunch of grapes, are among the finest and most genuine examples of Murillo's painting. The way they eat, watching each other but preoccupied with eating, is taken from life and reproduced with all the charm that is inherent in accurate observation. In this respect—though in few others— Murillo's painting approaches Velázquez's. Indeed, his work contains elements of such modernity that one can trace a path from it to that of Manet.

JUAN DE VALDÉS LEAL

Juan de Valdés Leal was one of the great Spanish seventeenth-century painters. His father, Hernando de Niza, came from Portugal, and his mother, Antonia Valdés Leal, was born in Seville. Valdés Leal, who (like Velázquez) adopted his mother's maiden name, was christened at San Esteban's in Seville on 4 May 1622. He probably spent his youth and actual period of apprenticeship in Córdoba, which is why that city was earlier regarded as his birthplace. He is assumed to have been a pupil of Antonio del Castillo, who was twenty years his senior. When Castillo married for the second time in 1649, Juan de Valdés Leal, the bride's cousin, acted as witness. His first dated work is the *Martyrdom of St Andrew* in Córdoba which he painted at the age of twenty-six. It shows clear signs of his master's influence. On 14 July 1647 he married Doña Isabel Martínez de Morales (called elsewhere Isabel de Carrasquilla), daughter of a noble cutler, in the Parish Church of San Pedro at Córdoba. Patrons provided him with large-scale commissions even as a young man. In the year 1653 he did some paintings for the church of the Convent of Santa Clara at Carmona. These depict scenes from the Saint's life, and the best of them is *The Attack of the Saracens on the Convent of St Francis*.

From 1656 onwards, Valdés Leal's presence can be detected in Seville, for from that date he lived in the parish of San Martín. The following year his daughter Eugenia Maria was baptized, but it was not until several years later that he requested the Sevillian authorities for permission to pursue his profession in their city. In 1657 he painted pictures for the Monastery of San Jerónimo de Buenavista, most of which are now housed in Seville Museum. In the same year he completed his pictures for the High Altar in the Church of the Carmelite

Monastery at Córdoba, but his chief work is the great *Elias* altar-piece in Córdoba's Carmen Calzado, dated 1658. It is very probable that the painter worked on the spot. Valdés Leal participated with Murillo in founding Seville Academy, but relinquished the post of *diputado* in the year of its foundation, 1660, because he had been appointed Alcalde of the Guild of St Luke. In 1663 he became the Academy's major-domo and on 25 November 1664 he was elected president, but by October 1666 he had left the Academy, probably because he had fallen out with his colleagues. He took no part in the discussions of 1673, which were concerned with statutory amendments. During his lifetime he was regarded as the greatest painter in Spain. At the ceremonies held to mark the canonization of King Ferdinand in 1671 his services were enlisted in decorating the Cathedral. He was probably responsible for the 'monument' and the interior decoration of the main façade, assisted in his task by the architect Simón de Pineda, Herrera the Younger, his pupil Matías Artega y Alfaro, his son Lucas Valdés, and his daughter Luisa.

According to a description by his pupil Palomino, Valdés Leal was of medium height, fat but well-built in other respects, rotund of countenance, pale brown of skin and lively of eye. These observations are confirmed by a self-portrait in a large painting in Carmona and by an etched self-portrait signed with his monogram. The latter shows him as a choleric, apoplectic-looking man with thick hair falling in curls to his neck, a jutting pointed beard and twirling moustache, and a pugnacious expression. Palomino calls him a great architect, a master of perspective, draughtsman, and sculptor, but he chiefly praises his skill in modelling clay. Like Pedro de Campaña, Tintoretto, Greco, Poussin, Géricault, Daumier, and others, he seems to have made clay figures to serve as a guide when painting. He treated his numerous pupils kindly and generously gave them studies and sketches, but his kindness and generosity ceased as soon as his own atelier and pupils were not involved. He was a boisterous and ill-controlled man with a tendency towards arrogance and a consuming ambition to be 'in all things the only one'. He envied the success of others, and even Murillo suffered much from his outbursts of temper. When visiting Madrid to study the old masters he went to the Academy in the evenings to draw, but remained aloof from his colleagues.

Valdés Leal's paintings came to full fruition in the pictures which Don Miguel de Mañara, Knight of Calatrava, commissioned him to paint for the Hospital de la Caridad in Seville after 1670. Don Miguel, who had the words 'Here lie the bones and ashes of the worst man the world has ever seen' inscribed on his tombstone and avowed in his will that he had spent most of his life offending against God and serving Hell and the Prince of Darkness, founded the Hospital de la Caridad and a large number of other pious institutions. Juan de Valdés Leal painted de Mañara's portrait as Governor of the Hospital, a *Triumph of the Cross*, the lunette picture in the Choir of the Church, the murals at the intersection of the nave and by the altar, and the two allegories *Death* (plate 97) and *Vanity* at the entrance to the nave—'hieroglyphs of the world to come' and 'repulsive still-lifes of decay'—of which Murillo said that they were only to be viewed with fingers stuffed up one's nose.

Loga assumes that the *Portrait of Canon Bonaventure* in the Cook Collection at Richmond dates from *c.* 1663 (plate 96). Others put it in the same period as the portrait of Don Miguel de Mañara, but one can more readily imagine it as being close in time to his allegories

41

Death and *Vanity*. This portrait is a microcosmic representation of the Spanish character. Its spiritual and formal stature place it in the first rank of European portraiture. It depicts an individual elevated to the status of a type. It is reminiscent, even though it came into being entirely independently, of Greco's seated Ildefonso, of Titian's portrait of Charles V with his dog, of portraits by Velázquez—of all that is essentially Spanish in Spanish painting and all that creates a link between Greco, Velázquez, and Goya. It is as natural and yet as complex in its significance as only great painting can be. Canon Bonaventure, who is shown seated at his desk with an open volume in his left hand, a goose-quill in his right, and a crucifix beside him, looks like a cross between an inquisitor and a scholar. His expression is a blend of meditation and fanaticism, absorption and alertness, and he grasps his pen as though it were a spear or dagger. His physiognomy is a combination of the eagle and the shrew. There is infinite vivacity in his meditative pose, and his mental vigour is so great that it seems to strain at every fold of his gorgeous robe.

Juan de Valdés Leal has been called the greatest Spanish colourist in a century in which Ribéra, Zurbarán, Velázquez, and Murillo were all active, but viewed in its entirety his work creates a conflicting impression. Mentally, humanly and artistically, he is the most turbulent of the seventeenth century's great figures. The lack of self-control which figured so prominently in his personal character (and which repeatedly spoiled the success which life brought him) is also evident in his painting. He was, both as a man and an artist, versatile and inwardly reft, predestined but without vocation. His finest pictures capture the external world with uncanny precision and bathe it in ghostly luminosity, but his weakest fail to convey even a vestige of its richness. He was a painter who let himself be carried away by it and achieved richer effects than he could exploit to best advantage. There is a suggestion of great thematic and formal abundance throughout his work, but it is often richer in detail, which he depicted with feverish concentration, than in overall composition, which often evinces a routine staleness. When one compares his painting with that of Murillo, from which it must be differentiated, one realizes that it contains greater genius and less purity of form. Valdés Leal ventured to depict an ugliness which is beneficial when set against Murillo's beauty because, where it is fully realized, it contains nobility of soul and conveys Heaven in terms of Hell.

In 1672 Juan de Valdés Leal spent a short time in Córdoba, where he instructed and advised the young Palomino. An etching of the interior decoration of the Cathedral in Torre Farfan's book bears this date, and he also painted several pictures for collectors at the same period. His latest signed panel painting was the *Christ with the Scribes*, dated 1686, which is now in the Prado at Madrid. It reveals a considerable waning of creative power. While painting on a platform he suffered a stroke, but did not die until two years later, on 14 October 1691. He was buried the following day. His son Lucas, who was christened on 24 March 1661, carried on his father's studio after his death. His pupil Matías de Artega y Alfaro, a Sevillian by birth, also painted in his manner, and Domingo Martínez perpetuated his style into the eighteenth century.

VELÁZQUEZ

Critics of Velázquez—and he has seldom been without—have taken far too narrow a view of his human and artistic, spiritual and intellectual stature. They have made the mistake of confusing flatness with superficiality, reserve with indifference. He is the greatest Court painter in the history of European painting, but he is more than that. So far from confining himself to mere likenesses of the King and his entourage, he imbued his work with an abundance of human, intellectual, and spiritual contrast. Beyond this, he recorded not only the glamour of the Court and its social hierarchy but also its background and underworld, its dwarfs and jesters, observing and portraying the latter even more richly than he did their masters because he endowed their dwarfishness, deformity, and madness with more soul and feeling, more inherent and external emotion. Even at the height of his fame he felt a closer affinity to them than to the royal and aristocratic personages whose reputations he served. He poured all the freedom of action which was forbidden him when painting the King and his immediate circle into these human curiosities. Their gaze as they stare back at one from the canvas is unforgettable. Only fanatical devotees of Greco, of the type which has become common in the past half-century, could call Velázquez soulless and devoid of feeling. The honesty of his treatment of kings and infantes extends to his dwarfs and Court jesters. Whether standing or seated, holding a dog or laying one hand magniloquently on their breast, drawing a sword or reaching for a dagger, they seem so close to the beholder that they might have been painted yesterday. Above all, their faces convey a wealth of expression denied to portraits of the King and his Court: sorrow and discernment, scepticism and resignation, intelligence, ingenuousness, and cunning. It is no accident that Velázquez's style seems freer and less inhibited in these pictures than in most of his portraits of the King and the infantes. In the former he relaxed, gave free rein to his genius, and released his excitement from its formal confines, producing still greater miracles of painting than appear in his other work.

Diego Velázquez was the son of Juan Rodríguez de Silva and his wife Gerónima de Velázquez, who lived in the parish of Santa Magdalena in Seville. He was baptized on Sunday, 6 June 1599, in the Parish Church of San Pedro. His father came from an old and aristocratic family which prided itself on tracing its ancestry back to Aeneas Silvius, while his mother was descended from the noble Velázquez and Zaja families. Following Andalusian custom, the boy took his mother's name. He grew up in the old quarter of Seville, was carefully brought up, and received instruction in Latin and philosophy. At the age of eleven he went to study under Herrera the Elder, but lasted the course for only a few months—probably because of his master's violent temper. When the painter Pacheco returned from his visit to Court, the boy was entrusted to him for further training. 'Pacheco's house was the golden home of art,' as Palomino puts it. 'His guidance was more valuable than his example, but a training based on theoretical principles and the sober restraint of that dry pedant were the ideal discipline for a genius, and this thorough, systematic, many-sided education bore good fruit.' Pacheco himself wrote, after Velázquez had ceased to be his pupil: 'Moved by his good conduct, honourable character, and the glowing prospects afforded him by his great talent, I gave Diego Silva de Velázquez my daughter's hand in marriage after five years of

training and instruction.' The Sevillian painter was soon attracted to the capital, and in April 1622 he visited Madrid for the first time. Having travelled there with the intention of painting the King's portrait, he returned to Seville with only a portrait of the poet Luis de Góngora to show for his pains. In the following year, one of his patrons succeeded in commending him to the attention of a senior member of the royal Court. Summoned to Madrid with his wife and children, he proceeded to paint such a fine portrait of Fonseca that it paved his way to high places. 'That same night the son of the Conde de Peñaranda, Chamberlain to the Cardinal Infante, took it with him to the palace, and within the space of an hour it was being examined with admiration by all its inmates, the King and princes included.' On 6 October 1623, Velázquez was installed as Court Painter. His monthly retainer amounted to twenty ducats, his works were to be paid for separately, and he was entitled to free medical treatment. Although his emoluments were increased several times in the coming decades they were always in arrears, and until the very end of his life he had to fight a running battle to secure payment of what was contractually his.

During Rubens's second visit to Madrid in the autumn of 1628, Velázquez showed him round the city and the Escorial. Rubens was enchanted by the young Spanish painter's work and copied some of his pictures. It may have been Rubens who advised him to visit Italy, for on 10 August 1629 Velázquez embarked from Barcelona armed with two years' salary and letters of recommendation. From Genoa he travelled through Lombardy to Venice, where he copied Tintoretto's *Last Supper* and *Crucifixion*. On arrival in Rome he succeeded, through the good offices of the Spanish Ambassador, Count Monterey, in securing the Grand Duke of Tuscany's permission to live in the Villa Medici on the Pincio. Painting as though he were still in Madrid, he produced *The Forge of Vulcan* (plate 58) and *Joseph's Coat* (plate 59). When he fell ill he was moved from the Villa Medici to the residence of Count Monterey, who was also the brother-in-law of his patron Olivárez, and on his recovery he received a commission to travel to Naples and paint the Infanta Maria. He probably met Ribéra on this occasion. When his work was finished he returned to Spain by sea. In the ensuing years the King spent a great deal of time with his Court Painter, as Pacheco's account suggests. 'It is scarcely believable, the amity and intimacy with which he is honoured by His Majesty. Since the King keeps a key to his atelier, where a chair is set ready for him, he makes a habit of watching him at his painting almost daily. . . . He shows himself a tireless model, and has, when being painted on horseback, persevered for all of three hours on end.'

For all that, Velázquez's career at Court proceeded slowly. From 1632 onwards his services were employed in the artistic decoration of the Palace of Buenretiro. He undertook only one of the historical pictures in the Sala de los Reinos, namely *The Surrender of Breda* (plate 70). In the following years he painted three hunting portraits for the Torre de la Parada in the game preserve of Pardo, each of which was a masterpiece. The portrait of Baltasar Carlos, the finest in the series, was painted in 1635, the Infante's sixth year. On 6 June 1633 Velázquez was promoted to a more senior post at Court, and in 1634 he became 'ayuda de la guardaropa de S. M. sin ejercicio'. It was still a subordinate position, however. An ordinance of 17 September tells us that his salary, like that of the barbers who held the same rank, was raised to eighty ducats, while that of the Court dwarf Antonio el Ingles was increased to

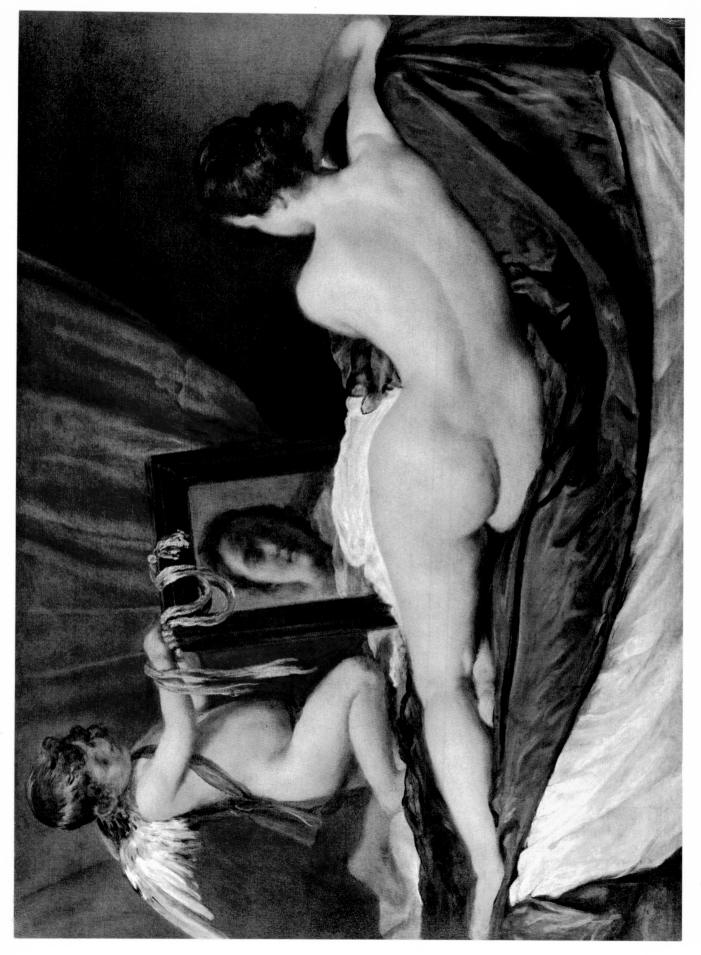

V VELÁZQUEZ. VENUS AND CUPID

seventy-two ducats—eight ducats' difference between the remuneration of the greatest contemporary Spanish painter and a dwarf of the royal Court! In his new position Velázquez had to follow the King everywhere, and on 26 April 1642 he accompanied him into the field. On 20 January 1643, after the fall of Count Olivárez, who had been his constant patron during the past decades, Velázquez was sworn in as 'ayuda de camara'. The new post entailed so much work that he was left with less time for painting than hitherto. On 2 January 1647, in recognition of his efficiency, the King put him in charge of work at Buenretiro.

Then came an opportunity to pay a second visit to Italy. In November 1648 he joined the delegation charged with fetching the King's bride, Maria Anna of Austria, previously destined to be his son's wife, from Trento. The delegation embarked at Málaga and landed at Genoa. On 21 April 1649 Velázquez arrived in Venice, where he acquired pictures by Tintoretto, Veronese, and Titian for the King. He then travelled via Modena, Parma, Bologna, Florence, and Rome to Naples, whence he returned to Rome after completing more business there. He acted as the King's agent in Rome, too, buying pictures on his behalf and getting casts made of the most famous classical sculptures for the royal collection. He had also intended to visit the other world centre, Paris, after leaving Rome, but the King was impatiently awaiting his return and refused him permission. Velázquez postponed his departure from Rome on a variety of pretexts, however, and did not arrive in Madrid until 1651. In the following year a vacancy appeared among the King's *aposentadores* or Court marshals. Passing over all the other candidates who had applied for the post, most of whom belonged to the high nobility, the King gave preference to his Court Painter.

Velázquez's career culminated in his appointment as a Knight of the Order of Santiago, but this involved arduous duties. The illness which eventually caused his death was brought about by his exertions on the King's behalf. After the Peace of the Pyrenees, Philip IV entrusted him with the task of preparing accommodation for the Spanish and French royal families on the Isle of Pheasants in the River Bidassoa. On 7 April 1660 he set off from Madrid accompanied by his son-in-law and José Nieto, the Queen's *Aposentador*. In his capacity as a Marshal of the Spanish Court, he had to be present at the royal meeting. The uninterrupted and strenuous work of the previous weeks had so weakened the painter, now sixty years old, that he fell sick. On 31 July (the day on which he wrote his only extant letter) his condition took a turn for the worse and began to give rise to the gravest anxiety. The King's personal physicians tended him, but without success, and he died towards two o'clock in the afternoon of Friday, 6 August. A week later his wife also died and was buried at his side. When Philip IV read a letter dated 15 August 1660 proposing that the painter's salary of one thousand ducats be discontinued, he wrote in the margin: 'I am utterly cast down.'

Velázquez was already a great painter at the age of twenty-six. His full-length *Portrait of the Infante Don Carlos* (plate 54) looks like a further development of the full-length *Portrait of Philip IV* (plate 55). The Infante stands there in an attitude of haughty negligence, characterized as much by his stance as by the expression on his face. Note the keenly observed right hand with the glove dangling from one finger. All the young man's arrogance is compressed into this one gesture. The portrait of the King holding a letter in his right hand looks self-conscious by comparision, as though Philip's pose lacked the weight which would have

given it assurance. The Infante, on the other hand, is really there in the room, filling it with movement. That is why he needs no chair or table for support. The narrow face with the heavy lower lip, high temple, and thin moustache is modelled in simple planes, and, although one would not venture to talk in terms of physiognomical elaboration, it contains every living quality which could find expression in the youth's features: inbreeding and degeneracy, intelligence and arrogance, shrewdness and mistrust, weakness and cruelty. He looks at us across the centuries like a man of our own day.

The two pictures which Velázquez painted during his first visit to Rome belong together, just as they also occupy a special place in his work. *The Forge of Vulcan* (plate 58) takes its theme from the myths of antiquity, while *Joseph's Coat* (plate 59) portrays an Old Testament story. In one picture a misdemeanour is being discovered, and in the other a crime is being concealed. What prompted Velázquez to paint such pictures we cannot tell, but it was probably a combination of different factors. They may have provided a relief from his regular material in that they allowed him to incorporate clothed and semi-nude figures in juxtaposition. But it is also as if he were giving expression to his experiences at Court, to the multitudinous intrigues, human iniquity, and hypocrisy which surrounded him. In both pieces the action— the moment of discovery—is framed with a dramatic intensity which is foreign to most of Velázquez's work but which he none the less succeeds in conveying perfectly. Every last detail of their construction is determined by the need to portray the action as clearly as possible. General consternation takes a different form in each figure, yet the spiritual, mental, and emotional impact is distributed with miraculous consistency throughout the breadth and depth of the picture. *Joseph's Coat* is a veritable manual of instruction on pictorial structure, on the arrangement of individual and grouped figures, on the posing of single figures and their relationship to background.

The *Equestrian Portrait of Don Gaspar de Guzmán* (plate 63) which Velázquez painted of his patron Count Olivárez in about 1633 first came to the attention of the public in an etching by Goya dating from 1778. Philip IV's favourite commissioned Velázquez to paint him in the guise of a general, and Velázquez complied with his request. Count Olivárez's contemporaries report that he was mad about war but stayed as far away from the firing-line as possible—not that this deterred the King from promoting him as though he had won a succession of brilliant victories. His enemies poked fun at the 'heroic minister and great man' who found it impossible to board a ship without becoming sea-sick immediately, and when the *Equestrian Portrait* which Velázquez had painted of him was displayed for sale in the Calle Mayor in 1635 the crowd threw stones at it. Velázquez planned the portrait so brilliantly that its actual execution can have presented him with little difficulty. Like Titian in his portrait of Charles V on horse-back at Mühlberg, he buttressed the picture at one edge with a massive tree-trunk. The horse rears diagonally (from right foreground to left background) and the General looks out of the picture in the opposite direction. 'This general is a humbug, like his brown hair,' writes Justi, but the portrait is a great achievement for all that. It depicts a shallow man with a plump, 'pretty', self-satisfied face, but Olivárez was like that, from all accounts, and Velázquez transformed him into great painting.

Breda, a fortress in northern Brabant which Justin of Nassau had defended heroically

against the Spanish general Spinola, capitulated on 2 June 1625. The beleaguered garrison's exodus and the handing over of the keys followed on 5 June. The victorious General granted the enemy extremely favourable terms, even though his troops were opposed to the idea, and the garrison left the town by the Herzogenbusch Gate with cavalry in the van and bringing up the rear. According to eye-witness accounts, both generals dismounted and Spinola waited, surrounded by princes and officers of noble birth, for the garrison's Commander, whom he greeted with a friendly smile and a friendlier word.

The Surrender of Breda (plate 70) is the noblest of all European war pictures. It contains a fund of spiritual and artistic strength which remains unexhausted to this day. It does not depict war itself but, rather, because the victor is chivalrous, an end to war which gives promise of better times to come. Our gaze is drawn imperceptibly into the picture from each margin and directed towards the proceedings in the centre. Similarly, two of the marginal figures create a link with the beholder: the young musketeer on the left, who has shouldered his weapon and is looking out of the picture, and the man on the right, who is standing by his horse and likewise looking out of the picture (plate 71). The latter is, in fact, the painter of this magnificent picture, portrayed with the same grave animation which characterizes the whole work. The event has been reproduced exactly as it happened, yet it seems so freely conceived that it might have originated, in every detail, in the painter's imagination. Never have victor and vanquished been pictured together with greater nobility because they have never been visualized more grandiosely. The opposing armies and the two generals (one of whom is looking up, handing over the key, while the other looks down kindly with one hand resting on his adversary's shoulder) are juxtaposed with a wealth of formal and emotional contrast and, thus, inseparably linked together. There is as much pride in the face of the officer behind General Spinola as there is sorrow and shame in the expression and stance of the young man next to the Prince of Nassau's horse. Something of their leaders' nobility is reflected by even the farthest figures in either group. The victor's pride is tempered with moderation and the grief of the vanquished remains free from self-abasement.

Philip IV was a dutiful king in a great era, and this alone meant that he exerted a beneficial influence on his country. People have called his greatest achievement the way in which he ousted his father's favourites when he acceded to the throne and carved out a place for himself. He was a good Catholic but not a fanatical one, the finest horseman of his day, an excellent shot and a first-rate huntsman. Apart from this, he practised the art of self-control. He had feelings but thought it unkingly to show them, so his entourage seldom if ever saw him angry or excited. However, not even he managed to preserve moderation in every field. He had innumerable affairs with women and was credited with having sired thirty-two natural children, of which he acknowledged eight. One passion which he did display openly was his craze for the theatre, and his reign became the golden age of the Spanish stage. At the age of nine he appeared as Cupid in a mythological play performed by young girls of the Court, and he later took part in the improvised comedies which were performed before select audiences in the Queen's apartments. He learned foreign languages and started on a translation of Guicciardini. Numerous anecdotes indicate how enthusiastically he encouraged art and how his moderation and severity became transformed into gentleness and generosity when he was

dealing with artists. Such was the king and master whom Velázquez had to serve both as courtier and painter from his early years until his death.

Velázquez's numerous portraits of Philip IV convey both his own spiritual and artistic development and the physical and intellectual development of the King. Their full range becomes apparent when one compares the early half-length portrait in armour (plate 80), painted in about 1628, with the portrait in indoor clothes painted in about 1655 (plate 81). More than thirty years separate the two pictures—a vast span in the development both of King and painter. They are similar in pose, being half-length portraits and slightly less than full-face. The first has all the characteristics of youthful work, the second all the marks of mature achievement. The early half-length portrait of Philip IV shows him in armour and scarf, smooth blond hair carefully combed and glistening as though anointed with pomade, full red lips looking as if they had been rouged. The linear development is emphasized, the area round the eyes rich in light and shade, and the bridge of the nose modelled by the shaded area beside it. For the rest, one senses a certain tautness of pose and expression which may have derived from the young King's wish to cut a dashing figure. The half-length portrait of the elderly King, on the other hand, is painted in quite another way. One fact makes a substantial difference in itself, namely that Philip has had himself painted in indoor clothes rather than armour. He has become genuinely older in the thirty years which have elapsed since the early portrait was painted. Face and stature have changed, the body becoming thicker and the lines of the face heavier, too, the oblique set of the eyes accentuated because of diminished tension in the lids, the lips paler and less full, the mouth less prominent because of the upswept moustache on the upper lip, the chin broader and more forceful, the hair less well-tended and falling on to the white collar, the look in the steel-grey eyes no longer expectant but cold and a trifle morose. These, however, are only the most superficial differences detectable from a preliminary glance at the two portraits. It is not until one looks behind the differences governed by the King's changing physiognomy that the differences in artistic treatment emerge.

There is more observation, vision, experience, and artistic richness in every brush-stroke which goes to make up the fastening on the grey robe in the later portrait than there is in the gleaming armour and wealth of drapery in the earlier one. Armour and scarf are superbly painted, but they could have been painted even more superbly in the later manner. By contrast the mouse-grey jacket (with its sparse, quickly brushed-in folds and the broad highlight playing across it) is as perfect as only great painting can be, apparently painted with nothing yet saying everything. The path of development running between the two portraits leads from profusion to proportion, from external abundance to external simplicity, from representa-tionalism to abstraction, from a pose of outward tension to one of inward self-assurance, from a marked degree of linear and pictorial, mental and facial tautness to a pose in which King and painter are entirely self-contained, from outward show to inward reality. The paint-ing of the first portrait is that of a virtuoso; the painting of the second, that of a genius.

During the same period as he painted *Mars* (plate 73), Velázquez painted another allegory which merits comparison with it, *Venus and Cupid* ('The Rokeby Venus', National Gallery, London) (plate V). The winged Cupid with quiver is holding a mirror for a nude Venus, seen from behind, who is gazing into it so that her face is visible to the beholder. Few

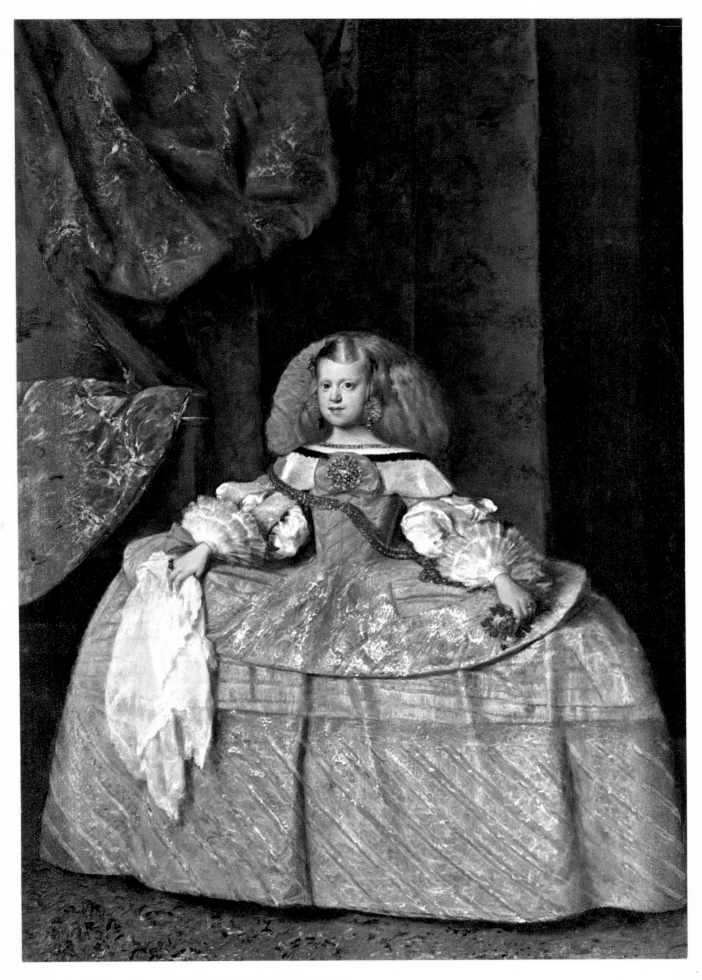

VI VELÁZQUEZ. THE INFANTA MARGARITA

greater contrasts between works painted by the same artist in the same period can be imagined. It is almost as if *Venus and Cupid* were Velázquez's way of compensating for *Mars*. While everything about the theme and execution of the former appears normal, everything about the latter is noble. No one looking at *Mars* can rid himself of the impression that the picture is a deliberate travesty, that Velázquez was making fun of the God of War (although that was not his intention). The thematic clarity of the other picture is such that no one could possibly be in any doubt as to its subject. This nude was the only naked female body Velázquez ever painted, but he treated it without a trace of inhibition, and his Cupid is portrayed with the charm of a Titian, Rubens, or Poussin.

In this picture, Velázquez shows himself as superb a painter of perfect feminine beauty as any of the great European exponents of the nude. He reproduces a classical subject in a manner which evokes all past and future trends in the history of European painting. Velázquez's œuvre is miraculous enough, but this picture represents a miracle in itself. The painting is objective yet full of vision, reminiscent of a brilliant sketch yet increasingly rewarding on closer acquaintance. The point and counterpoint of the upper and lower curves of the slim naked body, which is lying on a coverlet in front of a back wall and a heavy, draped curtain (its projecting left hip is accentuated by another, white cloth), form a rich ornament which is set off by the drapery of the cloth on the bed. The pale skin is painted with the same tension which achieves graphic impact in the outline of the body. This female nude, whose contours almost imperceptibly recall Mannerist treatments of the same subject, embodies an almost modern grace and worldliness absent in all other Spanish painters including Goya.

The woman's pose is youthful and self-admiring. She is naked but not 'starkly' so. Her body, which is surrounded by an aura of coolness, seems to have been painted dispassionately and at a single sitting. Its outline—from the right hand propped against the cheek, via the elbow (which cuts the picture's right-hand margin) and the arm to the left foot (which cuts the left-hand margin), and back again, via the projecting left hip, to the face (seen only in semi-profile)—seems to have been the outcome of a uniquely fortunate coincidence and, at the same time, of brilliant planning. The face, reflected in the mirror and thus detached, leads the eye back again to the slim, pale body. Widely divergent from the rest of Spanish painting in its pagan modernity and intimate representationalism, this picture observes and portrays the beauty of the female body, deliberately and brilliantly, as though for the first time.

The Oriental practice of keeping dwarfs existed in Europe until the advent of the French Revolution, which put a stop to it. Royal and princely courts combed Europe for these stunted creatures, who were bought up as rarities and curiosities, clad in gorgeous costumes, hung with gold and jewels, and exhibited on social or festive occasions. Even ecclesiastical dignitaries succumbed to the vogue, and Cardinal Vitelli once gave a banquet in Rome at which the guests were served by thirty-four dwarfs selected for their hideous aspect. Their masters treated them more like monkeys or dogs than human beings. Velázquez painted a whole series of dwarfs belonging to the Spanish Court—probably at the King's request. One of the finest and most audacious dwarf pictures is that of the Court dwarf Sebastian de Morra (plate 74). He is seen so nearly from ground-level that one gets the impression that Velázquez must have painted him sitting on a table. He is wearing a green doublet, green

trousers, a red cape embroidered with gold, and a wide lace collar. 'Originally, the frame enclosed him in a semicircle. He sat there like a watch-dog in its kennel' (Justi).

The *Portrait of the Court Dwarf Don Luis de Aedo* ('el Primo') (plate 75) can with some justification be regarded as a companion piece to that of *Sebastian de Morra*. Both portraits look related in that the dwarfs are depicted in a seated position. The first dwarf's attention is focused with surly belligerence on the beholder while the second is shown imitating the activities of a full-grown man—imitating, because although El Primo gazes meditatively from the picture, is surrounded by the attributes of a scholar (books, ink, pen), and is leafing through a massive tome, the beholder is left unconvinced. While the first portrait captures the attention immediately, the eye is led back by degrees to that of the thoughtful dwarf. The attitude and expression of the first is offensively aggressive, whereas that of the second is endearingly pensive. El Primo looks almost elegant when compared with Sebastian de Morra. He is holding the volume on his knees unaided, with his left forearm resting awkwardly on its open expanse and his right hand grasping a wad of pages. The thick book supporting the pen and ink-well and the other books lying on the floor to its left form a *repoussoir* which sets off the figure above. The portrait conveys an impression of nobility which, like its mode of painting, reminds one of Manet.

Justi mentions that the Italians had been struck by the Spaniards' predilection for jesters as early as the sixteenth century. One of them wrote that 'the Spaniards have surpassed all the people of Europe in their extravagant and passionate powers of imagination where things grotesque and comic are concerned'. Jesters played a great role in the life of the Spanish Court. Philip II had jesters at his table and even took some with him on his visit to England, but it was under Philip IV that they achieved their greatest prominence. They appeared at his side during plays and audiences, attended all his banquets and were admitted everywhere. At a bullfight in honour of the Duke of Modena they sat round the royal couple at the foot of the throne, dressed as ancient Castilian kings. Velázquez himself belonged to their category. At the bullfight in the Plaza Mayor he sat in the fourth tier with the barbers and lackeys of the nobility. His portraits of Court jesters may be regarded as a self-contained group. Though painted at various stages in his development, they may have many common features. They seem in general to be more facilely painted than his other portraits and strike one as brilliant improvisations, yet they all give vent to pure artistic inspiration. One picture which also belongs to the dwarf and jester group is *El Niño de Vallecas* (plate 68). Childish idiocy is observed as richly in this portrait (painted 1638–42) as dwarfishness is in that of *Sebastian de Morra*. According to the inscription beneath an engraving made by B. Vazquez in 1792, the Child of Vallecas was abnormally large when born and equipped with a full set of teeth. The physical deformity of the Court dwarf Sebastian de Morra is complemented by the physical and mental deformity, the gentle infantility of the Child of Vallecas. The deformed child in the jacket and long green over-garment is seated before a dark, beetling wall of rock. With its massive head tilted back and slightly inclined towards the right shoulder, it looks out of the picture with gaping mouth, bared teeth, and apathetic eyes. A Spanish landscape can be seen in the right background. The child's seated pose is conveyed with grotesque clarity by the contrast between the bandy, dangling left leg and the deformed right leg, which is lying almost

horizontal. The contrasting positions of the crippled legs are further accentuated by the calm, composed attitude of the hands and arms immediately above. The idiocy written on the face of the Child of Vallecas is exalted and ennobled by the manner in which it has been drawn and painted.

It is here that we can recognize the extent of the torment which must sometimes have afflicted Velázquez in his capacity as a Court painter and how great must have been his urge to redress his inner disequilibrium by painting a creature from the lowest order of humanity. Even the greatest artists, whose artistry transforms external compulsion into freedom, find purest fulfilment when they are working in perfect freedom rather than under compulsion. *El Niño de Vallecas* is testimony of this, for it depicts the greatest conceivable human defect —idiocy, or the total atrophy of the human mind—with an almost unparalleled intensity and richness. It is a painter's triumph over one of the absurdities of creation and the reaction of radiant genius to a human monstrosity. Something which in real life instils only horror or sympathy here summons up, for all the emotional impact of Velázquez's treatment, that sense of joy which only great art can evoke.

The two philosopher portraits, *Aesop* (plates VII and 72) and *Menippus*, are classed with those of the jesters and Court dwarfs because, like them, they afforded Velázquez a change from his normal routine and an opportunity for artistic realization lacking in his portraits of the King, the infantes, infantas, and senior members of the Court. Subjects of this type, like the dwarfs and jesters, represented an escape from Court etiquette and secretly contained everything that was forbidden Velázquez at Court itself. The two portraits *Aesop* and *Menippus* should be regarded as spiritual and artistic companion pieces. The philosophers' identifying attributes are lying on the ground, as in the portraits of Court jesters. The two portraits are also related (once again, like the dwarfs and jesters) in that their liaison with the beholder is more immediate than that of the royal portraits. Aesop stands there like some great character actor, his face framed in thick grey curly hair. Velázquez has tried to capture his character as it was in life. The face contains all the beauty and wealth of artistry of which Velázquez was capable. The head may, in itself, be that of a 'character', but the painter has recognized and exploited all the opportunities for chiaroscuro modelling offered by his subject's impressive features. It is a face ravaged by the storms of life—the face of a demoralized genius—but, beyond that, it contains the fathomless depth of his jesters and dwarfs and also (in a transposed form) the nobility of his kings. If ever a face painted by Velázquez deserved to be called inexhaustible it is this one. It looks up from the gutter and down from a throne simultaneously, the face of a beggar and a king—less a face than a spiritual landscape.

Velázquez comes closer to Rembrandt in this sort of portrait than in any other, yet no example illustrates the contrast between him and Rembrandt so clearly and abundantly. What emerges from a comparison of the two great contemporaries, Spanish and Dutch, whose life-span covered the first two-thirds of the seventeeth century? Rembrandt, who lived between 1606 and 1669, was born seven years after Velázquez and died nine years after him. Both Velázquez and Rembrandt produced their most mature work during the same decades. In a fairly wide sense, the former's style may be termed Latin and the latter's Northern. Velázquez's painting is related to the great Italian masters in that it projects itself in purely visual

terms. Rembrandt's, much as it accepts the visual element, is not characterized solely by it, a trait which it shares with German painting. Velázquez's painting looks so lucid that one often believes it to be devoid of secrets. It is brilliantly self-evident, as long as one confines oneself to simple scrutiny. However simple a form it takes, Rembrandt's painting can never be described as lucid. It seems not so much to be applied to a flat surface as evolved there in dimensions and surrounded by atmosphere. It offers one a better chance of experiencing the beauty of the external world and arriving at a realization of that beauty than Velázquez's. It is a gauge for measuring a man's receptivity to painting. However, one can love Rembrandt's painting without understanding its intrinsic content, without seeing and comprehending it correctly, prompted by a feeling which it conjures up but of which it does not demand—or appear to demand—confirmation in visual terms. With Velázquez, this is impossible.

In Rembrandt's painting every last brush-stroke emerges and flows back into a darkness seemingly compounded of excrement and gold. In Velázquez's, the eye is arrested by a surface in which every colour, every brush-stroke seems superimposed on a white ground. Rembrandt's painting leads the eye away from the surface because each brush-stroke helps to neutralize it. Whether he wants to or not, the beholder's gaze probes ever deeper, just as his feelings, thoughts, and dreams grow deeper too. It is because Rembrandt encourages one to do this and because he immediately summons and stimulates the whole man that he merits the love of all Europe. Equally, because he renders this impossible in most cases, Velázquez is under-rated. Even the portraits which seem like a descent into chaos (his dwarfs, Court jesters, and philosophers) display outward order and regularity, self-control and subtle reserve. Each portrait offers us a rich but circumscribed character, an individual and, beyond that, a type, with a clarity and lucidity which seems to extend into the innermost recesses of the soul. Each of Rembrandt's portraits depicts a human being who emerges from the all-embracing bosom of Nature for a finite period, fulfils his or her destiny according to an external law, asks the meaning of life—throughout life—in everything he or she does, strives to find an answer and passes on without ever doing so. Velázquez's portraits—except for his dwarfs, jesters, and philosophers—seldom pose this question. They repel from the outset anyone who tries to derive more from them than pure painting can offer, anyone who looks for the secret of painting not in painting itself but in life, of which it is an image. Velázquez's painting seems to be a classic example of 'l'art pour l'art', whereas Rembrandt's appears to embody the opposite of this approach.

Velázquez painted very few religious pictures. One of these, which appeared in 1645, was a *Coronation of the Virgin* (plate 61). Comparison with Greco's *Coronation* (plate 22) reveals the contrasting spiritual and religious approach of the two. Velázquez's is a thing of gorgeous but unemotional solemnity, a piece of worldly entertainment, a theatrical apotheosis. Mary is less a saint then a coolly beautiful lady of Spain with a flawless face, pure brow, rounded chin, heavy-lidded eyes demurely cast down as if in well-bred reserve, right hand on breast with thumb raised, left hand held a little above the knee with fingers slightly flexed. Christ is an earnest, handsome young man with curly hair, God the Father a splendid patriarch with noble but worldly features, temples wreathed in sparse hair, bushy eyebrows,

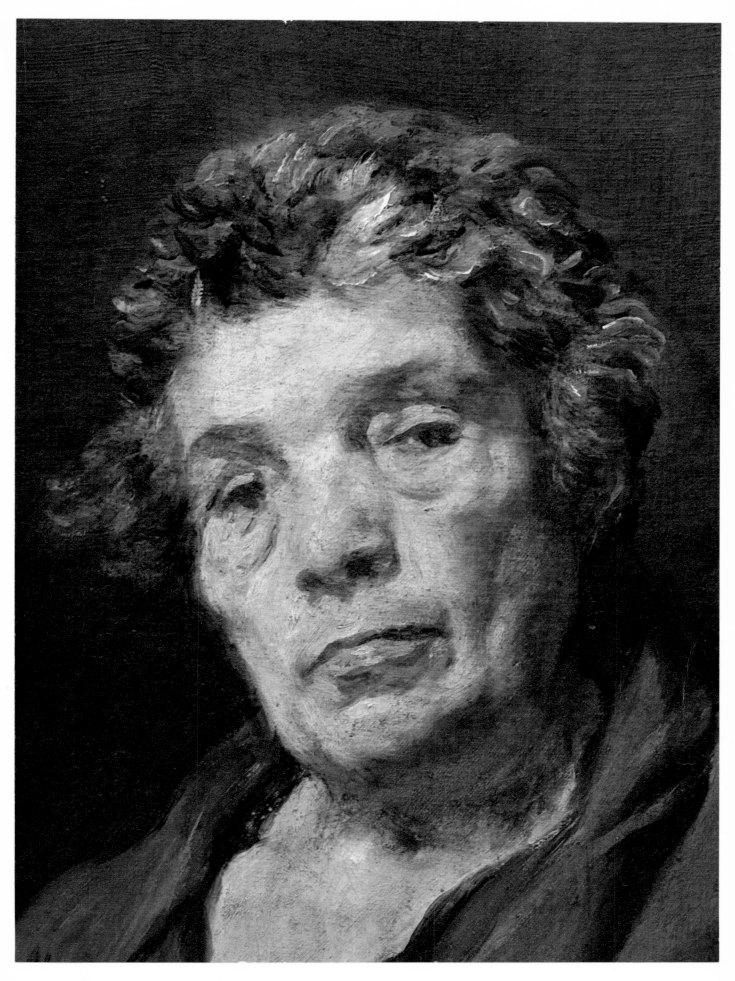

VII VELÁZQUEZ. AESOP. DETAIL

and a long white beard. For all their grave dignity, God, Christ, and the Virgin are posed rather than merged in the action of the picture. Greco's *Coronation*, which recalls icon painting, lacks the superficial solemnity of the other picture. At no point does it arouse mundane curiosity, yet the beholder is compelled to look upwards. What unfolds before him is a religious rite, not merely a piece of ceremonial.

In 1650 Velázquez painted a *Portrait of Pope Innocent X* in Rome (plate 78), where he had been staying for some time. This picture, which Reynolds called the finest in Italy, is now housed in Rome's Palazzo Doria. It represents the beginning of Velázquez's last and most mature period. On entering the small room where it is hung, the visitor experiences the same strong impact as that created by Rembrandt's *Portrait of Jan Six* in its little room in Amsterdam—although it does not excite the same inner emotions. The Pope's portrait looks alien in its Roman environment. The handling of face and background is ineffably brilliant, and the constant, uninterrupted process of revelation extends to the last fold of drapery in a manner equalled by few other portraits. The Pope is seated in a chair of State with his arms resting on the sides. He is holding a letter between the thumb and forefinger of his left hand, while his right hand hangs free with fingers loosely spread. In this pose he looks out of the picture with brows knit above grey eyes and a multitude of surrounding wrinkles, thin lips compressed and the right-hand corner of his mouth slightly drawn back, captured at a moment which lays his character bare: watchful, inscrutable—almost furtive—but mentally alert, too, as though about to spring into action at any moment.

This portrait illustrates better than almost any other precisely what constitutes great portrait painting, although even in its case this realization is subject to the limitations imposed upon any understanding of an artistic convention. Everything in it contributes to everything else. The position of the arms and hands prepares one for the physiognomical and spiritual tension in the face, just as the latter is analysed into two distinct components by the attitude of the arms and hands, the contrast between which provides the only key to a full comprehension of the man's spiritual and mental tension. In this portrait—which the Pope found too accurate for his taste—the actual painting seems simultaneously to recede into the background and impress itself on one's consciousness—in the eyes and their immediate vicinity, in the mouth, in the forehead, temples, and ear (plate 79). In his greatest works, the great artist is the freest of all men and endowed with infinite power. Looking at this portrait, one can only guess at the inner freedom which inspired this Court Painter's work. Velázquez was now painting as a mature Spaniard of fifty, with the long experience of a royal Court behind him, with knowledge of the Pope's origins and character, in possession of all the requisite artistic resources and techniques, in active competition with Rome's artistic past and present. When, on St Joseph's day, the portrait was exhibited in the monastery courtyard of the Pantheon, which was then used for art exhibitions, the Academicians of St Luke elected him a member.

In comparing Velázquez's two landscapes of the Villa Medici (plates 76 and 77) with Greco's two Toledo pictures, one is tempted to use catchwords of our own day to describe them: in Velázquez's case, Impressionism, in Greco's, Expressionism (especially in regard to the stormy view of Toledo). This, however, is not even an approximate description of either

59

man's artistic approach. The charming lack of constraint which characterizes Velázquez's landscapes has nothing to do with Impressionism, of which his portraits contain far more. They depict conditions, not impressions. Velázquez develops his painting on a secure, elaborate, and preconstructed framework. He chooses his view so that the landscape unfolds —like a superb stage set—in clearly defined architectonic layers with an inspired symmetry and a small range of selected colours which recalls Rubens's colouring in his grisailles. Greco's *View of Toledo* (plate 36) represents a contrast in every respect. It depicts no quiet state of affairs but a moment of intense natural turmoil, developed with an emphatic asymmetry which draws the eye along a zigzag course, like a flash of lightning, from the lower edge of the picture to its upper right corner, speeding it along one curve after another so that a ceaselessly flickering light seems to play across the whole canvas.

Velázquez's landscapes might have been painted from a window by someone in a state of perfect inner serenity. They are the work of a man who virtually neglected landscape— even the Roman landscape, whose historical associations must have appealed to him—but saw it as the image of a hierarchy in which each object derives dignity and significance from its place within that hierarchy. *View of Toledo* may also have been seen from a window, but this has no bearing on the painting itself. Here, the painter has stationed himself in the midst of the warring elements—indeed, it is almost as if he had conjured them up from within him-self. The picture is an expression of the strange tumult within the artist who painted it, just as Velázquez's landscapes are an expression of his inner harmony. With miraculous deftness, Greco threads his way through a natural occurrence which lasts no longer than a flash of lightning. He knows (far more from within than from observation) how the harsh glare or livid gleam of lightning can wrest a city from the darkness and illuminate its buildings, how light and shade are distributed in the process, and how unreal the colossal area rent open by lightning is. In *View of Toledo*, elemental turmoil emerges as the painter's own vision and be-comes an image of his inner excitement.

'Where is the picture?' Théophile Gautier asked, when confronted by Velázquez's *Las Meninas* (plate 86). Painted in 1656, this portrays the blonde Infanta Margarita and her maids of honour (*meninas*) in the artist's studio. Margarita has asked for a glass of water. One Maid of Honour (Doña Maria Agostina Sarmiento) is proffering a small red bowl on a tray. The Maid of Honour opposite, who is describing a slight curtsey, is Doña Isabel de Velasco, daughter of Don Bernardino López de Ayala y Velasco, Count Fuendalida. With one hand resting lightly on her skirt, the Infanta is curtseying in the direction of her royal parents, whose reflection can be seen in the mirror on the back wall. The picture affords a glimpse of the ceremonial which governed daily life at Court. In the middle distance stand the Infanta's guard of honour, Señora de Honor Doña Marcela de Ulloa and the *guardamas* whose duty it was to conduct audiences and ride beside the coaches of ladies-in-waiting. In the foreground can be seen the Infanta's other companions, a pair of dwarfs and a large (Spanish) bulldog. The female dwarf with the broad face and misshapen body is Maria Barbola, and the male dwarf who evidently finds it unseemly that the bulldog should lie down in the presence of the Infanta, and is kicking it out of the way, Nicolasico Pertusato. The royal couple's two *aposentadores* are also in attendance. The Queen's *Aposentador* (José Nieto) is just leaving the

studio by a rear door while Velázquez, the King's *Aposentador*, is looking round the edge of the large canvas in front of him.

The Infanta Margarita occupies the centre of the picture in every sense. Her small left hand rests on her farthingale while her right reaches for the little bowl on the tray. Her pose is taken straight from life, yet it might have come from a fairy-story. The white silk gown with the red and black rosette on the front of the bodice catches the light and holds it. The little girl's hair is golden-blonde on top of her head, white-blonde where it frames the delicate bluish translucency of her temples and falls, soft and shiny as silk, on to her shoulders. But, delicate though the painting of the little face is, nothing detracts from its expression of childishly animated precocity. In this picture of daily life at Court, Velázquez has embodied a self-portrait as well as the double portrait of the royal couple in the mirror—setting the rich abundance of his own life against its reflection. He gives us almost a full-length portrait of himself in Court dress, acting as a reporter of this trivial occurrence (plate 87). His left hand holds a palette, a bunch of brushes, and the supporting maulstick, which points obliquely downwards. His face is enclosed by black hair, his moustache slightly upswept. On his black jacket can be seen the red cross of the Order of Santiago. Light and shade play across the yellowish-brown skin of the face with its black, heavy-lidded eyes. Though unobtrusive, his figure is given a frame of its own within the larger picture by being located between the edge of the canvas, the picture-frame on the back wall, and the curtseying Maid of Honour. Velázquez's brush-work varies from deliberate restraint in the face to deliberate sketchiness in the slashed, puffed sleeves. The canvas on which he is engaged is large enough to accommodate the whole scene depicted here. From the way he holds and handles his brush one can deduce the way in which the picture itself was painted and visualize the swift, light, unerring dabs and strokes—applied as though the location of each separate stroke were already settled before brush touched canvas and the act of painting merely lent visible expression to a harmonious, predetermined plan.

Las Meninas epitomizes Velázquez's artistic technique and resources, in this respect meriting comparison with Greco's *Burial of Count Orgaz*. The process of human, intellectual, and artistic evolution which had been going on inside him ever since his early days at Court is poured into this one picture, which summarizes in concentrated form the world that inspired his work—from the King and Queen, to the Infanta and high-ranking officials, to the dwarfs and the dog. (Only the philosophers are lacking!) It is almost as if the two worlds which he depicted separately on other occasions had here been linked and merged in his own person because, as a painter and *aposentador*, he belonged to the servant class but was, as an artist, superior to it. What may have made it somewhat easier for him to portray this amalgam of differing social strata is that he only had to show the King and Queen in the mirror on the back wall. While the royal parents gain emphasis from their position in the centre of the picture, they are, equally, 'dethroned' by being seen only in reflection. The picture is a marvellous tribute paid by a mature artist to a princess in the flower of her childhood.

Carl Justi called *Las Hilanderas* ('The Spinners') (plate 85), 'one of the earliest worker- or factory-pieces'. Until recently it was thought to represent a scene in the factory in the Calle

de Santa Isabel, Madrid, but F. J. Sánchez Cantón, E. Lafuente, and Charles de Tolnay have demonstrated that this 'factory picture' portrays a subtly disguised mythological scene. Diego Angulo Iñiguez regards the old woman behind the spinning-wheel as Pallas Athene in the guise of an old woman (after the description given in the sixth book of Ovid's *Metamorphoses*) and the girl winding thread as Arachne. In the farther room, in front of the tapestry reproduction of Titian's *Rape of Europa*, a picture which came into the Spanish King's possession in 1562 and is now in the Isabella Stewart Gardner Museum in Boston, Pallas Athene stands beside Arachne as a goddess in armour and helmet. As for the other three female figures in the background, Charles de Tolnay adduces plausible reasons for regarding them as personifications of music (with the viola da gamba), sculpture, and architecture (without any special attributes). Arachne (standing beside the goddess immediately in front of the tapestry) personifies painting and tapestry-weaving. Thus the central idea of this picture is Pallas Athene as goddess of the major and minor arts, with special reference to tapestry-weaving.

Velázquez endows the subject with a variety manifest in the picture's construction alone —in the contrasting stratification of foreground and background, in the antithesis between the two large active figures in the foreground and the small figures in the background, which form a composition of their own in the centre and stand immobile on either side, in the relationship between the old woman with the spinning-wheel and the girl who is pushing aside the red curtain and looking down at her, in the two figures of the girl winding thread and her companion bending over a basket, in the way in which the shadowy figure of the girl in the centre supplies a link between the groups in the foreground and those in the background. Note, too, the mastery with which various forms of lighting are set off against one another or merged. The foreground area is more or less half-lit, while the background is lit brightly from an oblique angle, giving us a view through a shadowy room into an illuminated one peopled by figures in half-light, full-light, and varying degrees of eclipse—all of them rhythmically modified between foreground and background. The same process is apparent in the way in which the colours are gradated across the picture's breadth and into its perspective depth.

The portrait of Maria Anna or Marianne, Philip IV's second wife (painted *c*. 1652) (plate 84), must be compared with that of the Infanta Margarita (1660) (plate VI) before the special perfection of either can be fully recognized. In these portraits, Velázquez fulfilled different objectives with equal mastery. The first is a queen's portrait, while the second depicts her daughter, the Infanta. The difference between them is evident in the hair-styles alone. Maria Anna's coiffure is an elaborate creation, while Margarita's blonde hair is simply dressed. The contrast between the two portraits is further emphasized by their basic tonality, the Queen's being evolved from a foundation of red and black and the Infanta's from grey and red. The first portrait stresses the regal and, at the same time, the foreign appearance of the subject, the second expresses only the girlishness of a small royal personage and the childish charm which even the more cynical courtiers had to acknowledge.

These two portraits permit one to form conclusions about Velázquez's working methods. He had evolved a special high-speed technique during his long career at Court. In examining such pictures one should never forget that, even when 'off duty', he must have been

permanently conscious of his position as Court Painter and aware that he would, sooner or later, have to portray every face in the royal entourage. He painted the princesses', Queen's, and Infanta's faces and hands in their presence, but did not add their surroundings (gowns, embroidery, chairs, draped curtains, handkerchiefs, lace, real and artificial bunches of flowers, etc.) until afterwards. It is probably this which accounts for the artistic deliberation of his painting in just such places. The dresses (black embroidered with silver thread and grey interspersed with streaks and patches of raspberry-red) are alive with brush-work and artistic invention, and in them Velázquez surrendered himself to his imagination and painter's technique. Both these portraits are constructed round their most animated portions: the faces, which in each instance are enclosed by their surroundings as though by a frame; and the hands which rest either on a chair-back or on the farthingales. How effectively the very different characters of the young Queen and the Infanta are conveyed by the position of their hands. Maria Anna's hand, holding a filmy white handkerchief (three fingers on top and two beneath), rests on her skirt with regal composure, its attitude mirroring the expression on her face. Margarita's left hand, with the pale rose, wreath of small blue flowers, and vermilion bow on the white lace cuff, forms a still-life of its own, like an ingenious piece of Rococo decoration.

As a colourist, Velázquez's course was set as soon as he entered the King's service. He had to portray the King and his circle, infantes, philosophers, and dwarfs included, wearing robes and costumes which Court etiquette prescribed more strictly and precisely than we tend to assume today. The main colour at Court—and therefore the most fashionable colour of the day—was black. Thus the manner in which Velázquez used and handled black during his lifetime affords an insight into the nature and significance of the colour. Generally speaking, it is the painters who are sometimes called 'pure painters' who manage to endow black with most luminosity: Titian, Tintoretto, Franz Hals and, in the nineteenth century, Courbet and Manet. In Velázquez's painting, black is a symbol of supreme dignity and inspired calm. He applies the colour almost universally in large planes and seemingly with a minimum of internal construction, though closer scrutiny reveals that this internal construction is not as sparing and simple as it appears.

The characteristics which distinguish Velázquez from his predecessors and con-temporaries in the field of Spanish painting are anything but those which are normally regarded as the essential characteristics of a Court painter. They include an astonishingly modern attitude to life, a receptiveness towards and feeling for the right thing, a sense of pro-portion, and abnormal mental alertness. While these qualities prompted Velázquez to observe, with fascinating and sometimes uncanny tact, the limitations imposed on him by every commission he undertook as a Court painter, he still affords one a cool and almost passive insight, strangely immediate in its impact, into the individual concealed behind and within the King, Queen, and infantes. Having once recognized this, one is less struck by the apparent daring of what Goya set out to do in the following century. Since Velázquez's world quickly became limited to the Court, he turned the Court into a whole world. As a physiognomist and psychologist, he conquered in pure painting something which had hitherto been a pre-rogative of the methods and techniques of drawing and draughtsmanship.

GOYA

In Goya's work the spirit of Spain not only re-emerged in all its splendour but demonstrated the great transformation which it had undergone in the course of centuries. In him, Spanish painting for the first time produced an artist who was to exert a crucial influence upon French and, thus, European nineteenth-century painting. With his painting, Spain repaid its centuries-old debt to European art. As a man of peasant and craftsman stock who became Court Painter, Goya belonged to the class which came to the fore, throughout Europe, as a result of the French Revolution. He had an acuteness of vision which laid bare all that met his eye and stored it up for use in future decades. He was not an immature painter, but what he saw and experienced augmented his inner substance in such a way that he continued to develop until the end of his life, becoming ever greater and more mature until, in latter years, he possessed the sort of genius more usually associated with a youthful prodigy. Even in old age he retained the essential sturdiness of the peasant and, with it, a species of peasant cunning. He saw the quality of ordinariness in the King and Queen—a quality which they possessed in full measure but which Greco and Velázquez excluded from their work—with uncanny force. He regarded the aristocrats to whom he owed his rise in the world with the gaze of the peasant who stands by the road-side and watches them drive by.

When the deafness which could have been a curse, but proved to be a blessing in disguise, cut him off from contact with the outside world, Goya's creative energy increased as though hearing had joined forces with sight to heighten his visual perception. His inner life, enhanced by observation, now burst forth into full and splendid flower. The religious fanaticism which had so often found expression in Spanish painting became transformed in his case into mania—and realism and mania were the sources of energy which uninterruptedly sustained his work in the field of painting, etching, and drawing until the end of his life.

Francisco José de Goya y Lucientes was born on 30 March 1746 at Fuendetodos, south of Zaragoza. He came of a family of small-holders and craftsmen. Some years after his birth his father moved to Zaragoza, where he worked as a gilder. Goya's first teacher was José Luzán y Martínez, whose atelier he entered at the age of fourteen. He subsequently continued his training in Madrid, where he met Francisco Bayeu and got to know Tiepolo and Mengs, whose painting had split the artists of Madrid into two hostile factions. Towards the end of the sixties he went to Rome, probably subsidized by the Academy. In 1771, during a brief stay in Parma, he entered a picture entitled *Hannibal after crossing the Alps* (not extant) in a competition sponsored by the local academy, and won second prize. Between 1772 and 1774 he lived in complete seclusion at the Cartuja Alta near Zaragoza because of a stabbing incident which might have landed him in gaol. On 1 May 1775 he married Josefa Bayeu, sister of the painters Ramón and Francisco Bayeu, at Madrid. In the course of thirty-six years she bore him twenty children of whom only one, a son, survived his parents. In the years that followed, Goya received numerous commissions from the royal tapestry factory through the good offices of Mengs. Most of his cartoons, executed in vivid colours and with great illustrative talent (*Winter Scene* is one), appeared between 1776 and 1780. On 24 July 1779 he applied, without

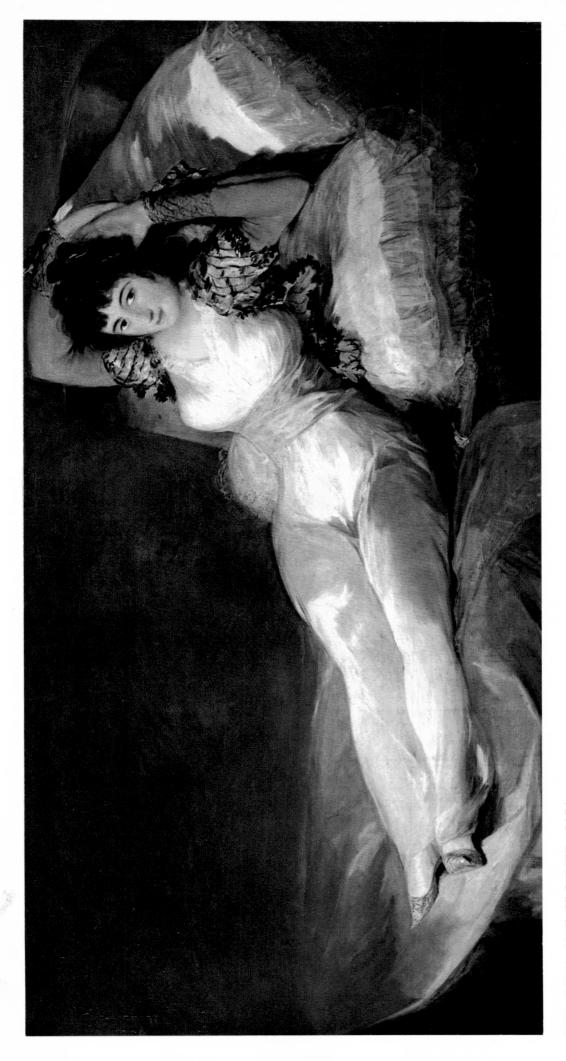

VIII GOYA. THE CLOTHED MAJA

success, for a post as Court Painter. In the following year he was nominated a member of the Academia de San Fernando.

It was during this period, when portrait commissions were flowing in, that he got to know the leading members of Charles III's entourage, among them General Ricardos, Mazarredo, Jovellanos, Floridablanca, Cabarrus, Campomanes, and the Duchess of Osuna. In 1785 he painted the Osunas, and a year later he was engaged as Painter to the Court, with a regular salary derived from his work for the tapestry factory. On 25 April 1789, shortly after his accession, Charles IV appointed him *pintor de cámara*. During 1798 and 1799 he painted a series of decorative pieces in the style of his tapestry designs for the Duke of Osuna's country mansion at Alameda. The Duke of Alba and his young wife also gave him commissions. He was received by them socially and even became a personal friend of the young Duchess, which gave rise to all kinds of speculation. On 31 October 1799 he was appointed Senior Painter to the Court. Shortly afterwards, as if in gratitude for this honour, he painted a portrait of the royal family. The numerous portraits of Charles IV and his consort, Maria Luisa, which Goya painted during their reign allow one to trace his spiritual and artistic evolution from a painter of talent into an artist of genius. In his early portraits, as in his other early pictures, he had not yet broken away from the traditions of eighteenth-century painting.

In 1792 Goya became so seriously afflicted by a nervous disease—not to define it too closely —that he had to abandon all forms of activity for many months. He does not appear to have shaken it off until 1794, when it was succeeded by an ear disorder which eventually resulted in total deafness. He spent the months which followed the critical phase of his illness in drawing and etching, being as yet unable to paint. After his wife's death he retired to a country-house on the banks of the Manzanares, whence he could see the outskirts of the capital and the Sierra de Guadarrama. There he created the environment which he needed for his life and work, and there he worked away at the pictures which now repose in the Prado, mysterious and often obscure pieces of which *Saturn* is an example. Towards the close of 1819 he was again struck down by a serious illness, but quickly recovered. While travelling to the French spa of Plombières in 1824, he settled in Bordeaux for good (after visiting Paris) because of its mild climate. He never left the place, and spent most of his time with Spanish expatriates. He died on 16 April 1828 at the age of eighty-two, of a stroke caused, so it is said, by excitement at the prospect of a visit from his surviving son. Such, in outline, was the life of the painter around whom so many legends have grown up.

The Spanish Crown Prince, also known as the Prince of Asturia, whom Goya painted mainly (from 1788 onwards) as Charles IV, was a powerfully built, good-natured man. His great passion in life, even after his accession, was hunting. In the evening he used to play lotto with the high-born officers of his body-guard or amuse himself by wrestling with them. He showed no understanding of political questions and evaded them with evident embarrassment whenever they were broached. On the other hand, he was a devout Catholic who never missed a Mass and docilely submitted to the influence of priests.

Maria Luisa, his wife, was a daughter of the Duke of Parma and had been betrothed to the Prince of Asturia as a child. When, at the age of twelve, she heard that her marriage contract with the Crown Prince (a close relative) had been signed, she immediately insisted

on being treated by her family and friends with the respect due to a future Queen of Spain. 'You must learn to treat me with deference,' she told her brother Ferdinand, 'because I am to become Queen of Spain, whereas you will never be more than a little Duke of Parma.' She was proud and imperious, and remained so. Her favourite, Manuel Godoy, who had first caught her eye because of his handsome face and who rose to high office after her husband's accession, was ten years her junior. Her children's resemblance to Godoy excited public indignation, though Charles IV himself remained unaware of the relationship for a long time. When it did come to his notice he flew into a passion, but later resigned himself to the situation. Maria Luisa had only been waiting for Charles III's death to abandon all pretence of concealing her relationship with Godoy. On the very day after her father-in-law's death she summoned the Ministers of the Crown into her presence, tacitly proclaiming that she, and not her husband, would rule the country. She proceeded to conclude a pact with Floridablanca under which he would retain unrestricted control over affairs of State provided that he left her free to distribute offices and honours as she thought fit. Despite this, Floridablanca was replaced shortly afterwards. A report written in 1789 by the Russian Ambassador, Zinoviev, describes the Queen as follows: 'Frequent confinements and indispositions—perhaps, even the germ of an illness which, it is said, is hereditary—have entirely withered her. Her complexion is greenish and the loss of her teeth, most of which are now artificial, has dealt her appearance a final blow. She is well aware of this, and the King has also noticed it. He often tells her, although in jest, that she is an ugly creature and growing old.' Shortly afterwards a dog was seen running through the streets of Madrid with a placard round its neck bearing the legend: 'I belong to Godoy, I fear naught.' Since the guilty party could not be found, the animal was gaoled instead. Goya not only painted Charles IV and Maria Luisa but Godoy as well. In the course of a decade, there appeared twelve portraits of the King and almost as many of the Queen.

One is constantly tempted to compare the various portraits of the royal couple. One full-length portrait shows the Queen standing, her right hand holding a fan and her bare left arm hanging loosely, in front of a landscape resembling a stage set (plate 110). A long black veil hangs from her black hair, which is carefully dressed. The two people who occupied the Spanish throne with Godoy between them were, in many respects, a good match. It is almost as though Goya thought of one while he was painting the other. It is apparent that they breathed the same air and (in different ways) indulged in passions which complemented each other. King and Queen look so ordinary that they might be two usurpers who had annexed sovereignty over the Spanish people after emerging from the gutter—the King robust, looking as though he could bend a horse-shoe with his bare hands, but weak-willed; the Queen an ill-natured, autocratic maid-servant; the King a good-natured person, resembling a harmless impostor in his royal garb, the Queen an ugly, overdressed creature—and each of them subject to an embarrassing reversal of roles which had turned the Queen into the master and the King into her lackey. One need only compare this royal couple from the closing years of the eighteenth century with Philip IV and his two wives to see the difference, both as regards painting and mental attitude.

Although the relationship between the King and Queen is readily deducible from

individual portraits, *Charles IV and his Family* (plate 111) lends it ultimate and astringent expression. The Queen not only occupies the focal point of the composition but forms, with the two children whom she has drawn to her, its focal group. In painting this family portrait in which the real paterfamilias is not present, the painter has succeeded, for all his inexorable realism, in flattering the violent and impetuous mother. He seems to have painted the whole picture for her benefit and to have subordinated everything around her to that end. Even her head seems to be enclosed by a frame of its own. In the background on the left can be seen a canvas with the painter standing behind it, looking as if he were gazing past the whole assembly into a vast mirror. This group is one of the most brilliant group portraits in the history of European painting. Where spiritual and artistic significance is concerned, it merits comparison with group portraits by Franz Hals and Rembrandt and with Velázquez's *Las Meninas*. It is a picture of a society on the verge of decay and dissolution. Outward order is still preserved, but behind that order, which seems to depend solely on the Queen's whim, lurks indiscipline. Goya saw and gave expression to both aspects. He did his duty just as Velázquez did, but in so doing wrought unintentional revenge on existing society.

His portrayal of the Condesa de Chinchón, Manuel Godoy's wife, painted just before the group portrait, is quite another matter (plate 108). In a letter dated 22 April 1800 the Queen wrote, among other things: ' . . . we should also be pleased if she would have her portrait painted, and if Goya can carry out our work there well and similarly. It is better if he paints her there because in that way we remain free of inconvenience. But, if this is impossible, let her come here, even though it will be irksome for us.' The Countess is seated on an upholstered chair dressed in a white gown bordered with a blue-embroidered hem. She is staring in front of her with an expression compounded of self-consciousness and sulkiness, her face very slightly averted and her hands clasped together in maidenly modesty. Face and hair are rich with line and colour—the slightly compressed, pouting lips, the eyes with their long fringed lashes, the artfully tousled hair with its white silk bonnet and decoration of spicules and wild flowers, which give her the air of a bird with ruffled feathers. In this portrait too, Goya, reveals himself to be a judge of character. He is on the side of the Condesa de Chinchón, not of the Court. His acute insight into this young, childlike woman, whose hands are shielding and protecting her pregnancy, is tempered by the tenderness with which he has treated her sulky charm.

The Fiesta of San Isidro (also known as 'La Pradera' or 'La Romeria de San Isidro') (plate 99) depicts the Madrid festival held annually on the banks of the Manzanares on the name-day of the city's patron saint. In a letter to Zapater, Goya wrote that he had been commissioned to produce a tapestry cartoon on the subject, but that the abundance of fine detail made it awk-ward to carry out in that medium. Goya probably made exhaustive studies for a tapestry cartoon of this nature, and his *Fiesta of San Isidro* came into being as a result. Ranged along the saddle of high ground in the foreground is a festive party of young ladies with pink and white sun-shades and gentlemen in cocked hats and tricornes. The nearer bank is thronged with standing, riding, and seated figures clad in black, white, and a variety of bright colours. The crowds on the river-bank are arranged in more or less parallel lines. On the farther bank rises the

69

lemon-yellow hill with the city straggling across it. The groups in the foreground look like a picture by Watteau seen through the eyes of Manet. This landscape, which occupies as excep-tional a place in Goya's œuvre as the Villa Medici landscapes do in the work of Velázquez, contains many features that did not appear in European painting until the nineteenth century.

At the beginning of 1794, Goya informed Yriarte in a letter that he had painted several 'museum-pieces'—'pictures in which I managed to use pieces of observation for which there is no place in my commissioned works and in which I was able to indulge my fancy and imagination'. By 'museum-pieces' Goya may have meant the five pictures in Madrid Academy, which depict a bullfight, a court of inquisition, a scene in an asylum, a procession of flagel-lants, and a carnival scene. The great change which Goya underwent during his severe illness exercised a splendidly liberating effect on his subsequent work, and his true genius dates from his year of sickness. In *Madhouse* (plate 103) and *Tribunal of Inquisition*—even in *The Village Bullfight* (plate 105)—he 'makes observations' but still bases his work on the external world reproduced with such brutal clarity in his portraits. In these pictures he gains relief from his overwhelming abundance of inner visions. As a mature artist and in his old age, Goya must have lived in a perpetual state of inner turmoil which found expression in his painting and drawing. *Madhouse*, *Tribunal of Inquisition*, and *Procession of Flagellants* (plate 102) are comparable with his etchings and lithographs. He might have put them down at the dictates of a demon—ejected them, as it were, to avoid being stifled by their profusion. Al-though the scene in the asylum may have been observed in an asylum, it is reproduced not with the rich variety of the external world but with a wealth of vision which, for all its super-abundance, preserves a splendid form of order. There is an almost hallucinatory intensity in *Tribunal of Inquisition* and in *Procession of Flagellants*, too. In these pictures Goya gives us what Velázquez gives in his portraits of dwarfs and Court jesters: a glimpse of the dark underworld and background by which all outward appearance is nourished. Goya the portraitist painted fast. He painted to order, one of the conditions being that he should finish the job within a stipulated time. That was why, in portraiture, even this great artist employed a series of craftsman's aids which he could almost always dispense with in his uncommissioned pieces. As a portrait painter, Goya had an ability to enhance his models, even though, at first, this might seem to be an unrewarding task. He sensed and saw the spiritual, mental, and instinctive abyss that lies behind a human face. Furthermore, his portraiture was permeated by two different kinds of approach, one of them based on the properties and resources of pure painting and the colour values of paints, the other aimed at a linear and conceptual treatment of physiognomy—and both subject to the need to produce a likeness. In these other pictures, by contrast, Goya's whole technique was determined solely by vision and conformity to artistic laws.

One of Goya's portraits depicts his brother-in-law Francisco Bayeu, another his wife Josefa Bayeu (plates 106 and 107). Comparative scrutiny discloses the facial resemblance between brother and sister but also reveals their differing relationship to the painter. The portrait of his wife is full of a rather desiccated charm, but it does not have the delightful piquancy which distinguishes so many of his other female portraits (notably that of Doña Isabel Cobos de Porcel). Josefa Bayeu sits before a dark background on a chair with a rounded back. She is

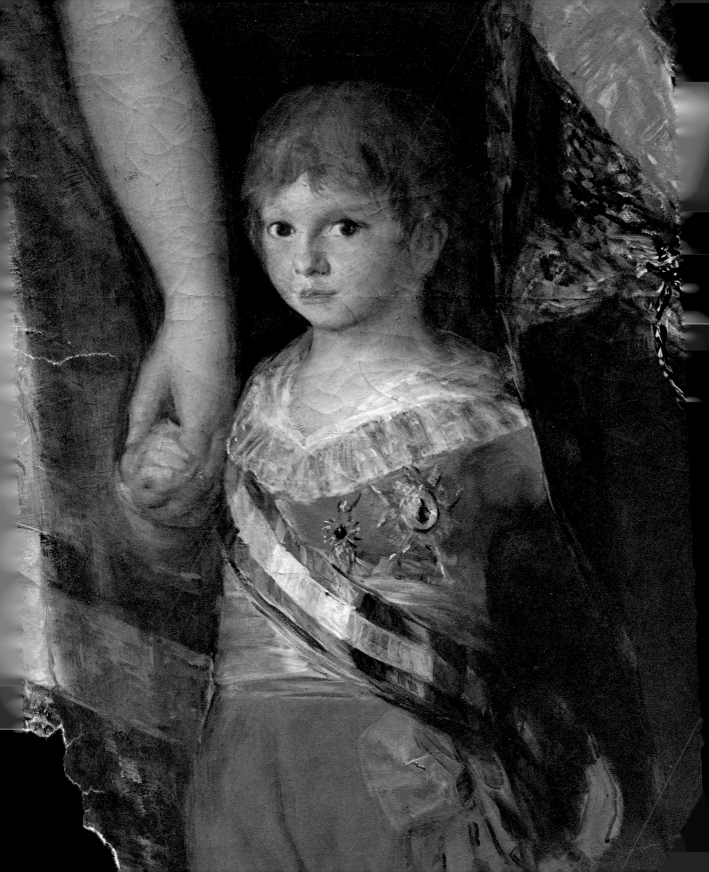

IX GOYA. CHARLES IV AND HIS FAMILY. DETAIL OF DON FRANCISCO DE PAULA

wearing a black dress draped to the elbows in a large white shawl. Her fair hair is wound round her head in numerous plaits of varying thickness, and her yellow-brown eyes are fixed attentively on the beholder. Goya painted his wife as a girlish and amiable creature rather than a motherly one, but his portrayal lacks seductive appeal. The posthumous portrait of his brother-in-law (painted in 1796) was based on a self-portrait by Bayeu himself but precisely conveys Goya's opinion of him. Francisco Bayeu gazes from the picture with his right hand (holding a brush) resting on the arm of his chair, his lips sullenly composed, mistrust in his deep-set eyes, and his features pervaded by an expression of weariness. The picture is a master-piece, brilliant and penetrating, the portrait of an uncongenial man seen by an artist of genius and painted with a gentle malice born of irresistible antipathy.

Goya's portraits are never caricatures even when they seem to point in that direction, but how greatly they differ from those of Greco and Velázquez! Greco's figures are etherealized and inspired by religious faith. The people portrayed by Velázquez are incorporated into an order of things against which they seldom rebel. Goya's portraits reveal the unseen powers latent behind visible phenomena. There is a vast difference between Velázquez's royal portraits and those of Goya, a vast difference in spiritual, mental, and emotional approach and an im-mense contrast in technique. Velázquez's painting is refined, deliberate and economical to the last brush-stroke; Goya's is turbulent, obsessive, sometimes florid. Velázquez sees the King and Queen as a balanced blend of human being and royalty. Goya permits himself to scrutinize them closely, to see them as accessible individuals who can be courted or betrayed and who, for all their outward superiority, can be approached without any necessity for repressing ones personal feelings and natural disposition. When Velázquez paints the King and Queen his every brush-stroke—without surrendering dignity or inner freedom—says: 'majesty'. Each of Goya's brush-strokes, on the other hand, seems a mark of familiarity.

The relationship between *The Naked Maja* (plate 112) and *The Clothed Maja* (plate VIII), which are among Goya's most celebrated pictures, is that of mutually complementary opposites. They elude any form of analysis which seeks to solve or interpret them in terms of this antithesis, yet they constantly invite comparative examination. The two pictures (painted in quick succession) are related in many respects, if only because the painter used the same model each time. In both pictures the girl is lying in the same position, arms clasped above her head, on a green day-bed in front of a brown background. *The Naked Maja* is the more famous picture. Its circumstances are similar to those which surround Velázquez's *Venus*, the work of an artist who never reproduced the naked female body on any other occasion and might almost have been ignorant of it, but who painted it—on his only excursion into the nude—with con-summate perfection. Goya's artistic gifts emerge here in their most disciplined form. Luminous pink and green shadows play across the plump young body as it lies there in an attitude of snug relaxation. The paleness of the skin, which everywhere seems to glow with hidden life, gains in rhythmical intensity as it runs from the tips of the girl's toes to her breasts, which seem to swell beneath one's gaze. Yet the pink of the breasts is alive, if only tonally, with every colour in the picture. Only Renoir ever managed to capture a girl's flesh in the same way. The naked and clothed Majas are in every sense portrayals of a naked and clothed woman. The naked Maja is superbly visible; the clothed version veils her charms. The naked Maja

displays Nature in all her lavish abundance; the clothed version is redolent of society and fashion. The naked Maja's face is as unadorned as a ripe fruit, saying no more than her hips, breasts, or knees, though saying it in subtler terms; the clothed Maja is rouged (as only a great painter knows how) and thus brought into closer association with the beholder. And, whereas the face of the naked girl, for all its attentive expression, preserves a certain distance between her and the beholder, the clothed girl's face has an enticing quality—much as fulfilment soothes and anticipation excites.

Goya painted two historical pictures. The first, *The Charge of the Mamelukes* (plate 116) depicts Spanish insurgents fighting French troops at the Puerta del Sol in Madrid, while the second, *Execution of the Defenders of Madrid* (plate 117) shows the rebels being shot outside the city gates next day. Both pictures convey the highest degree of dramatic tension to which Goya, a born dramatist in painter's guise, ever gave expression: first, in the battle between the inhabitants of Madrid and their mounted foes (a battle which is reproduced with uncanny impact and a wealth of exact detail); and, second, in the contrast between the firing-squad and the doomed insurgents, who have been herded into a bunch. Moreover, it is as though the picture showing the execution on 3 May 1808 were a development of that illustrating the insurrection on 2 May, just as one historical event was the outcome of the other. The engagement at the Puerta del Sol takes place by day, the execution by night—and by the ghostly light of a single lantern. While one picture compresses the action tightly (with a diversity equalled only by Rubens) and hints that the enemy's overwhelming superiority is about to prevail, the other divides the action into two contrasting groups, each of which intensifies the other's effect and so contributes to its own.

Both pictures exemplify Goya's various techniques, including his talent for still-life painting. They are among the few works of European art to which a whole nation seems to have contributed; and a nation capable of such achievements is never entirely lost. Both pictures, which are mutually complementary, are packed with a momentum dependent, down to the last brush-stroke, on brush-work and subject to a fundamental rhythm. Both, too, run the gamut of animal urges and human emotions, and both show man inwardly rent asunder and impelled towards victory or destruction by his own passions. Each picture conveys with shocking clarity all that the human countenance and body can express, from extreme blood-lust to utter terror, from supreme courage to abject cowardice. Because they contain the sum total of Goya's human and artistic greatness, human and artistic richness, they also contain many hints of what was to reach fulfilment in French nineteenth-century painting, heir to all the great European painting of the eighteenth century. Indeed, Goya's painting proved so rich in these two pictures that it stimulated not just one school of nineteenth-century painting but a whole series of successive generations. The impassioned animation in Gros's battle pictures looks, when compared with Goya's, like empty pathos. Géricault (heir to Gros and forerunner of Delacroix) seems to have learnt from these pictures, just as Delacroix's Moroccan mounted battles and scenes from the Greek War of Independence could never have come into being without them (or Rubens) either. Apart from Géricault and Delacroix, they also contain much that found further fulfilment in Daumier. (In French painting and litho-graphy, the background figures became transformed into foreground figures.) Finally, they

contain a large proportion of the linear, colouristic, and even material resources and techniques which Manet used in his work, paving the way for Impressionism.

Goya's painting was at its greatest when he was working on his own account, as in the mural decorations for his villa outside the gates of the capital. These represent a miraculous collaboration between his ability as a painter and his technique as a draughtsman. They are, a decade in advance of their time, Spain's great contribution to Romanticism. There is nothing to compare with them in the whole of European painting. They are a return to the womb. The elemental life-forces latent in Goya's earlier pictures seem here to have risen to the surface and assumed visual shape. They impart a glimpse of the chaos which is the eternal sustainer of all life. In them, a genius has turned into a child again and is playfully creating a primeval world. They pulsate with infinite movement. *Saturn devouring one of his Children* (plate 118) is life itself, a ceaseless round of generation and destruction. To look at these pictures is to feel as though the earth had suddenly begun to breathe like a mighty beast, to be borne aloft and hurled down again, to be sent soaring to the stars and then swallowed up in an abyss, to be wafted away on the stream of life itself—to speculate on the man who lived and painted among such pictures.

The medium used by Goya in his prime and old age was equivalent to a new and immediate approach to life. In this respect, though centuries apart, it seems related to the mature and late work of Titian and Rembrandt. But, whereas it appears in the work of the latter two as a formal reflection of a 'world-substance' and whereas personal vision is subordinated to a mythical picture of the world, its function in Goya's mature and late work is the equivalent of a personal 'life-substance' which is neither rooted nor merged in a 'world-substance' but projects itself with original and highly individual abundance. It is a reflection of the spiritual and intellectual diversity of man, of the bewildering complexity of the individual in a changing world in which one social order is dissolving and a new one just emerging, of a strange vacillation in modes of self-expression, of an oppressive but enthralling alternation between the exoteric and the esoteric. It is the equivalent of a fundamental approach which does not make use of paint but, rather, fulfils itself in it, through it, and in actual collaboration with it— paint as destiny, paint as the sole means of formal expression.

This is probably why Goya is closer to the present generation than to the nineteenth century. The formal relaxation and dissolution which developed by fits and starts during the course of his career was the outcome of excessive spiritual and mental pressure, an expression of uncontrolled power rather than spiritual and mental uncertainty. The transformation of chaos into cosmos exemplified by every work of art developed in some of Goya's mature and late work into something approaching chaos itself. One often recognizes the event rather than the result, senses the transformation, senses that the cosmos still contains chaos and is perpetually threatened by it. Goya was the first painter in the history of European art who dared to yield to his very individual attitude towards life and personal vision; the first artist whose work inspires one with a feeling that it has brought to the surface and lent visual expression to dark recesses of the human soul which the intellect rarely succeeds in conquering. His work occupies a position in European art which is less a secure domain than a place where life itself advances to meet humanity—grandiose, beneficent, stimulating, and uncanny.

75

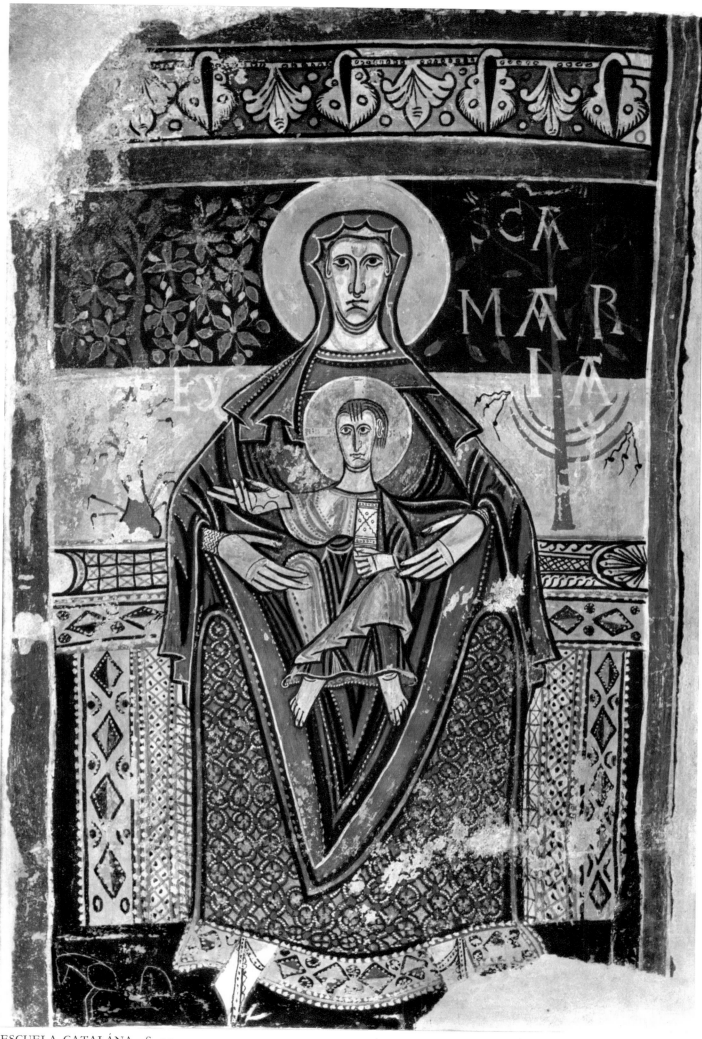

SCA MARIA

ESCUELA CATALÁNA S. 12

I

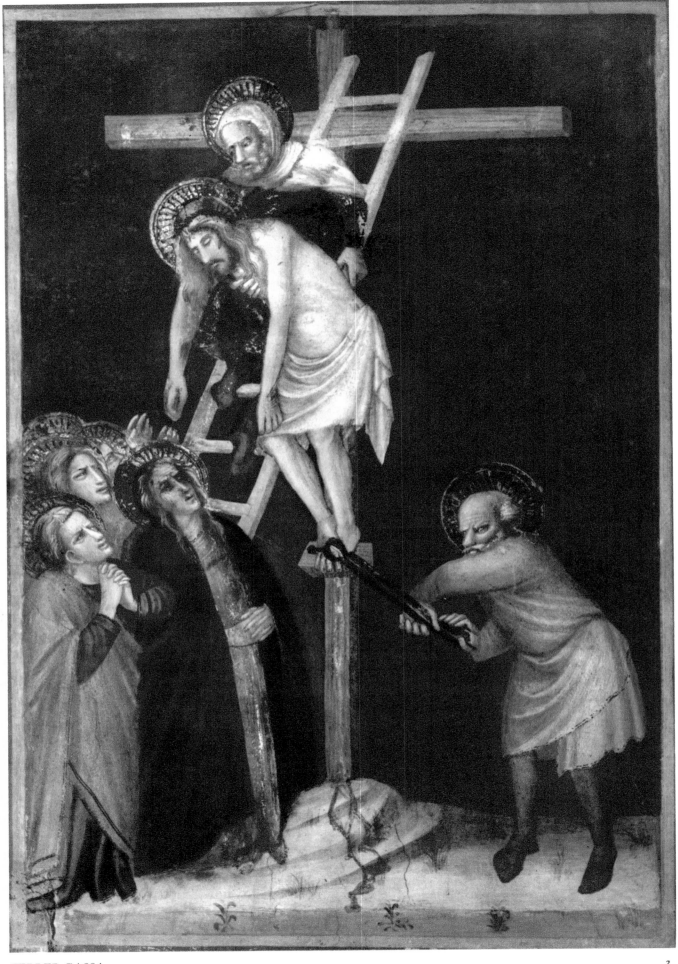

FERRER BASSA

SERRA

ESCUELA DE VALENCIA

4

ESCUELA DE VALENCIA

5

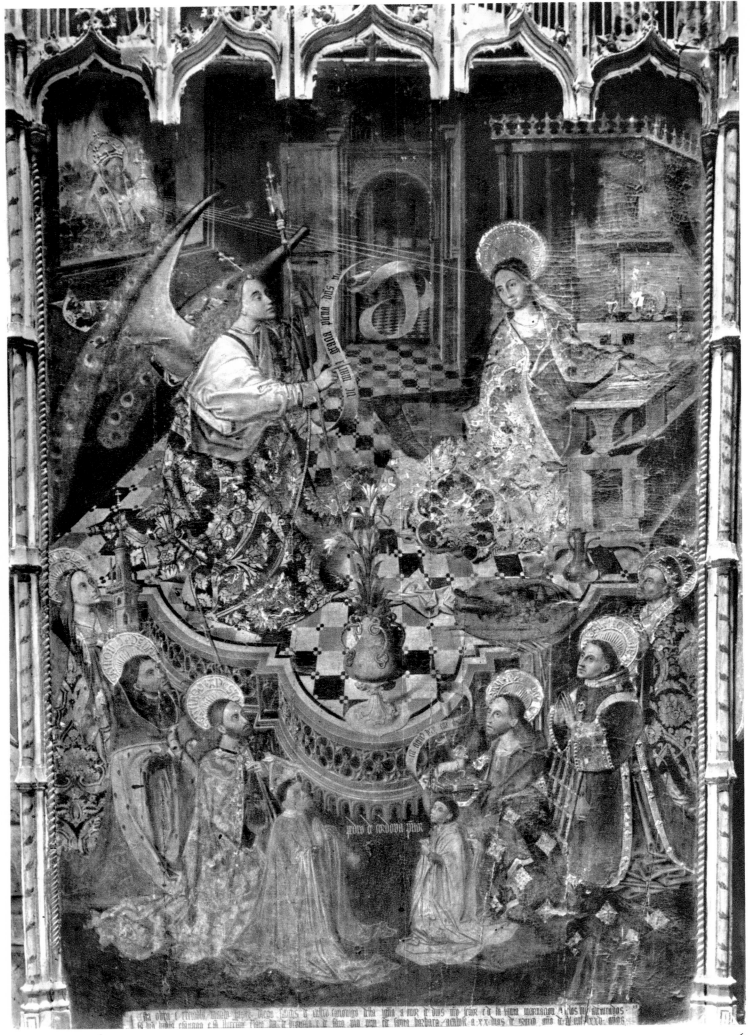

PEDRO DA CÓRDOBA

6

BERRUGUETE

7

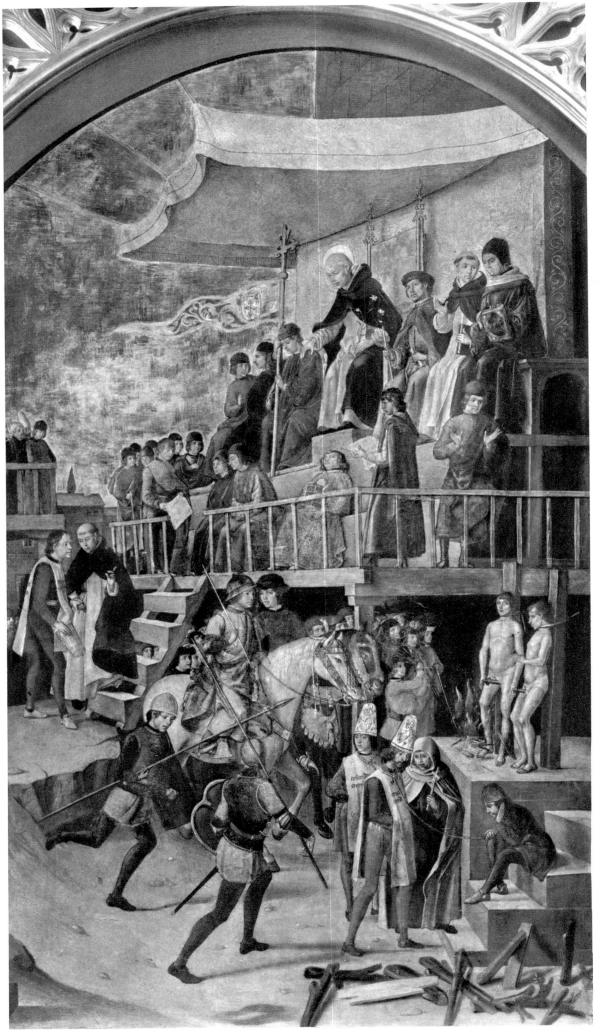

BERRUGUETE

8

ESCUELA CATALÁNA

CAMPAÑA

MORALES

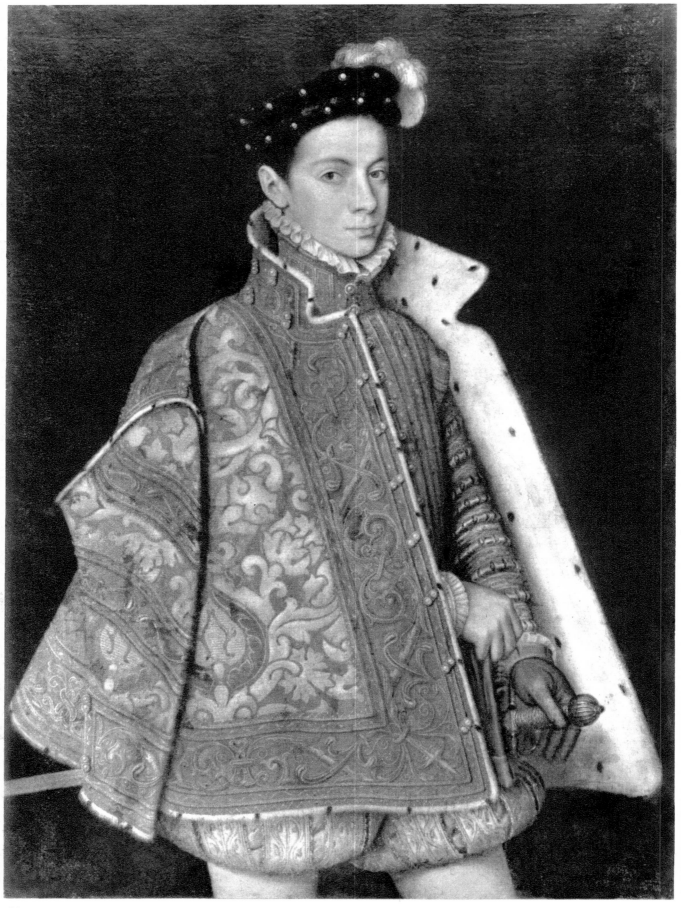

COELLO

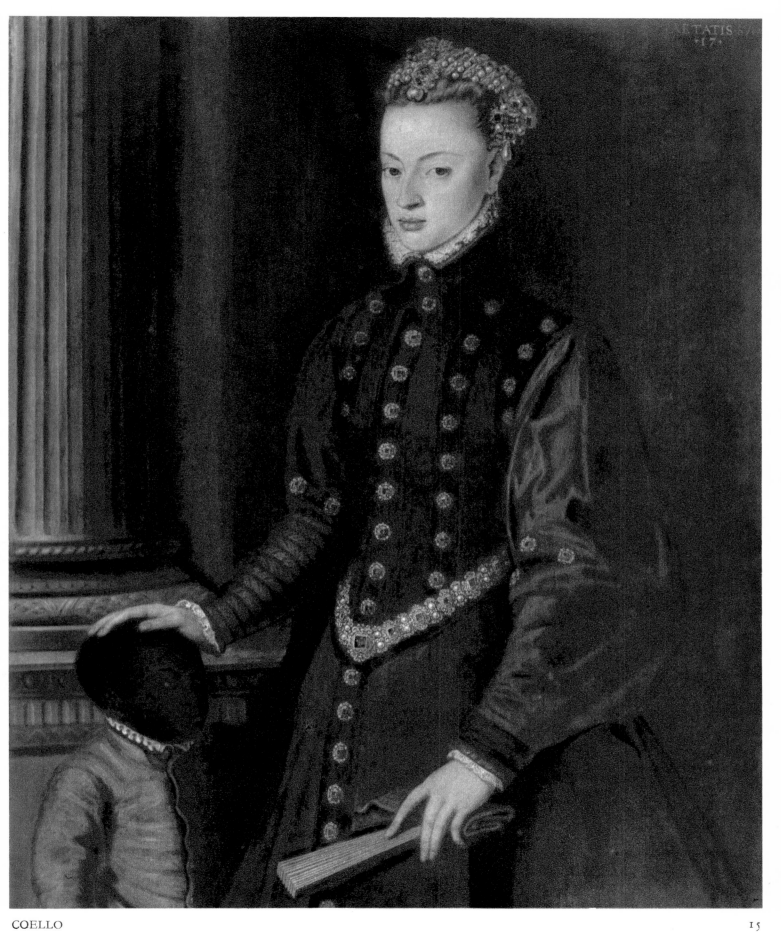

AETATIS 6?
177?

COELLO

15

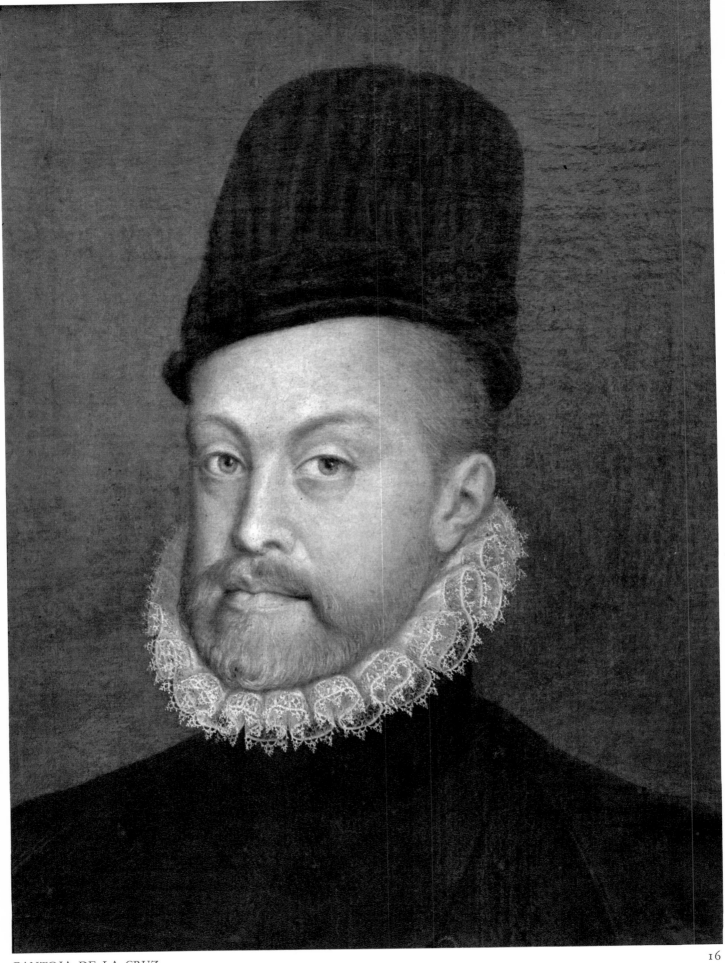

PANTOJA DE LA CRUZ

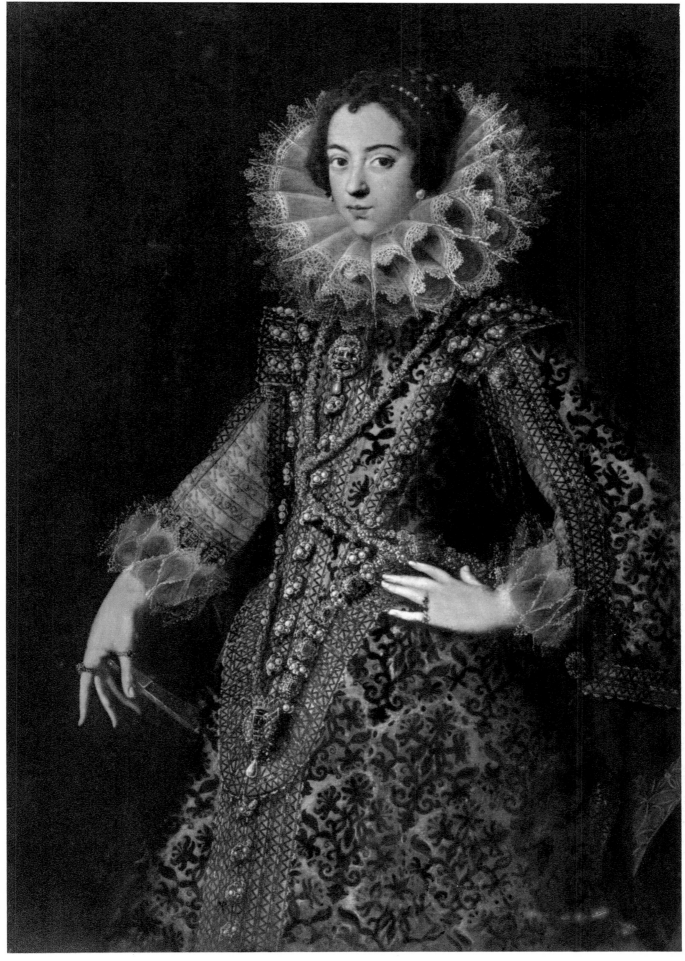

PANTOJA DE LA CRUZ

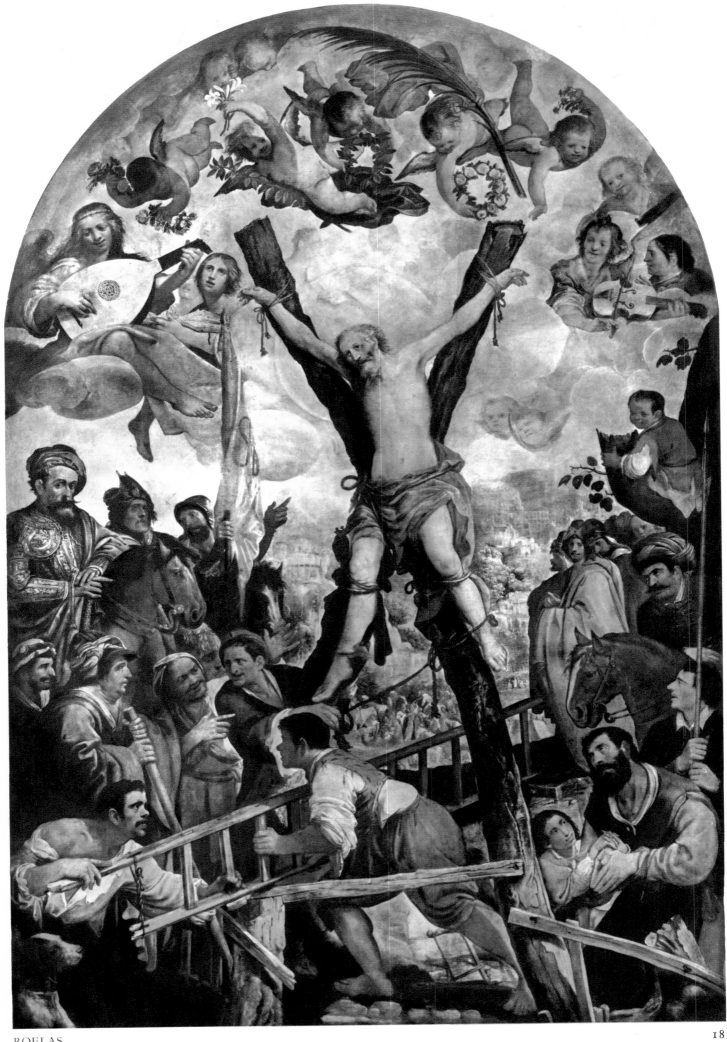

ROELAS

ROELAS

EL GRECO

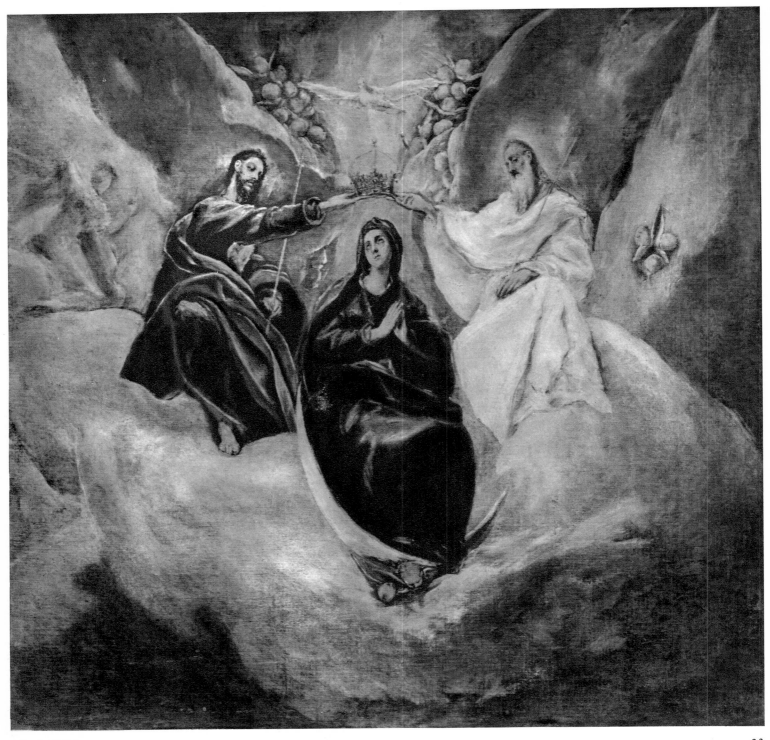

EL GRECO

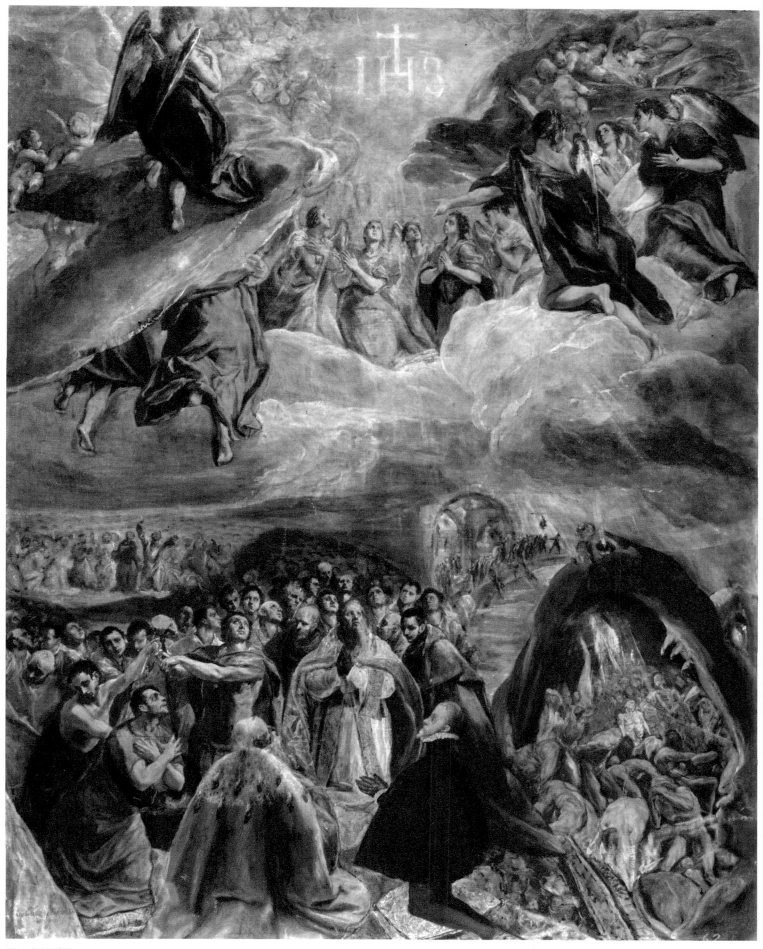

EL GRECO

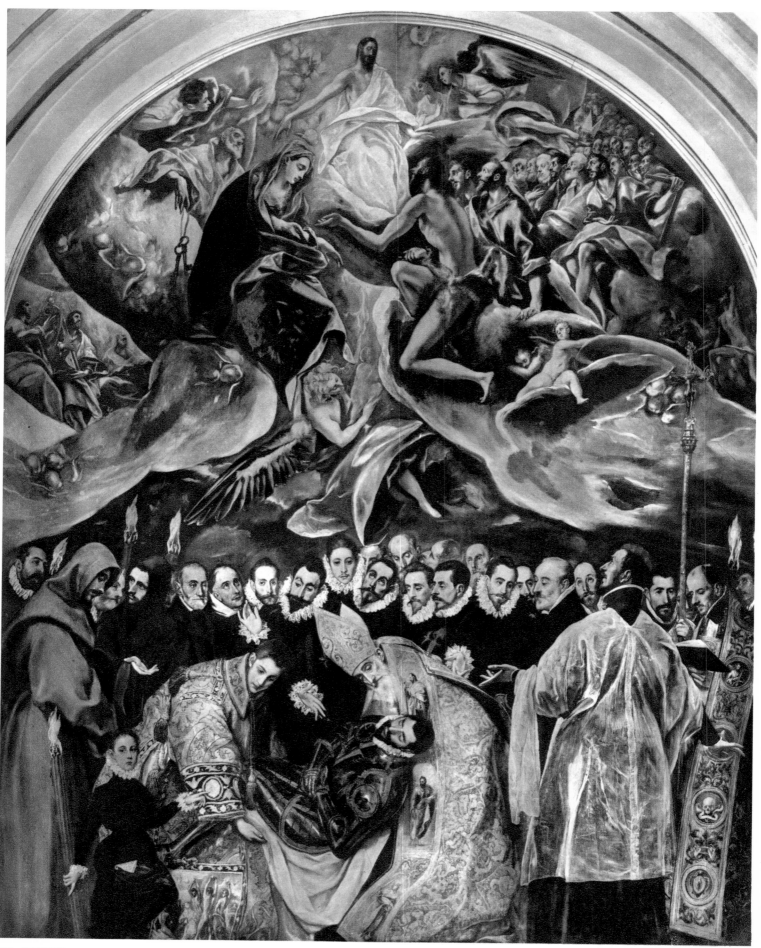

EL GRECO

24

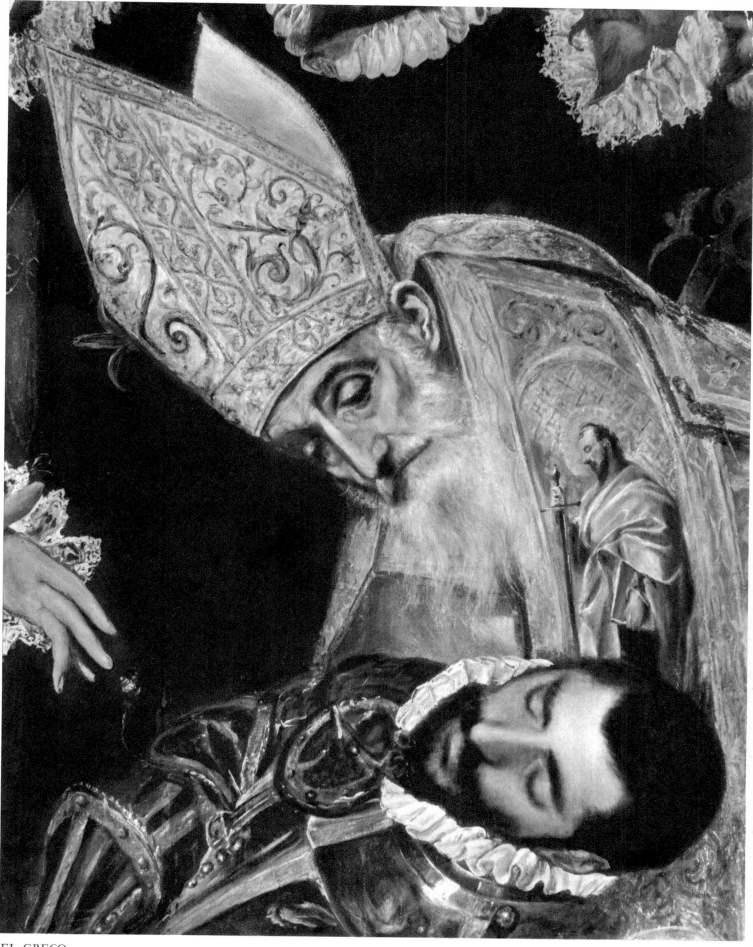

EL GRECO

25

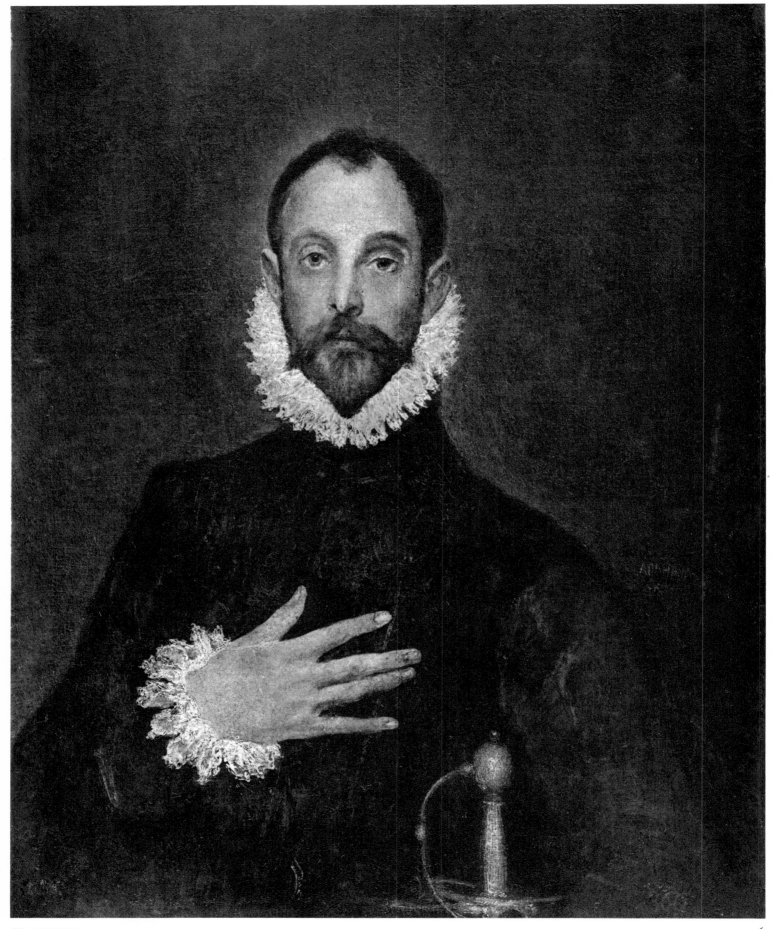

EL GRECO

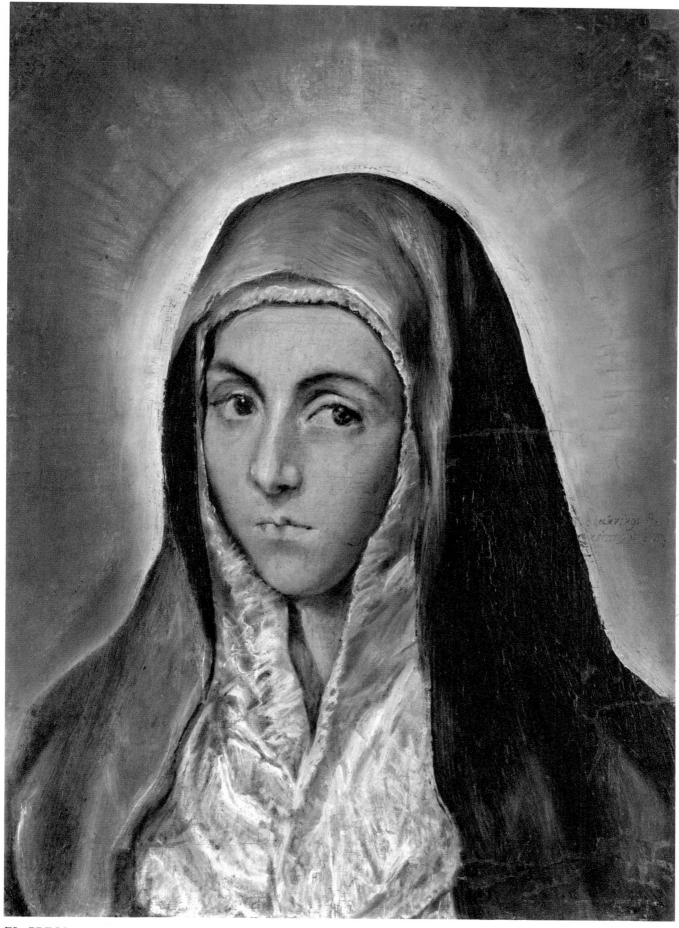

EL GRECO

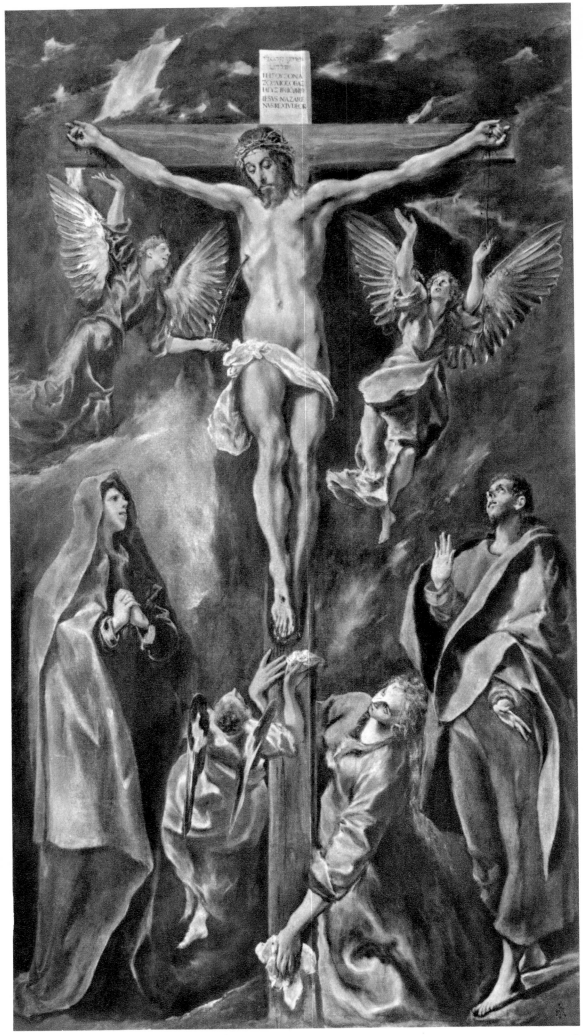

EL GRECO

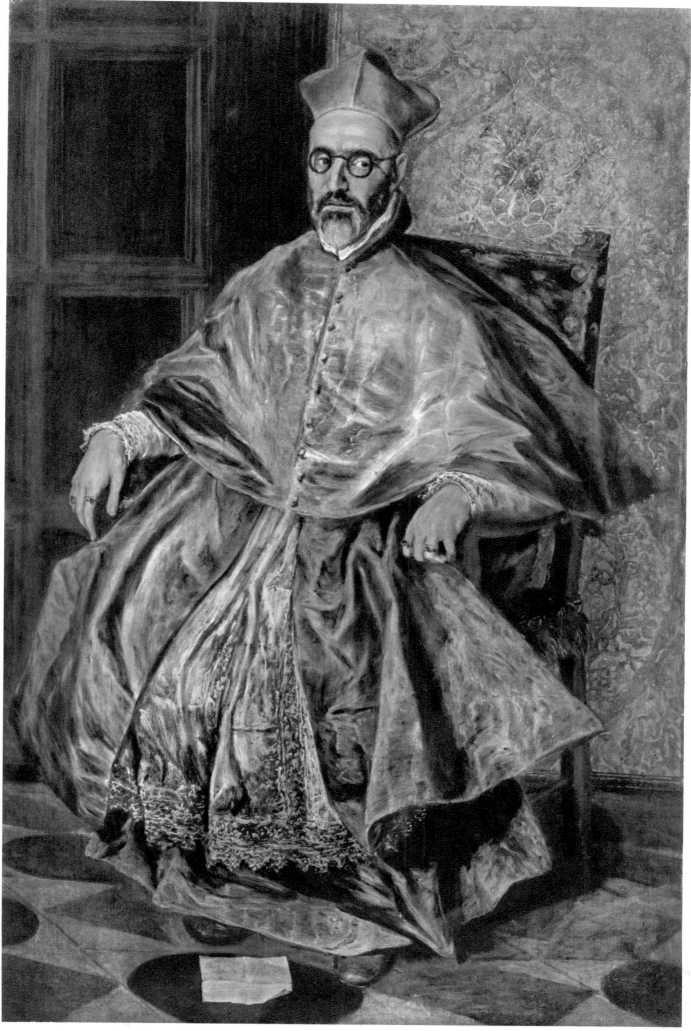

EL GRECO

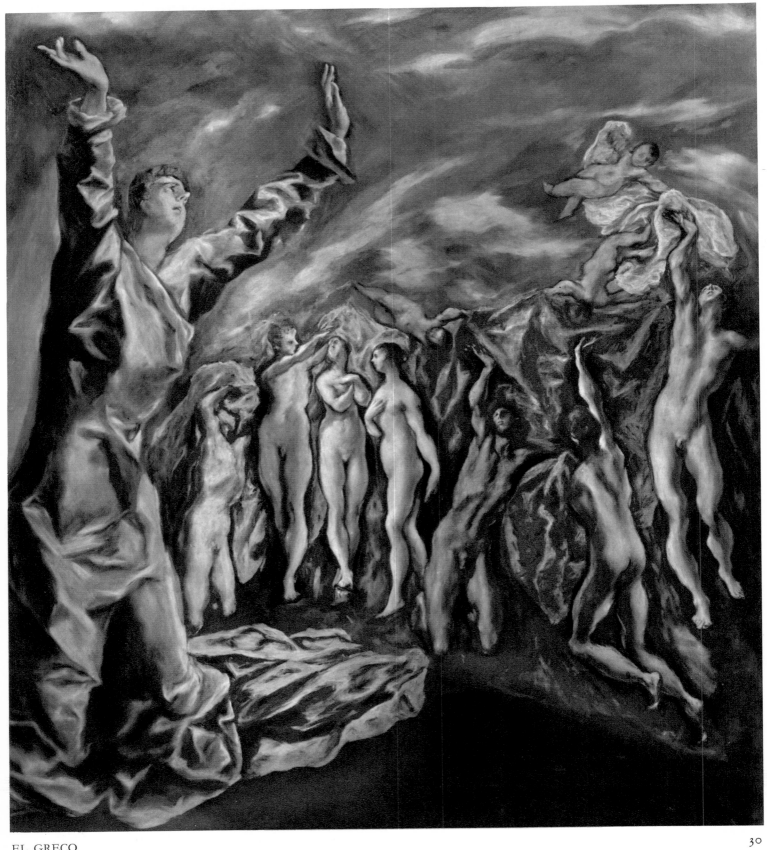

EL GRECO 30

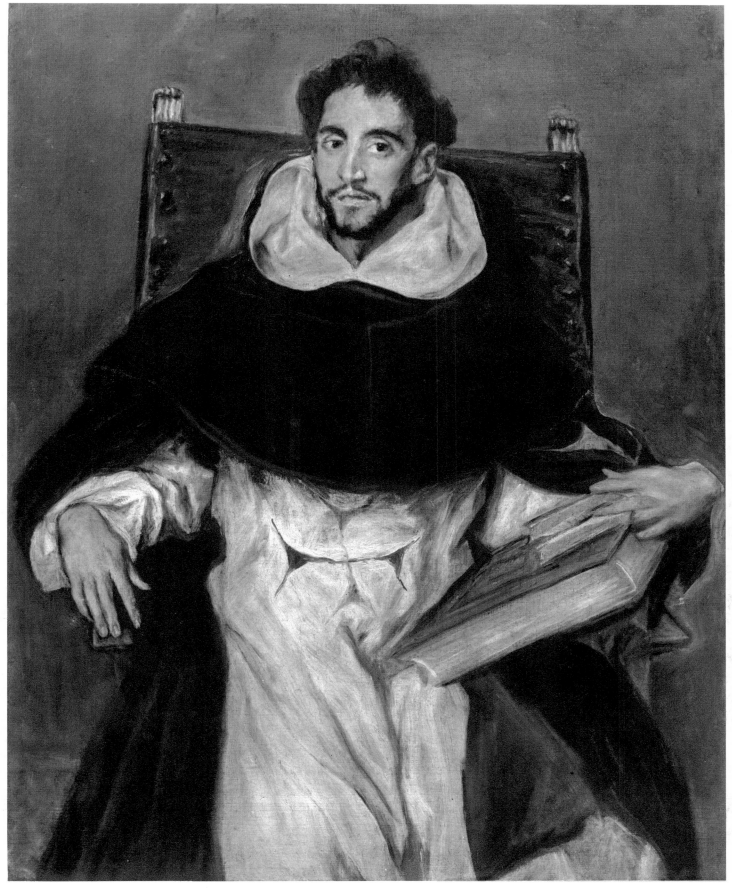

EL GRECO 31

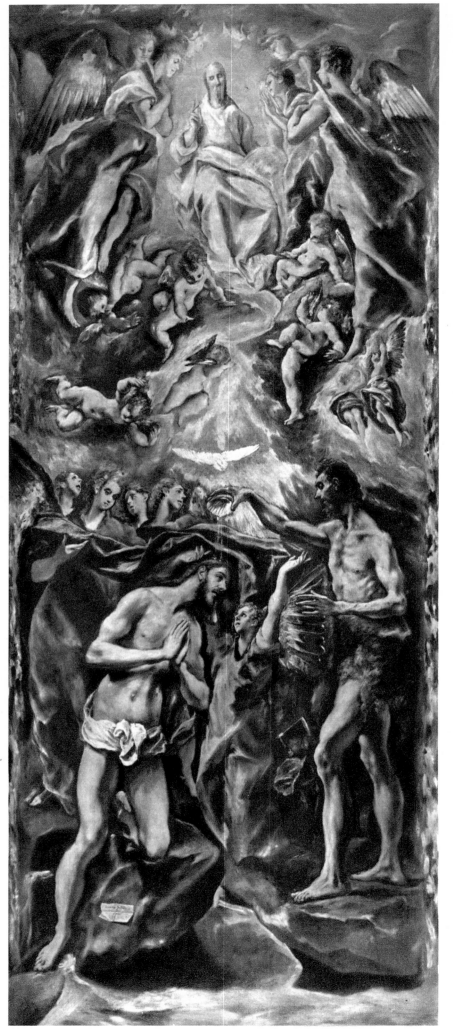

EL GRECO

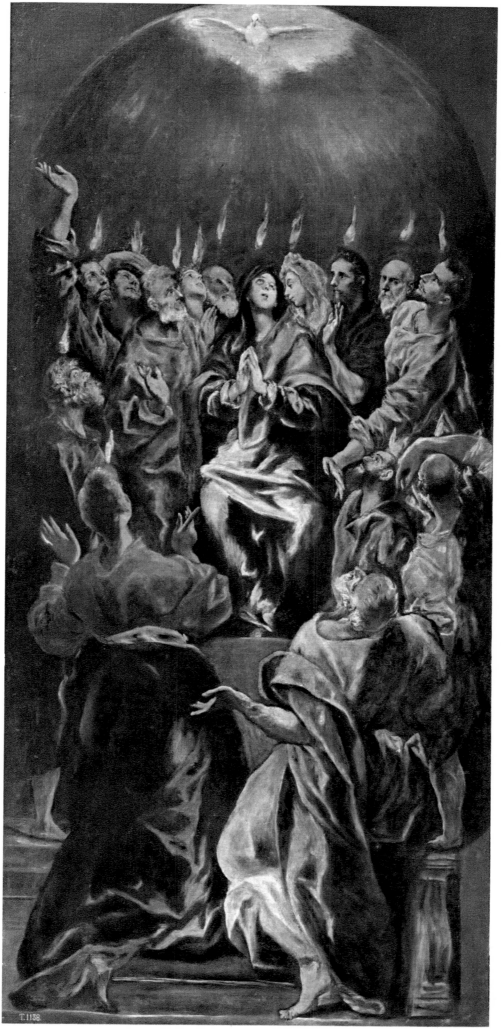

EL GRECO

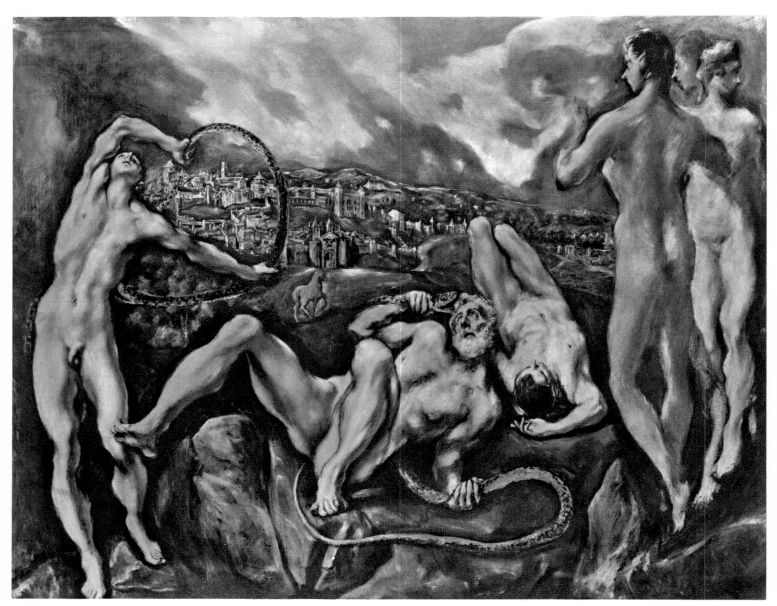

EL GRECO
34

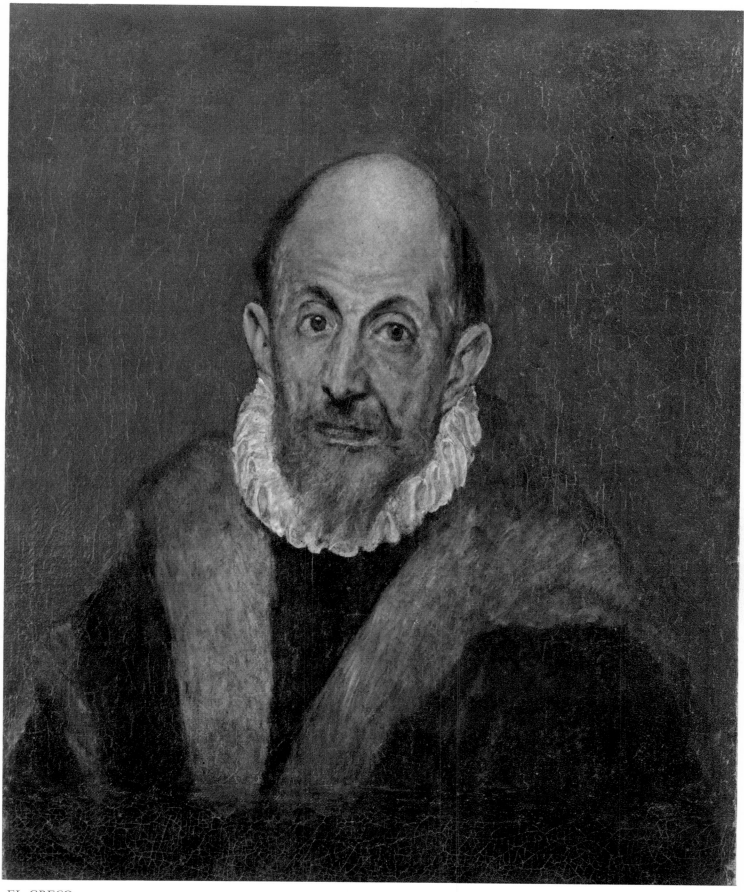

EL GRECO

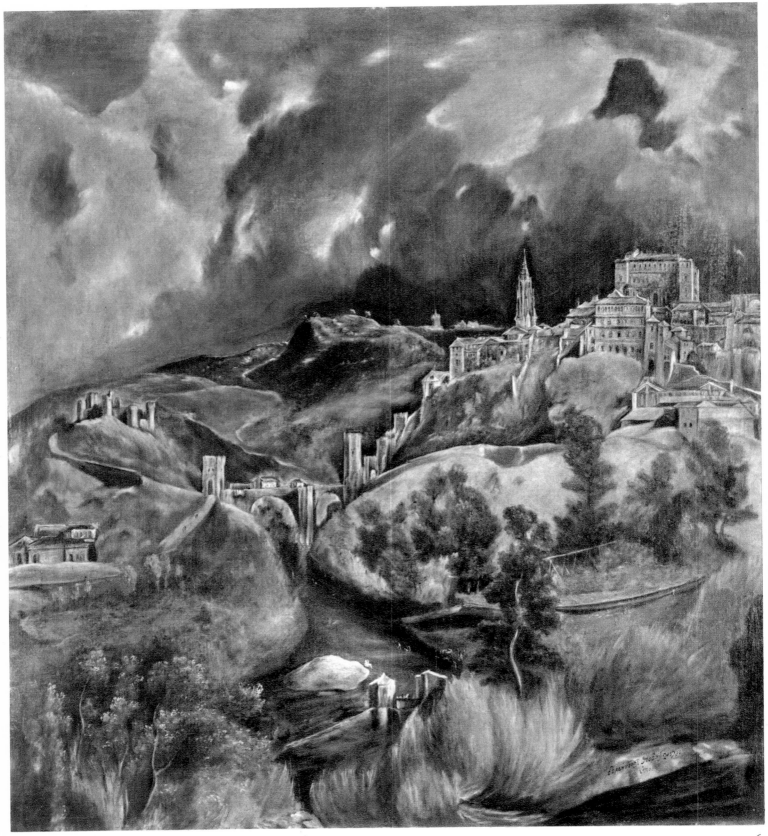

EL GRECO

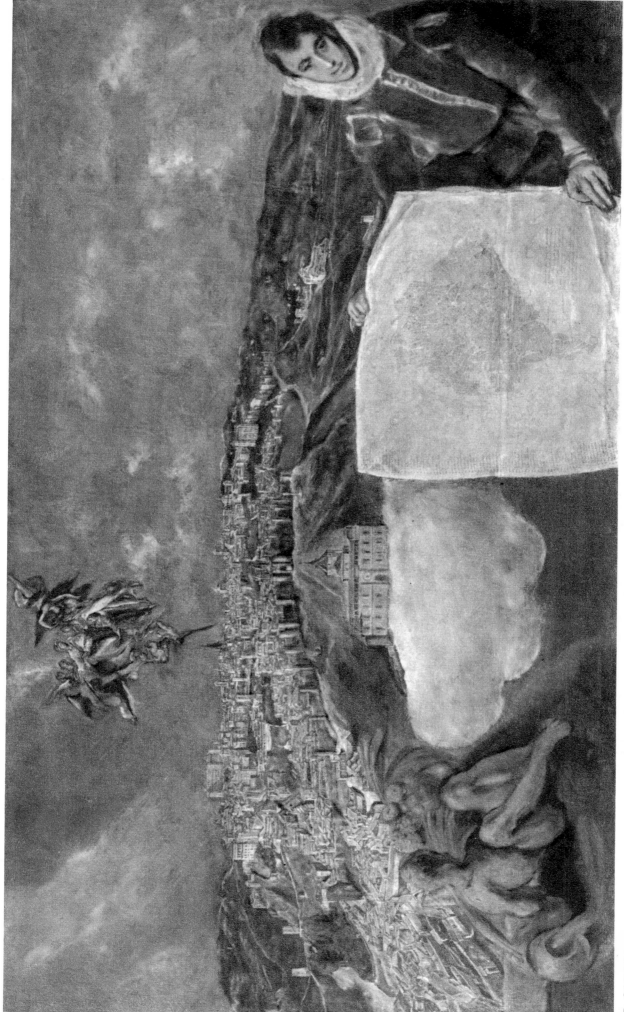

ZURBARÁN

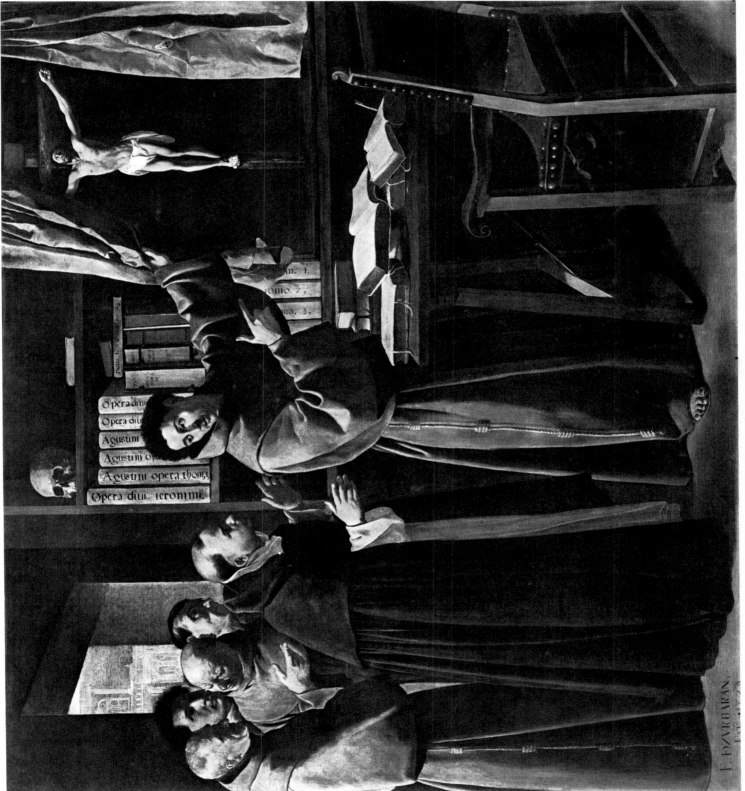

ZURBARÁN

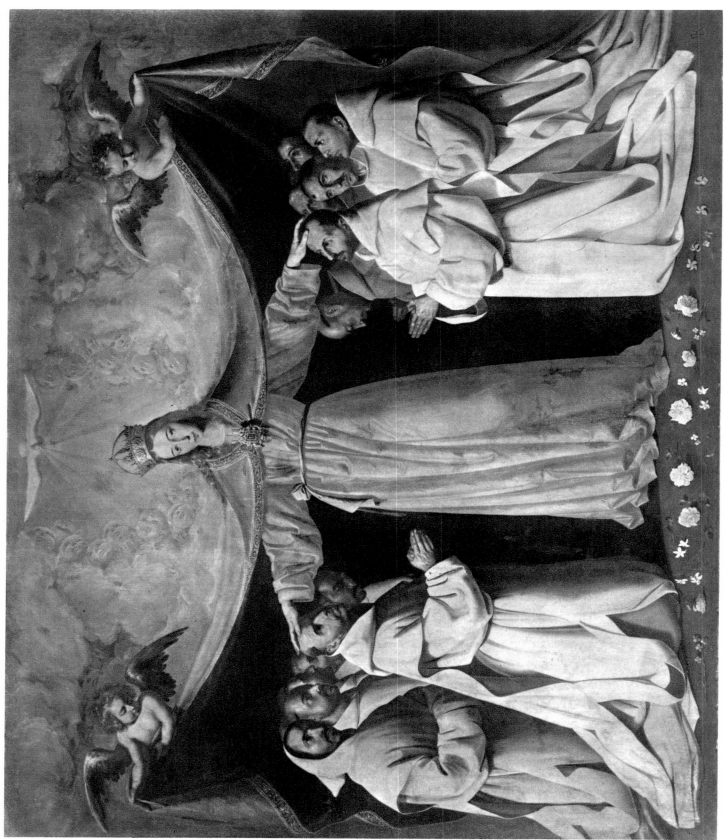

40

ZURBARÁN

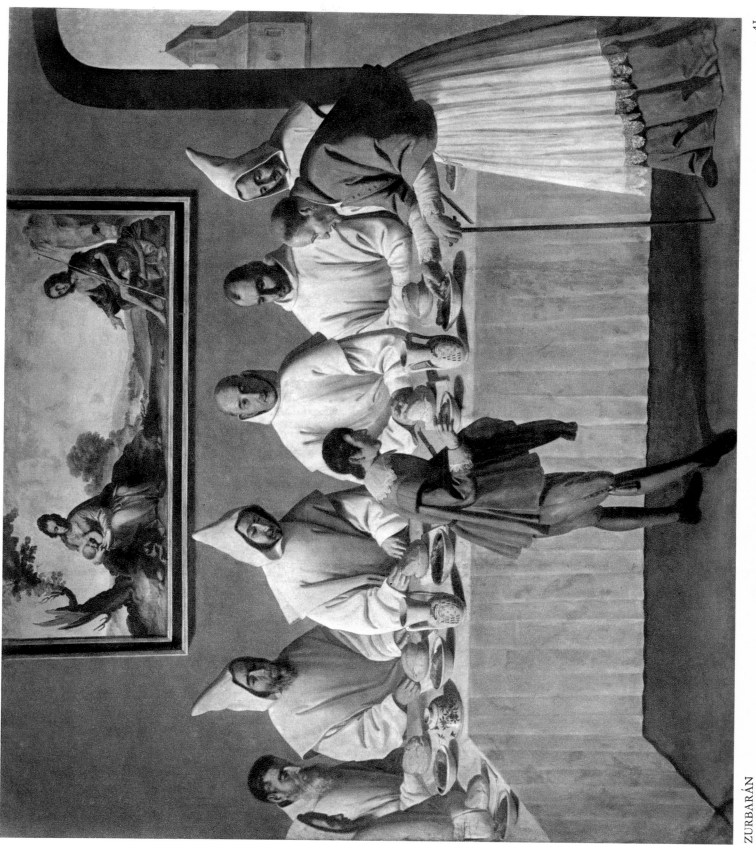

ZURBARÁN

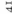
41

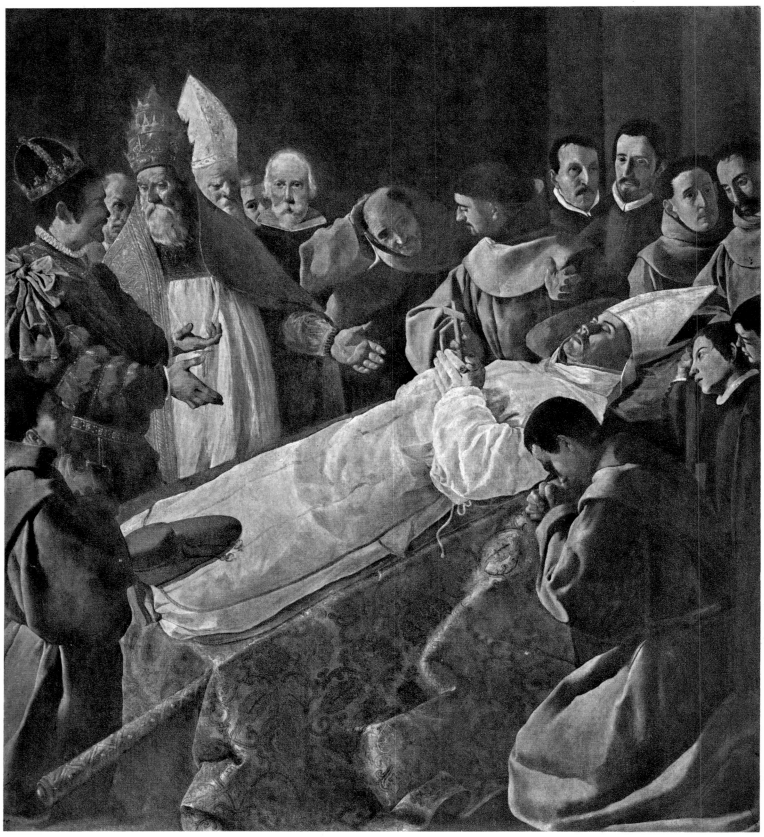

ZURBARÁN

ZURBARÁN

RIBERA

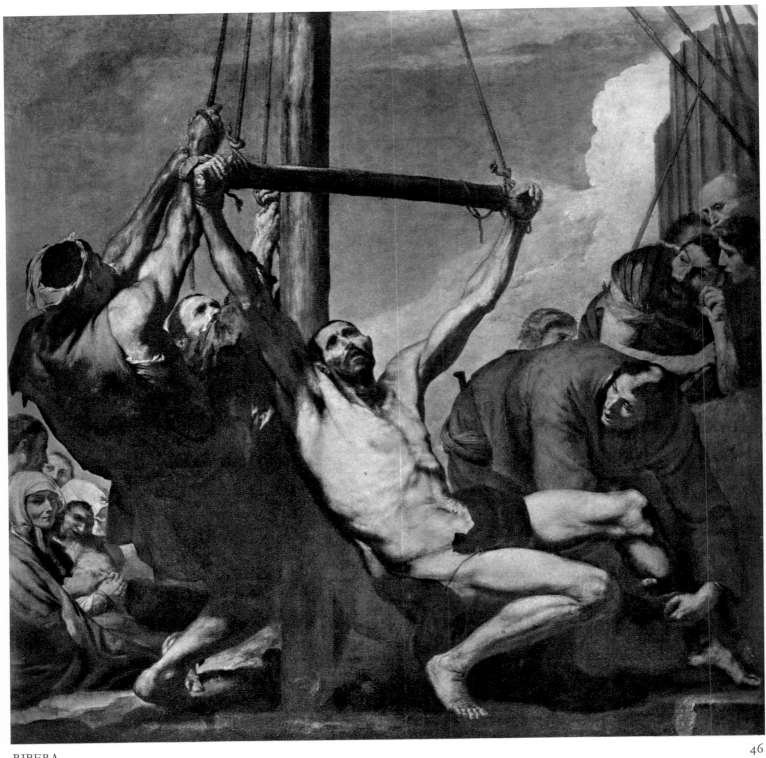

RIBERA

46

RIBERA

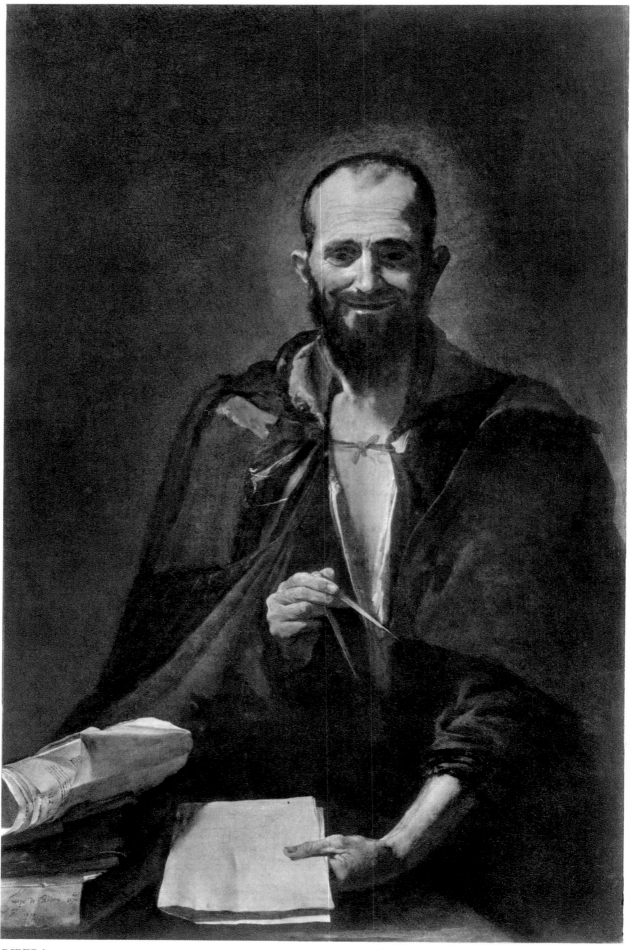

RIBERA

48

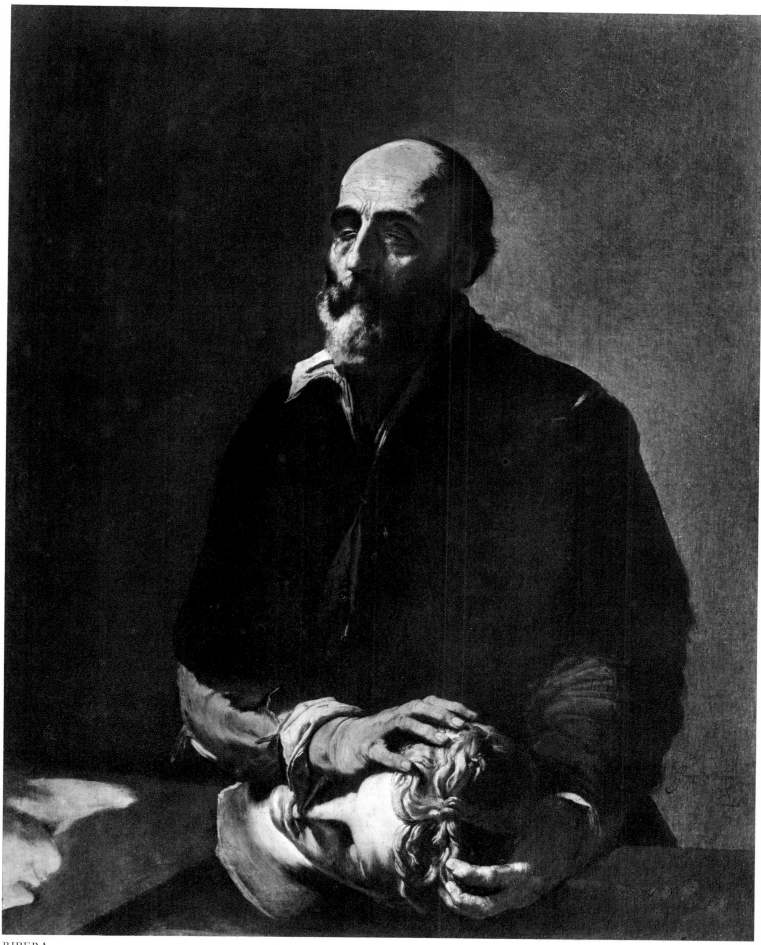

RIBERA

49

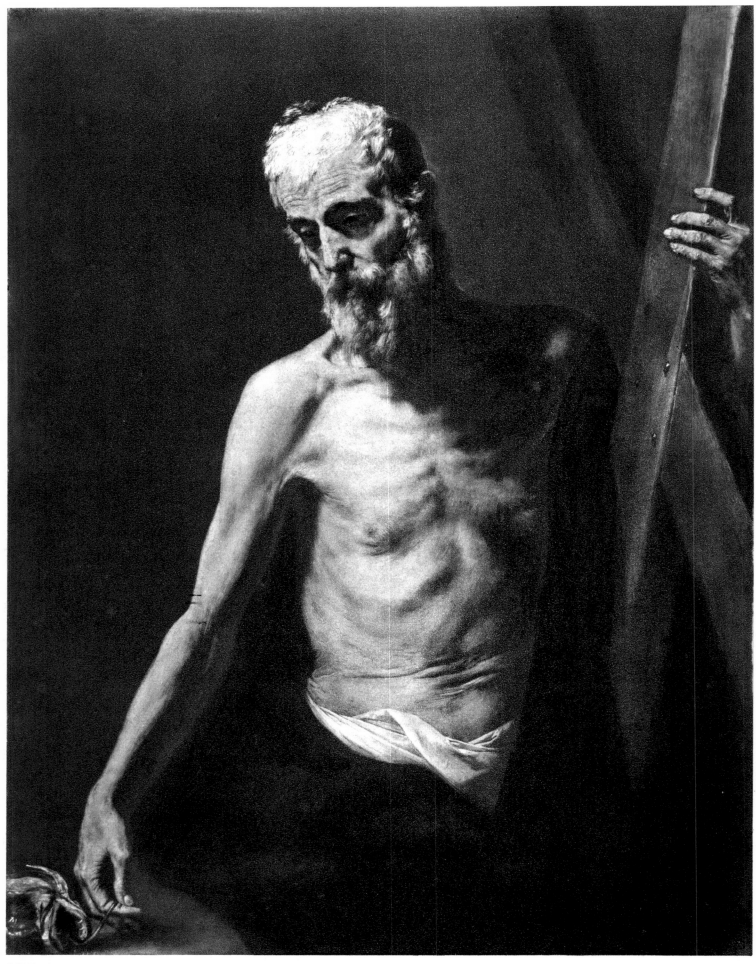

RIBERA 50

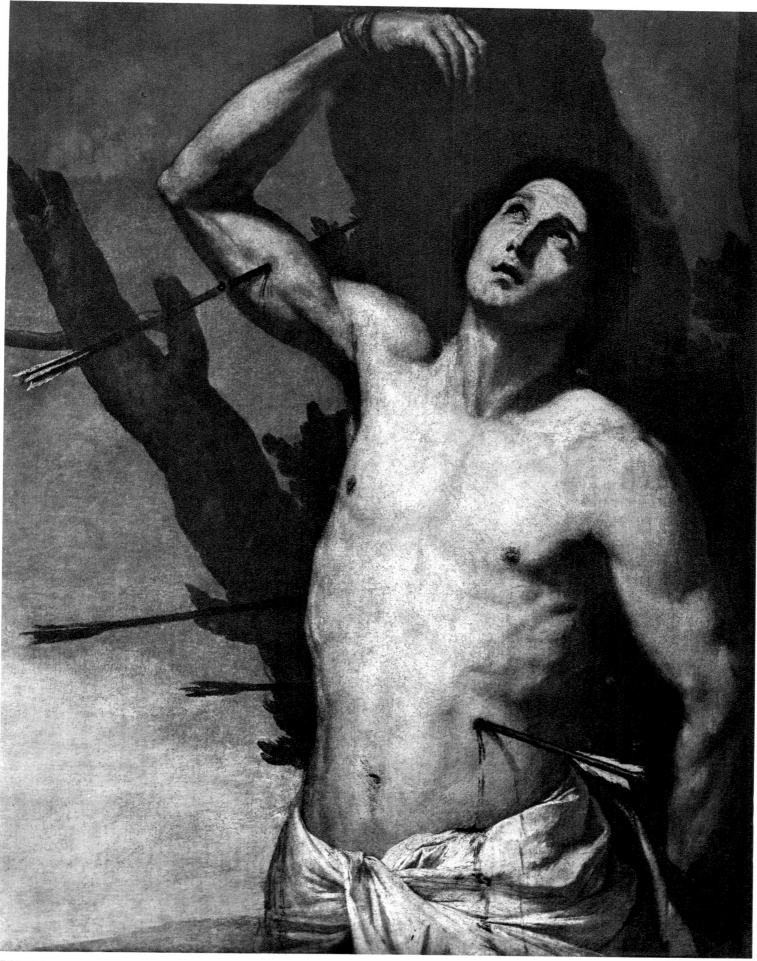

RIBERA

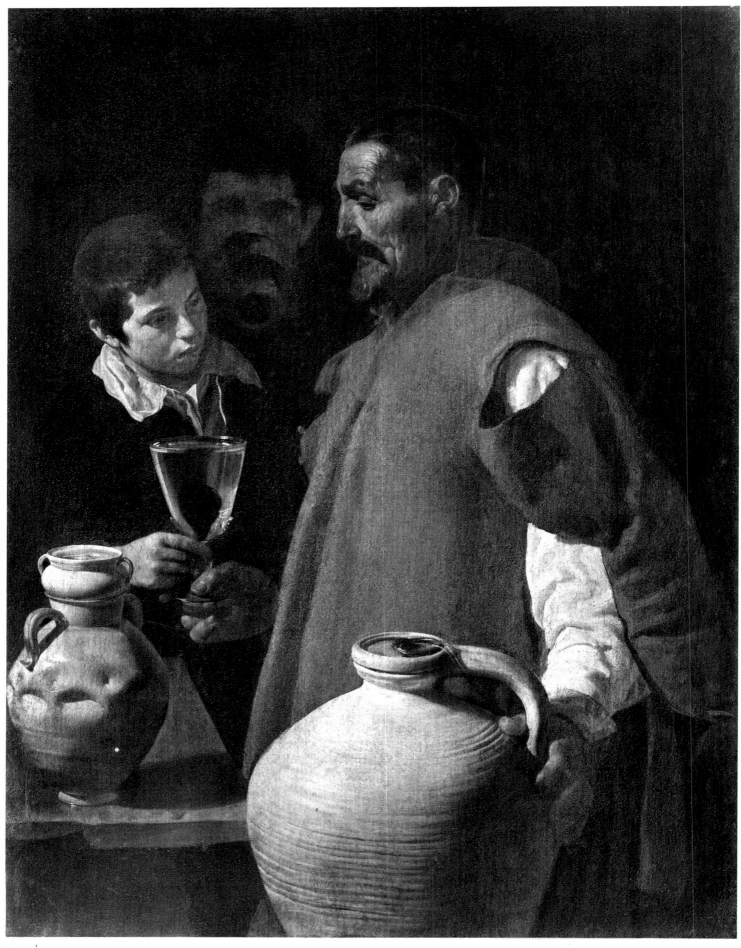

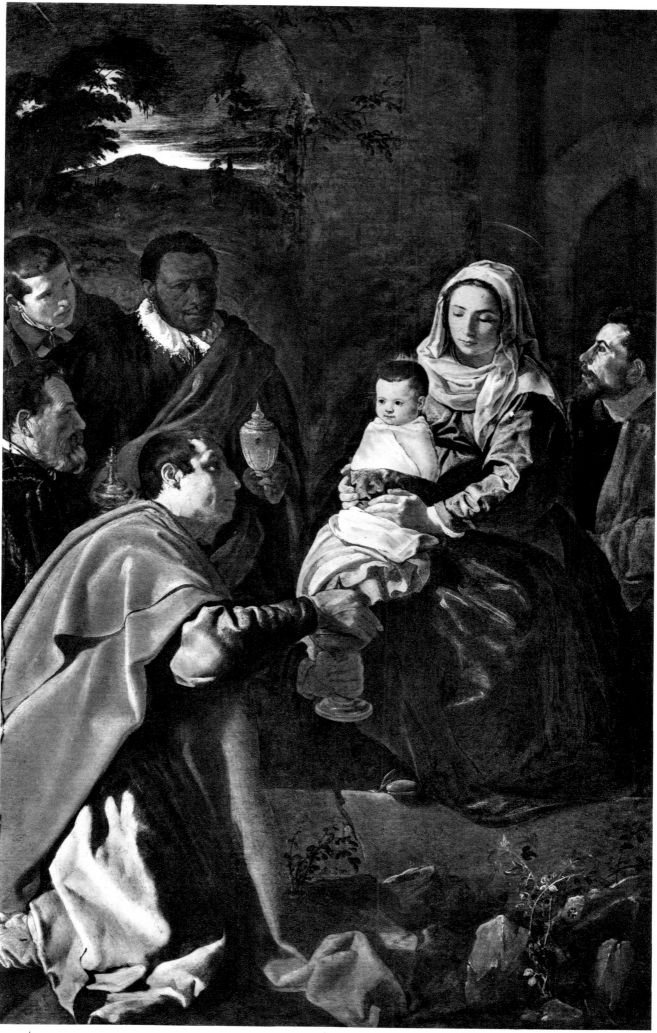

VELÁZQUEZ

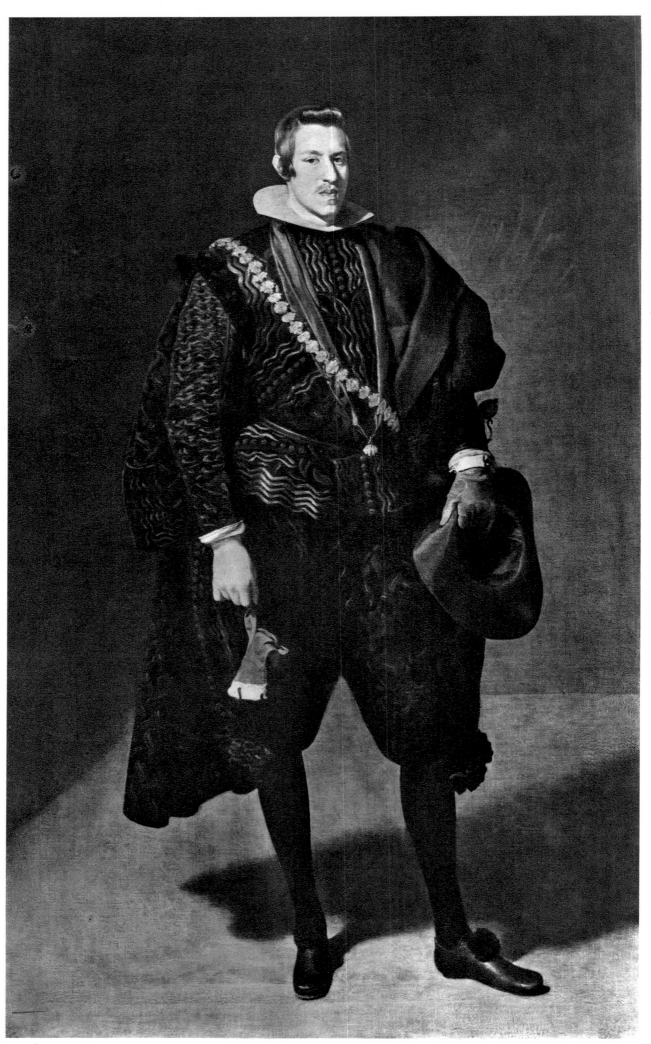

VELÁZQUEZ

54

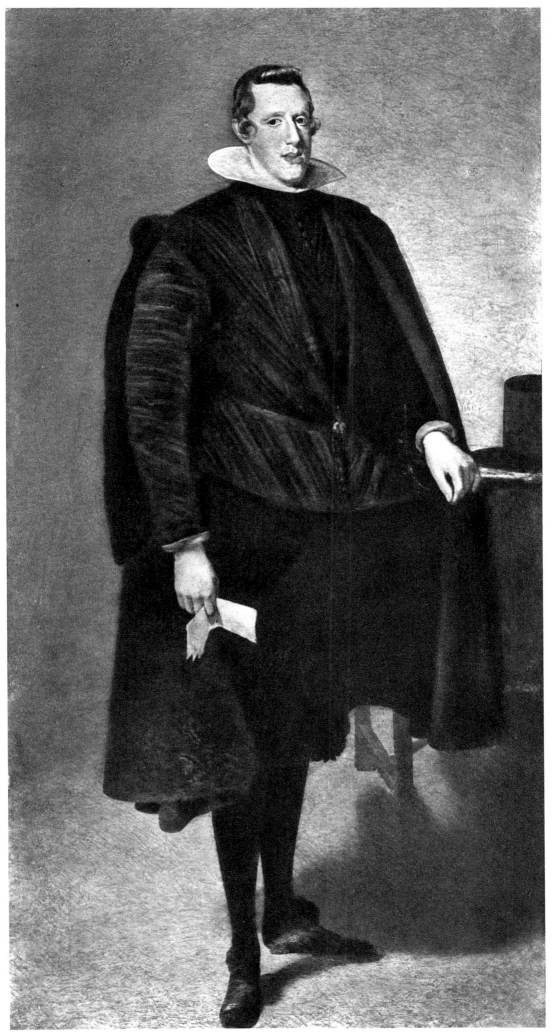

VELÁZQUEZ

55

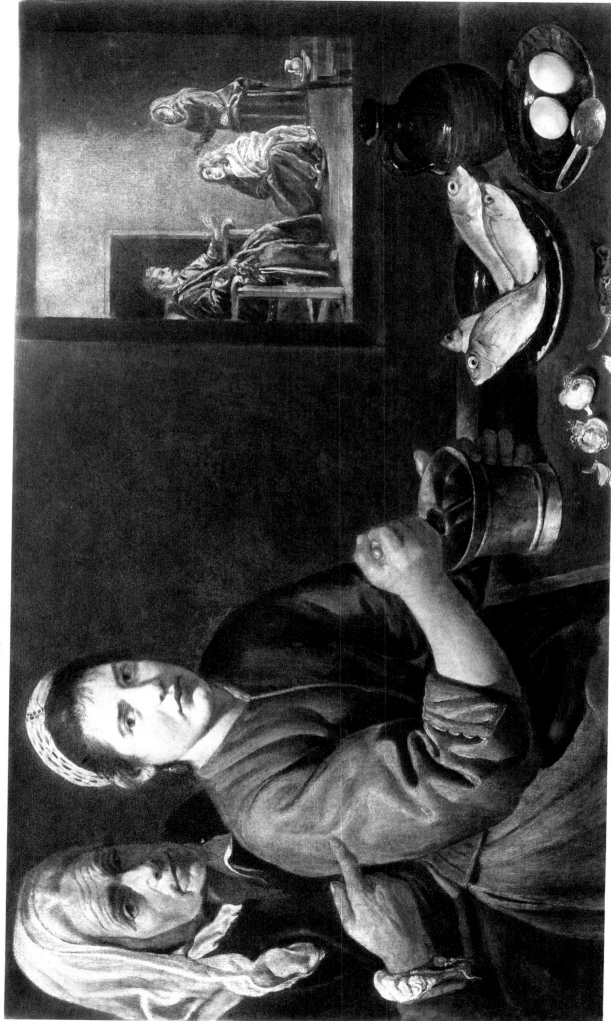

VELÁZQUEZ

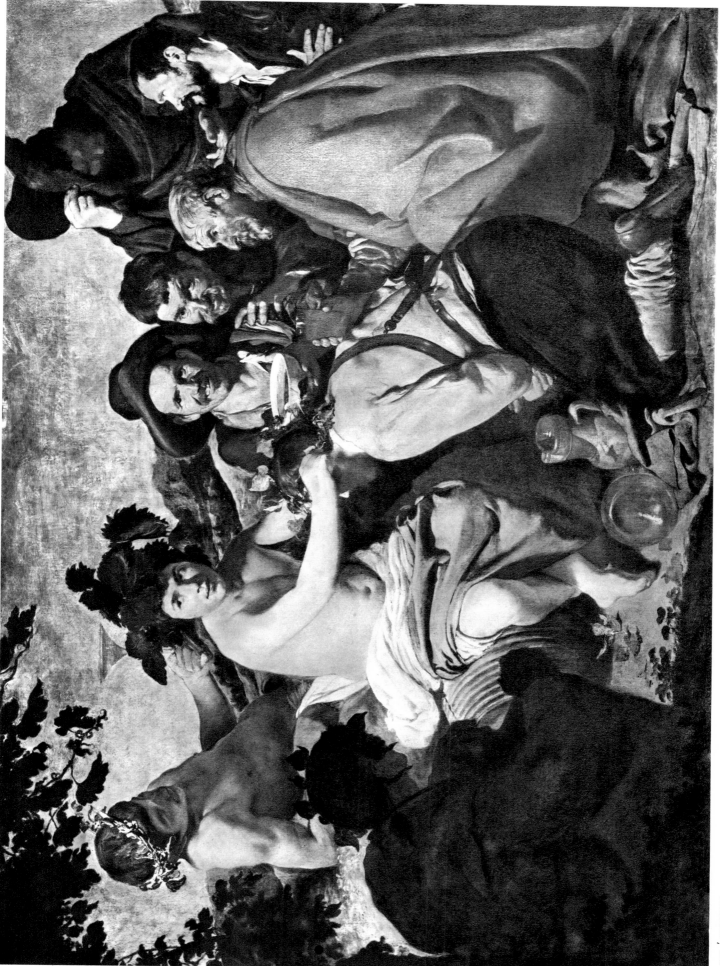

VELÁZQUEZ

VELÁZQUEZ

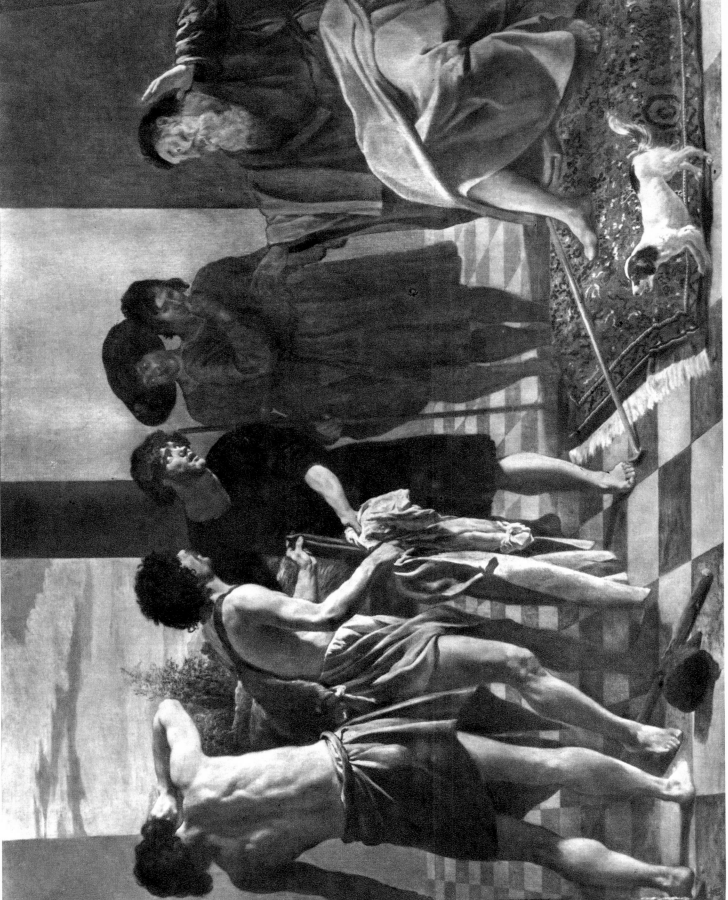

VELÁZQUEZ

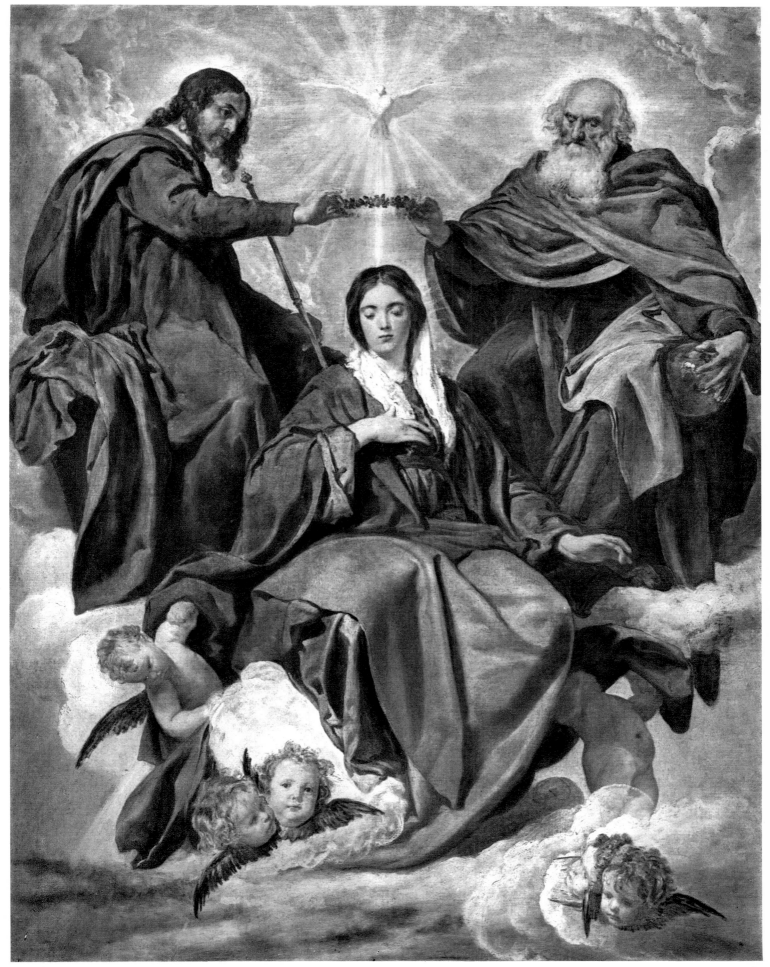

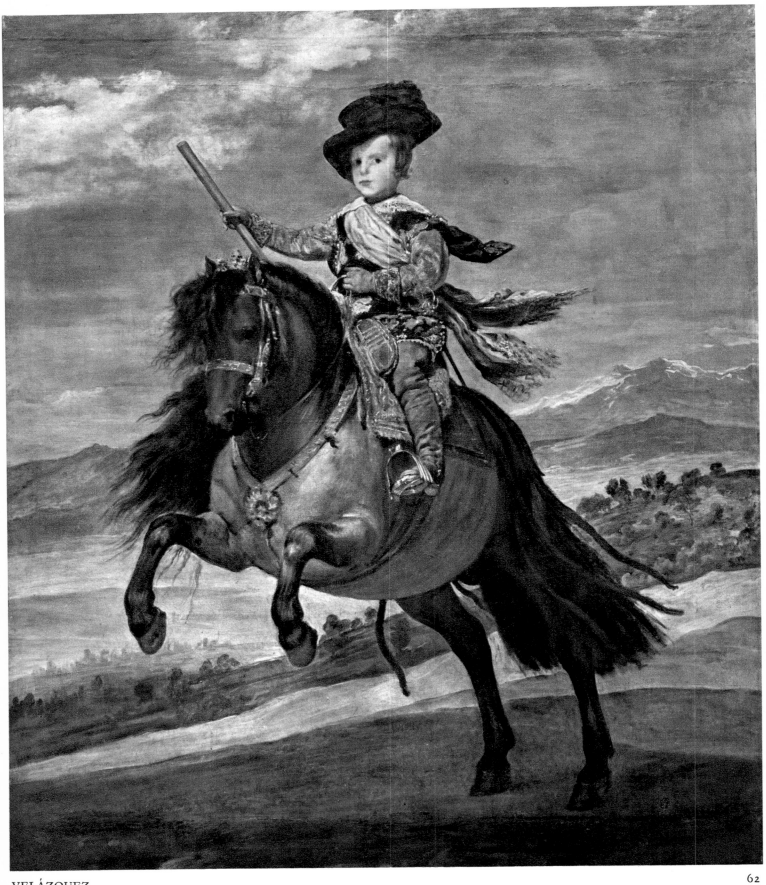

VELÁZQUEZ

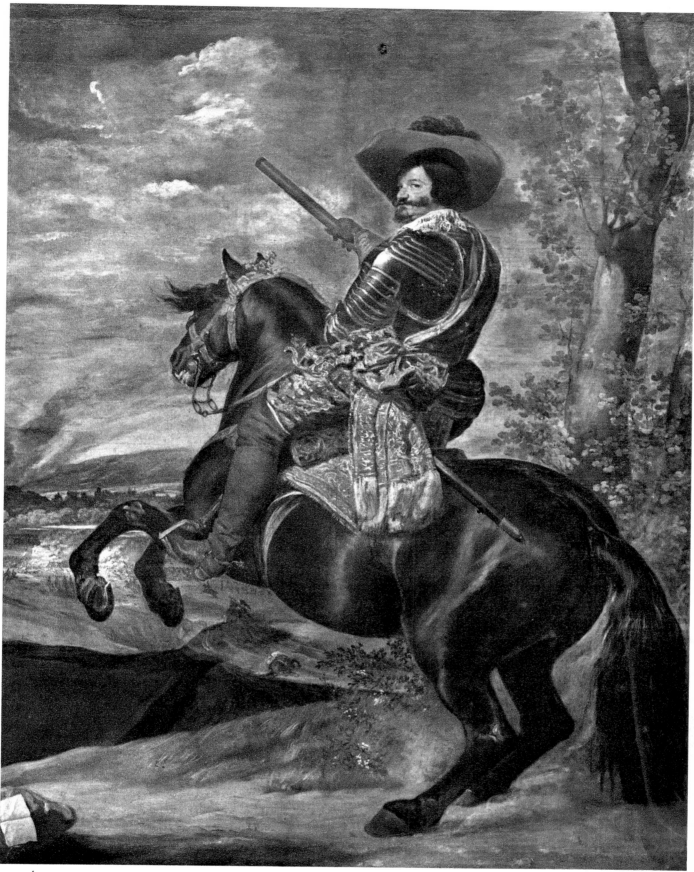

VELÁZQUEZ

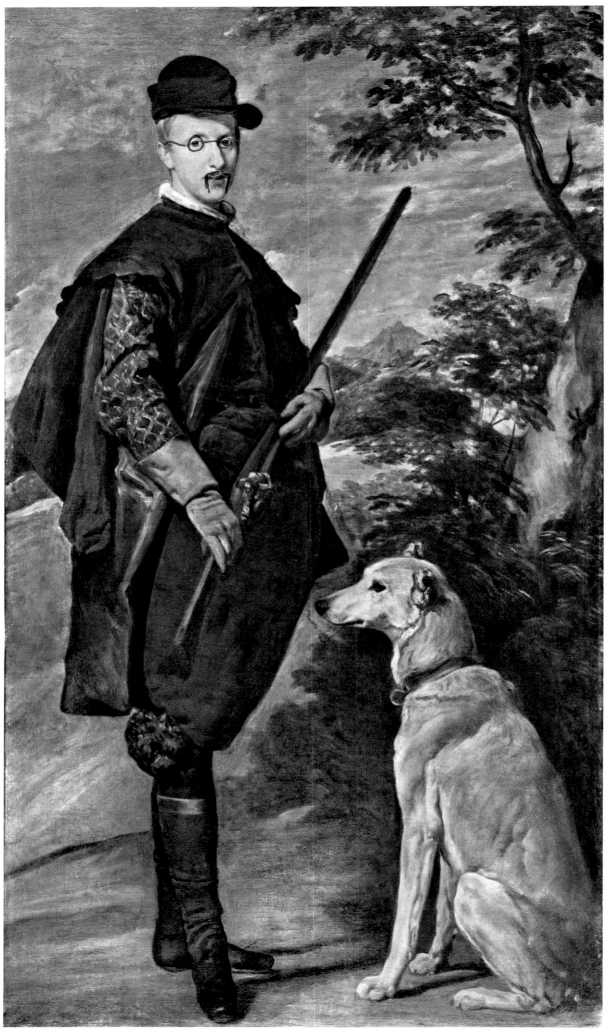

VELÁZQUEZ

64

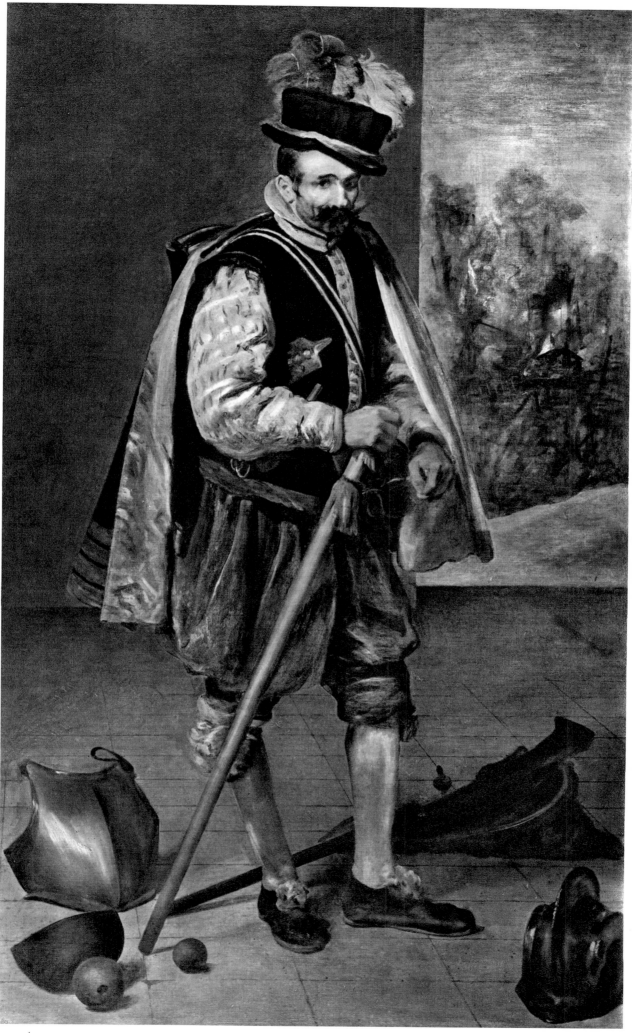

VELÁZQUEZ

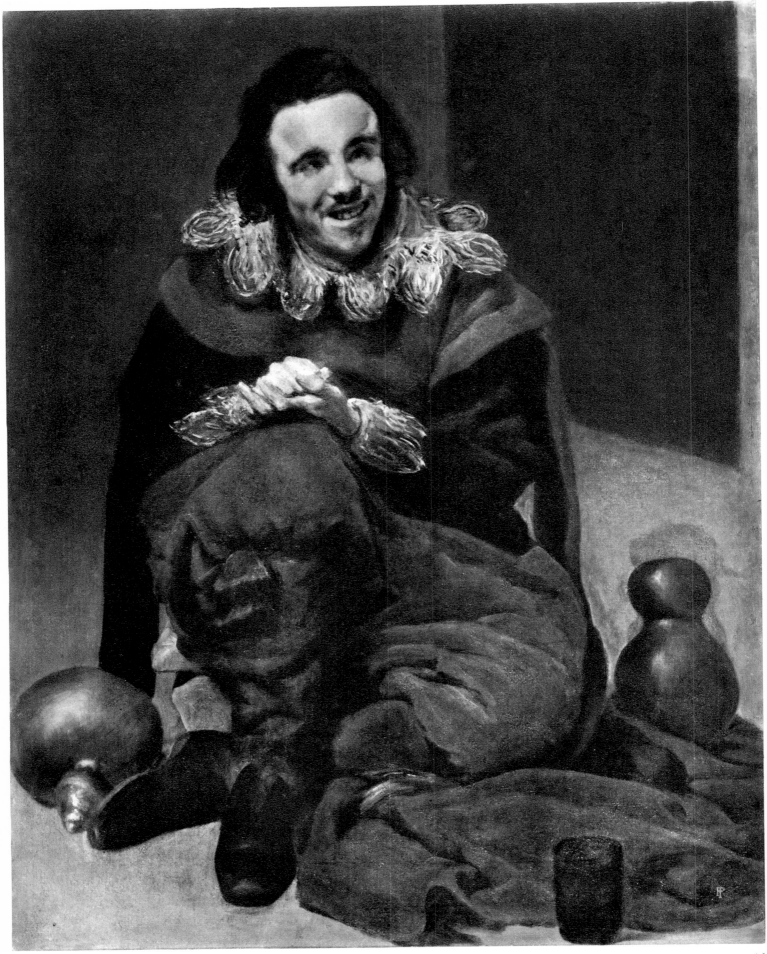

VELÁZQUEZ

66

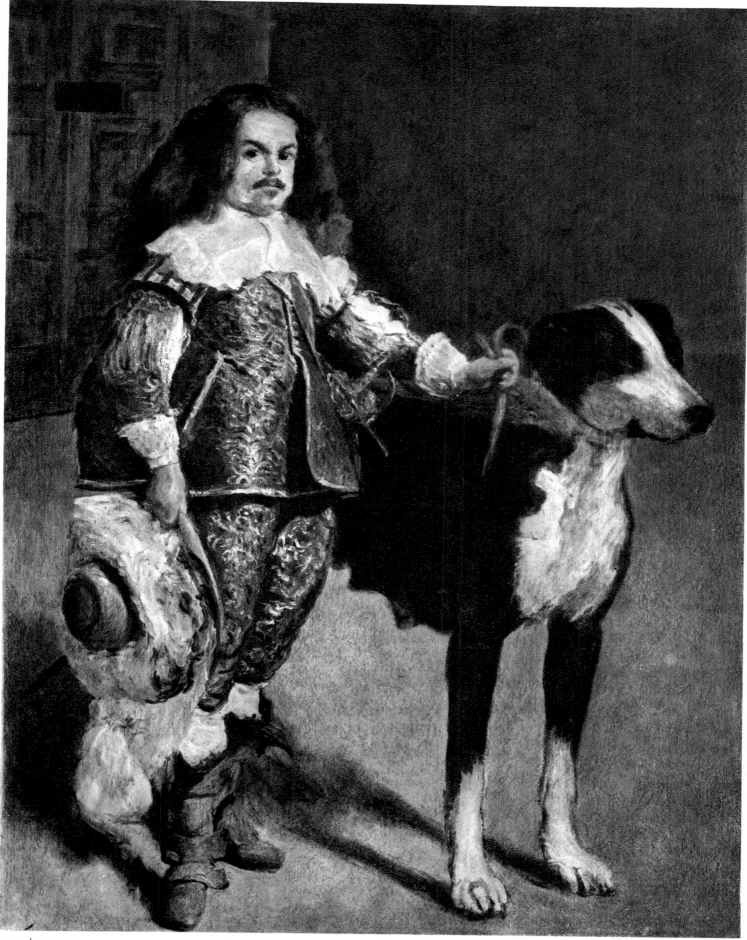

VELÁZQUEZ

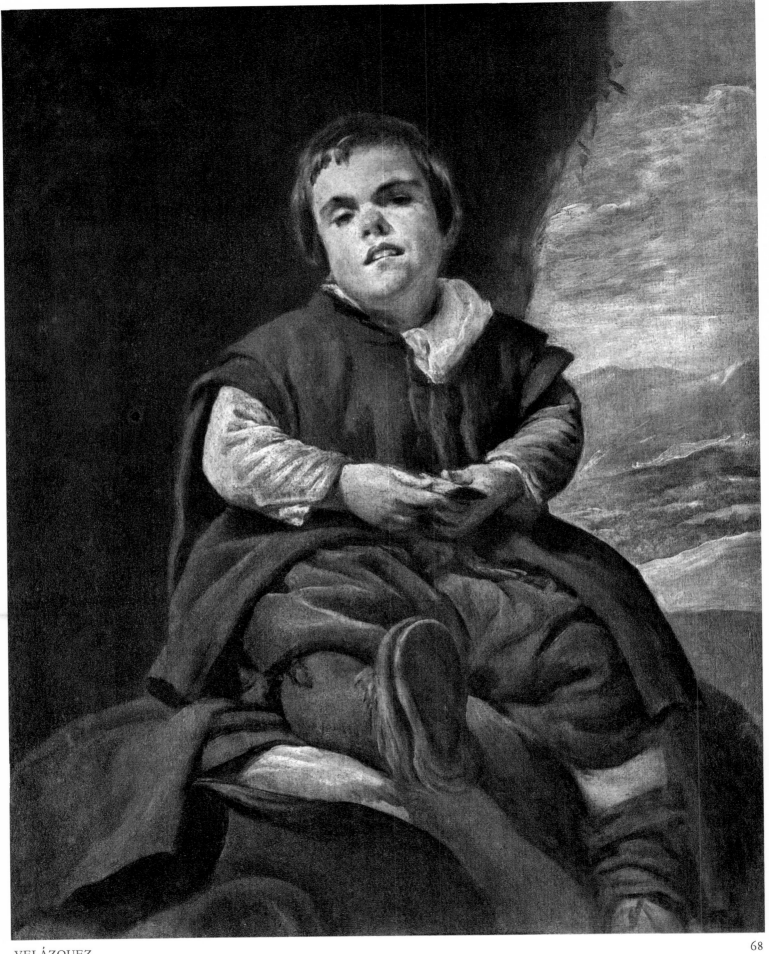

VELÁZQUEZ

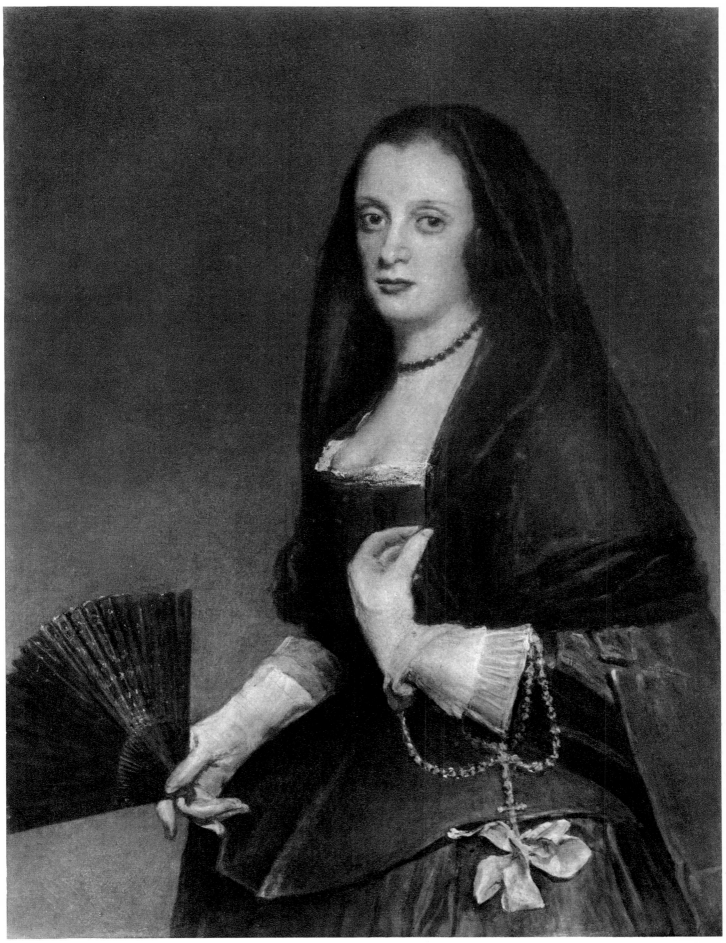

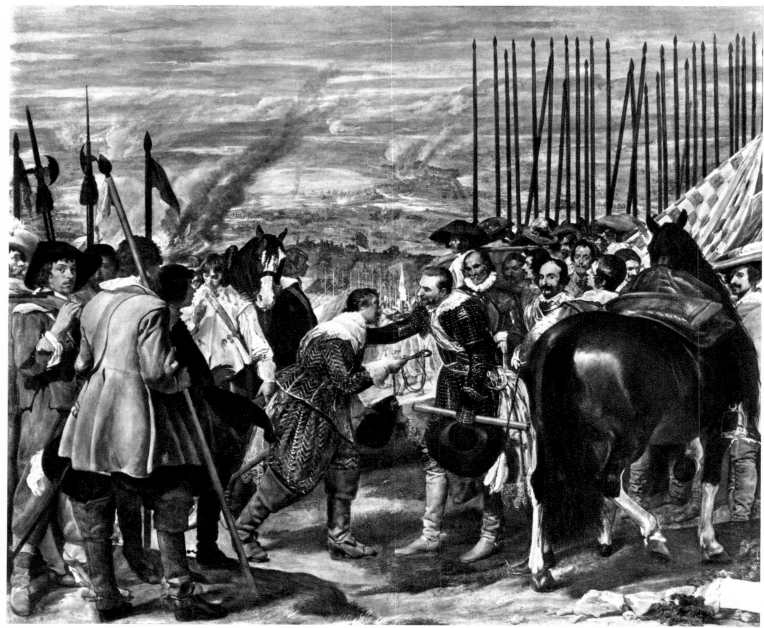

VELÁZQUEZ

70

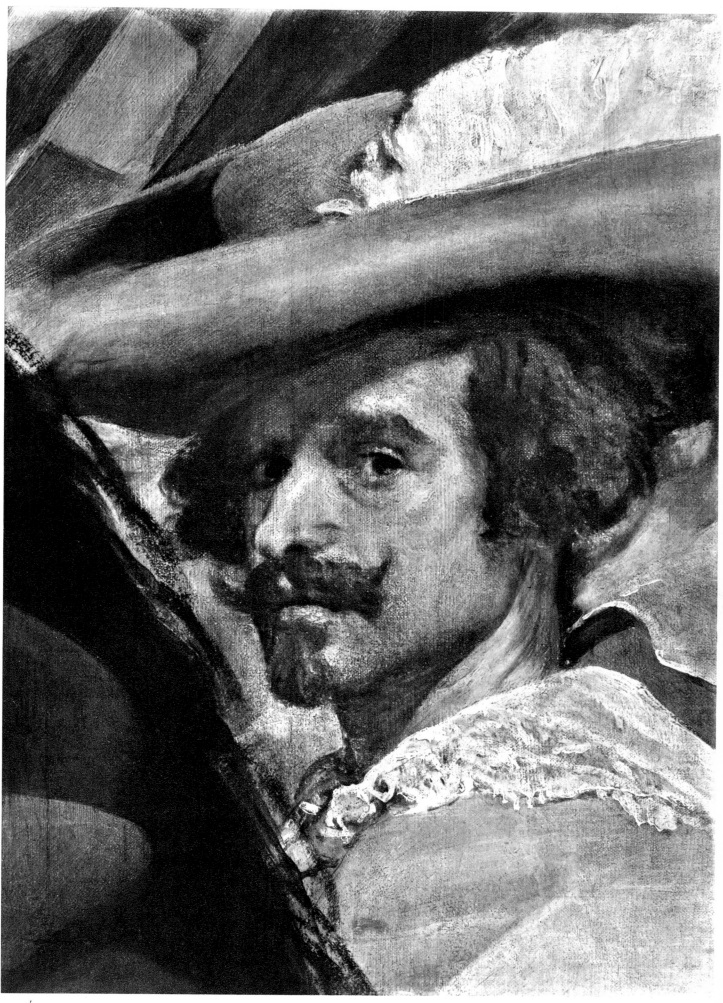

VELÁZQUEZ

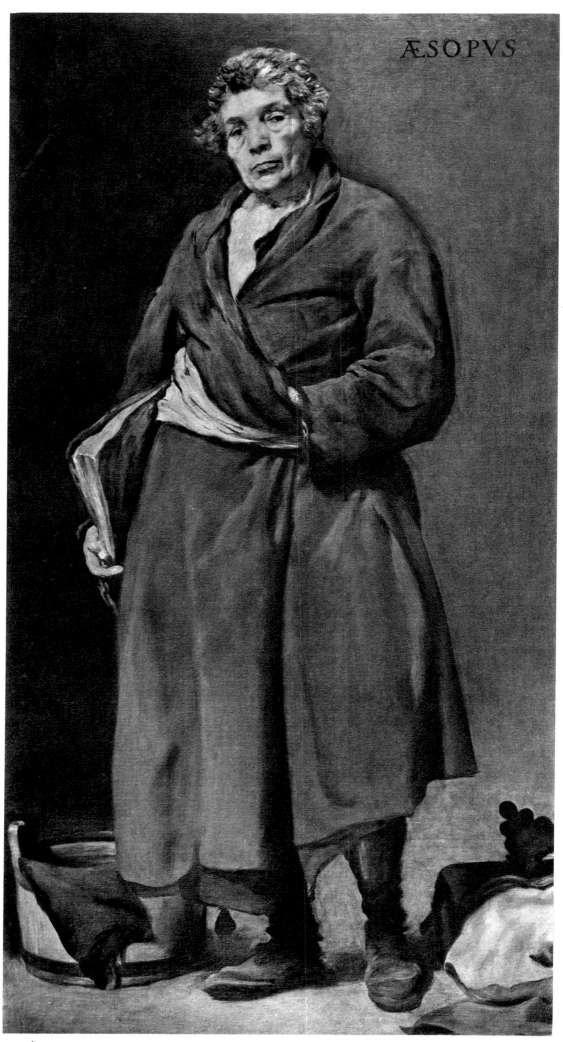

ÆSOPVS

VELÁZQUEZ

72

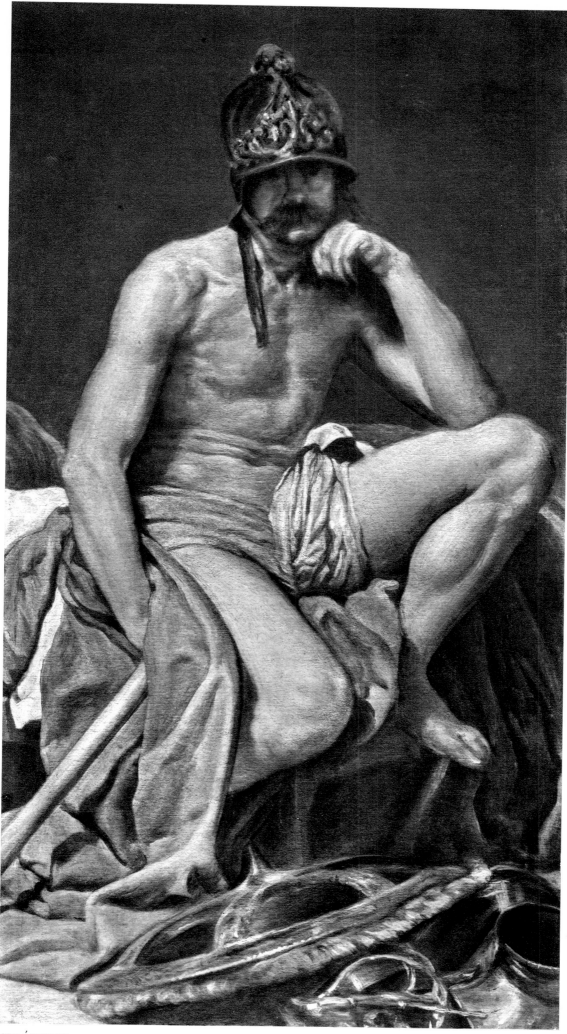

VELÁZQUEZ

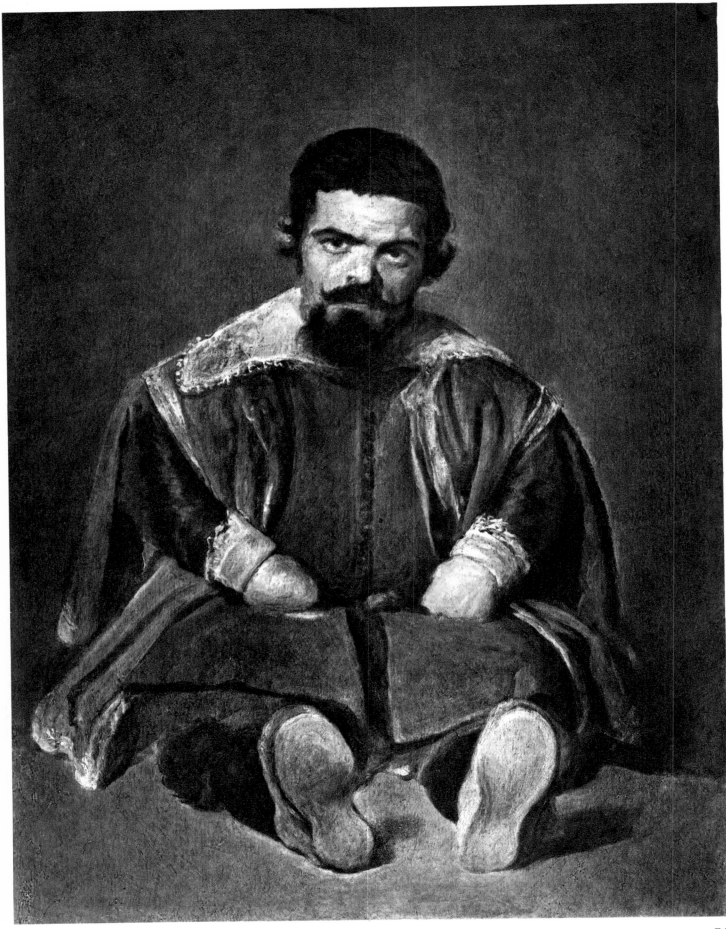

VELÁZQUEZ

74

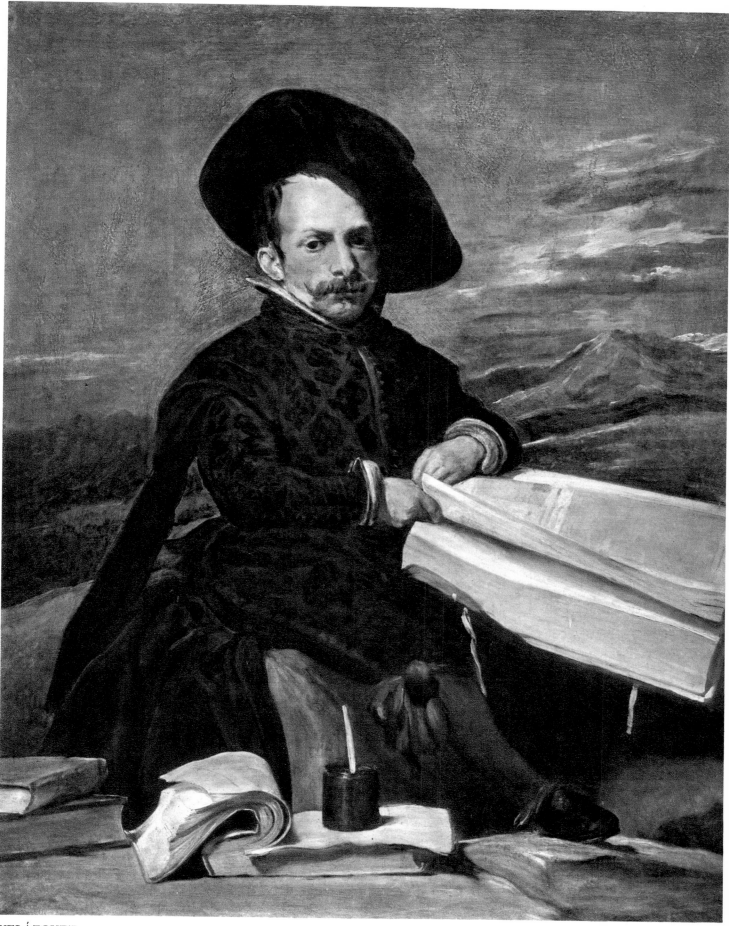

VELÁZQUEZ

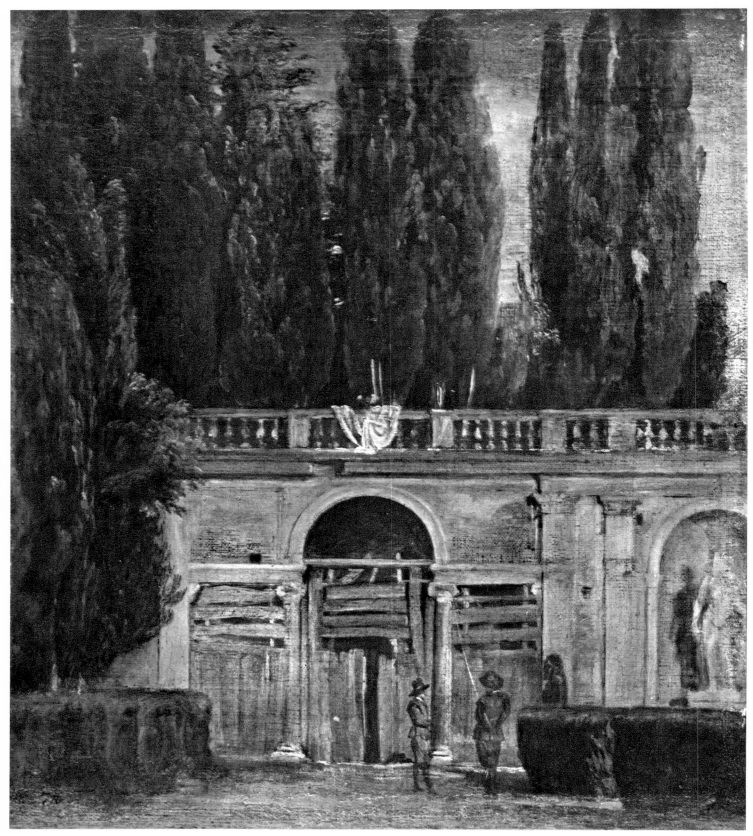

VELÁZQUEZ

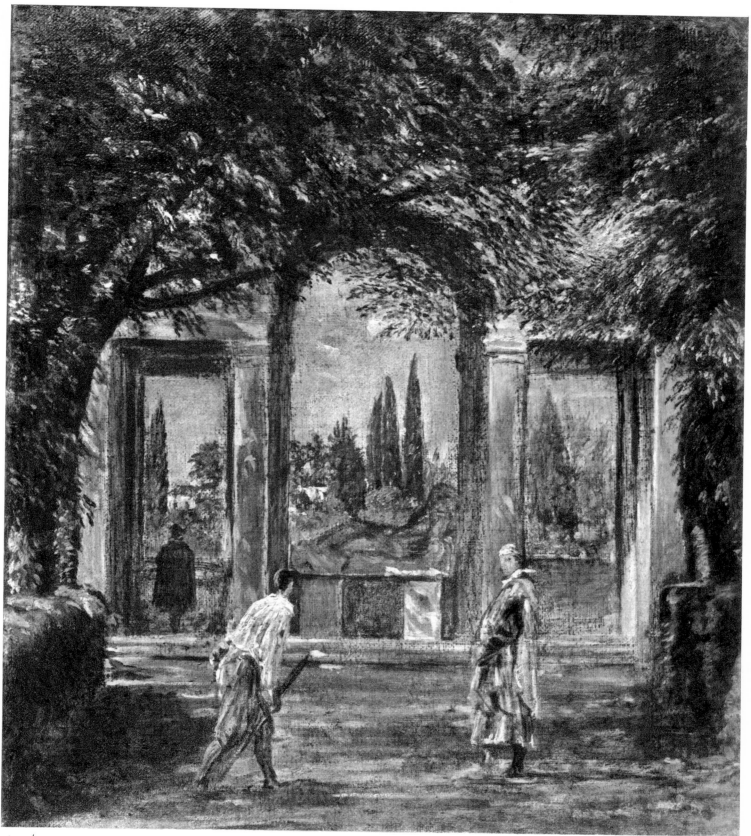

VELÁZQUEZ

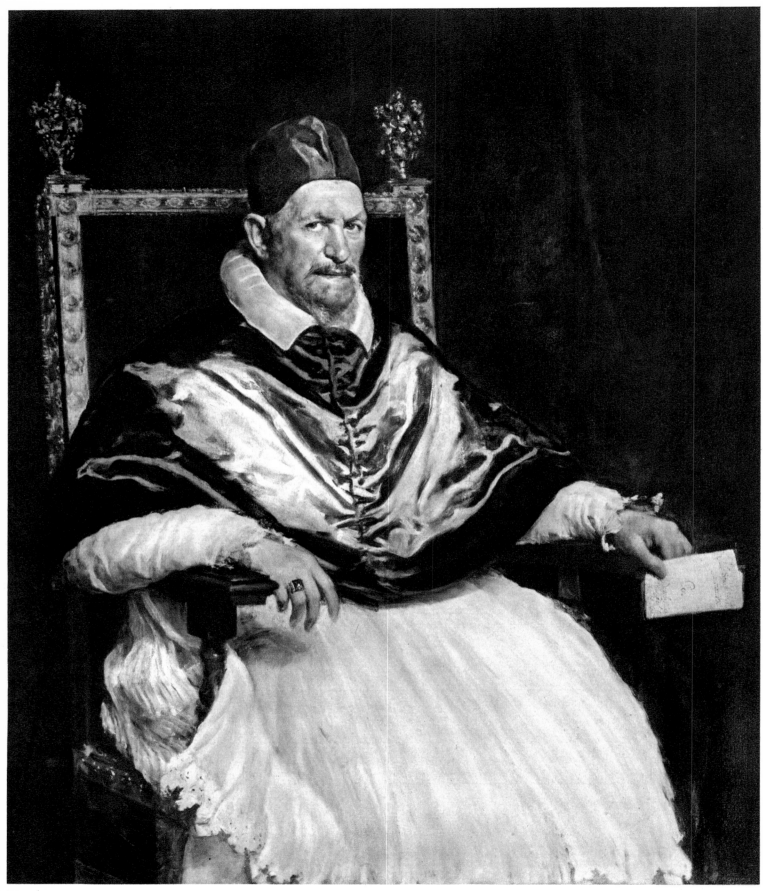

VELÁZQUEZ

78

VELÁZQUEZ

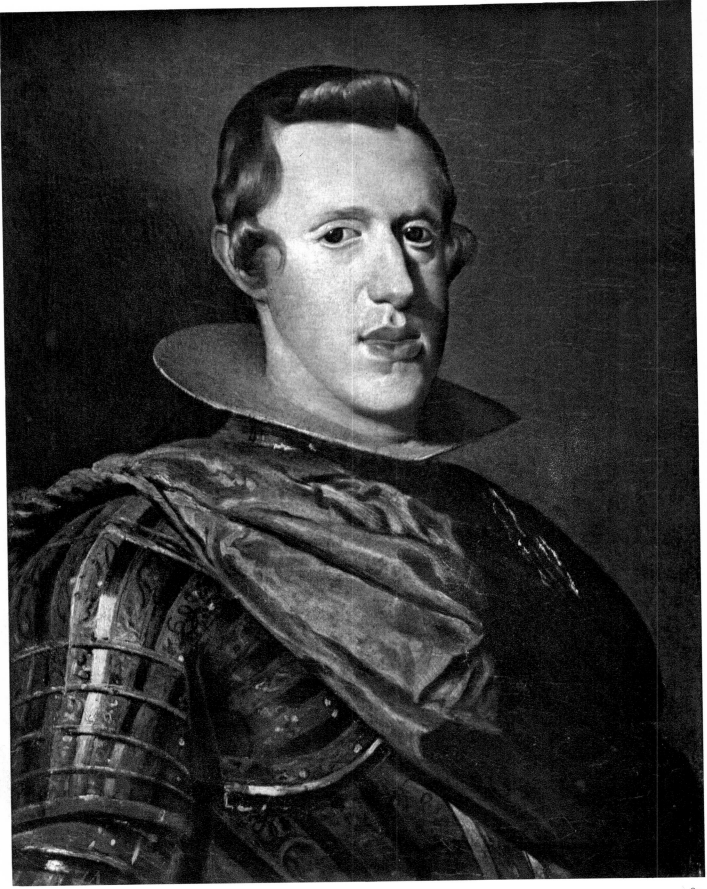

VELÁZQUEZ

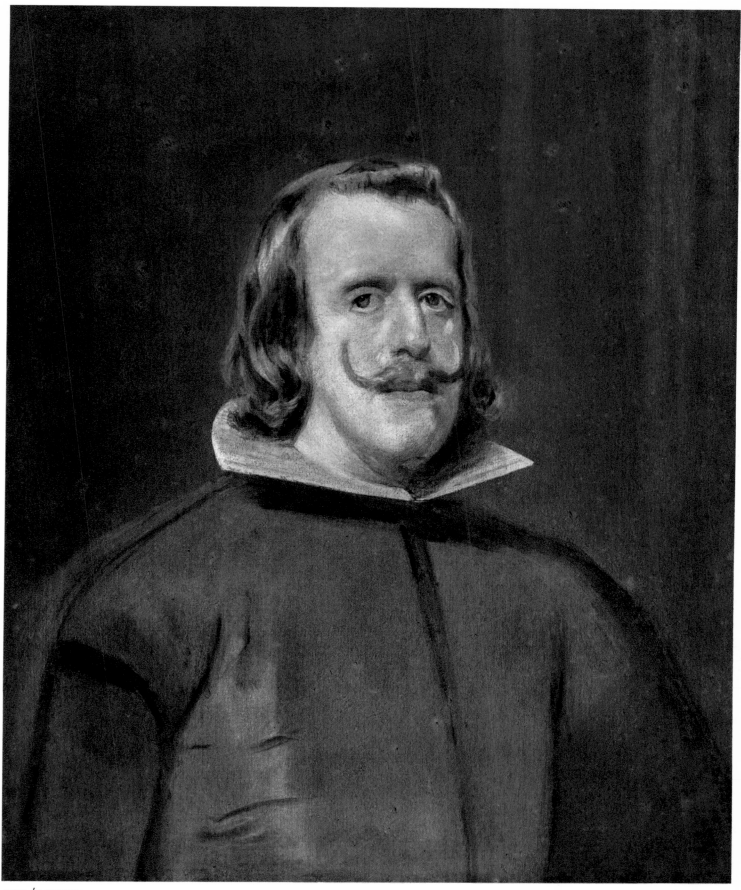

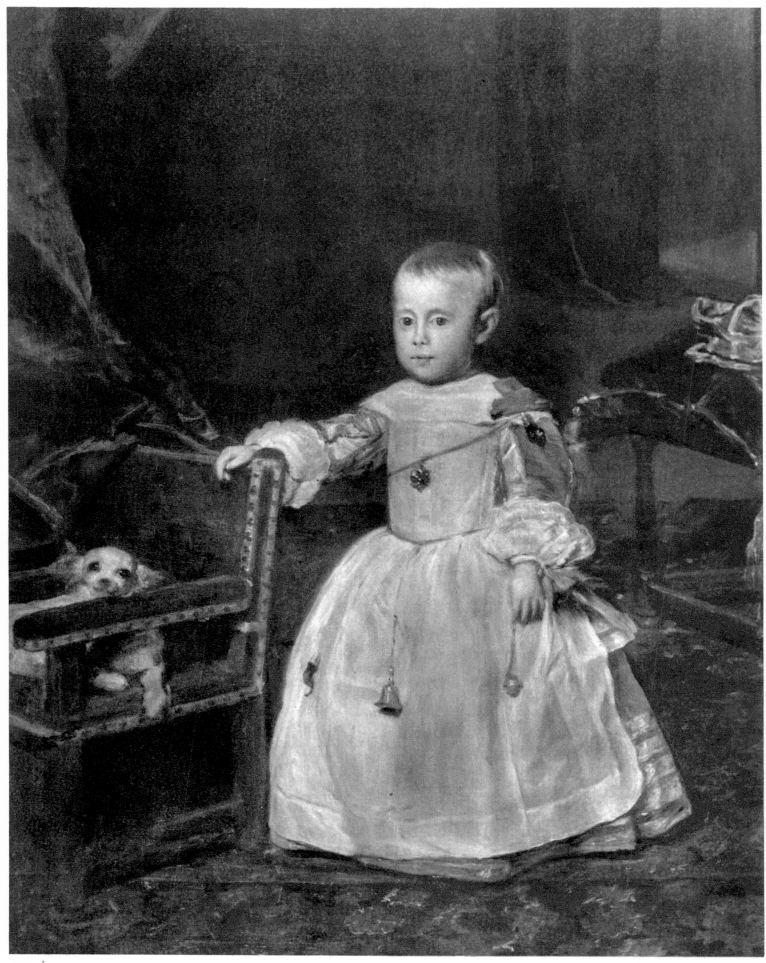

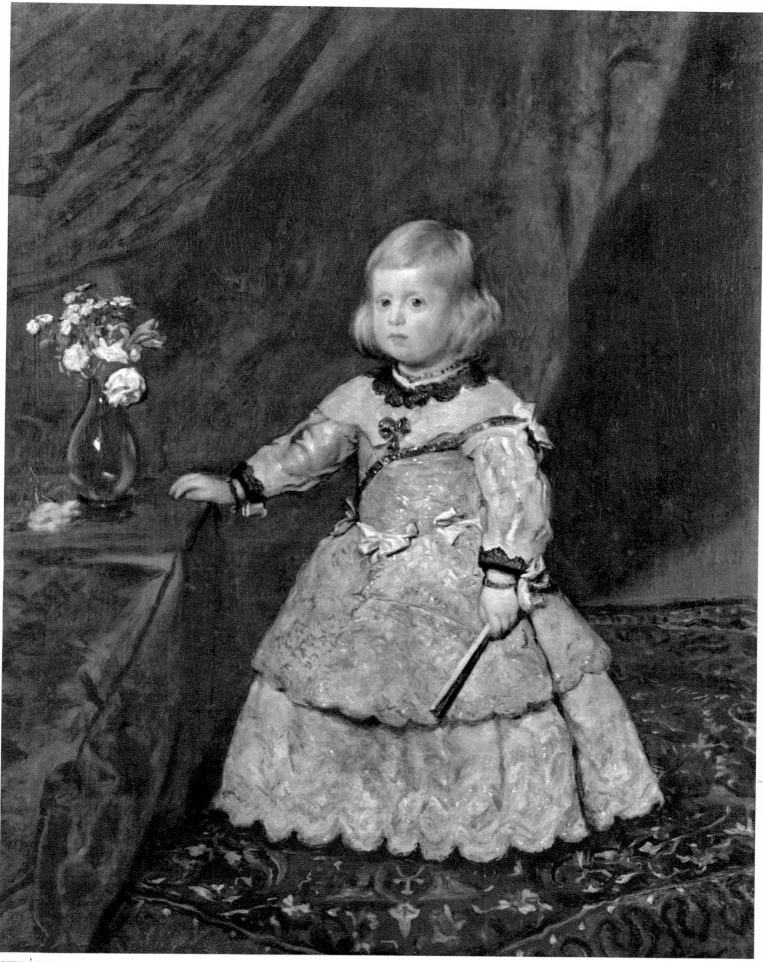

VELÁZQUEZ

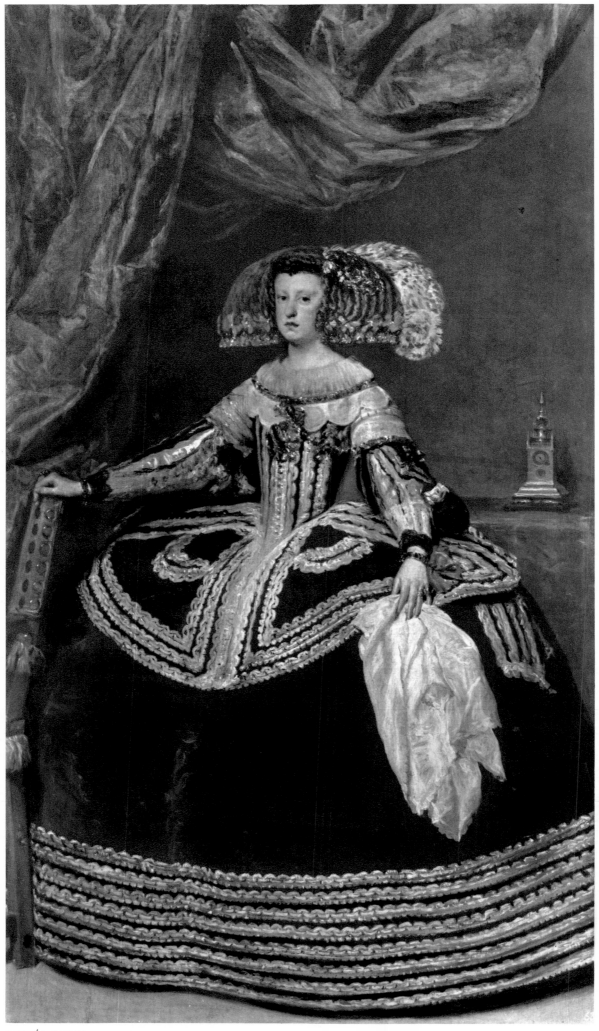

VELÁZQUEZ

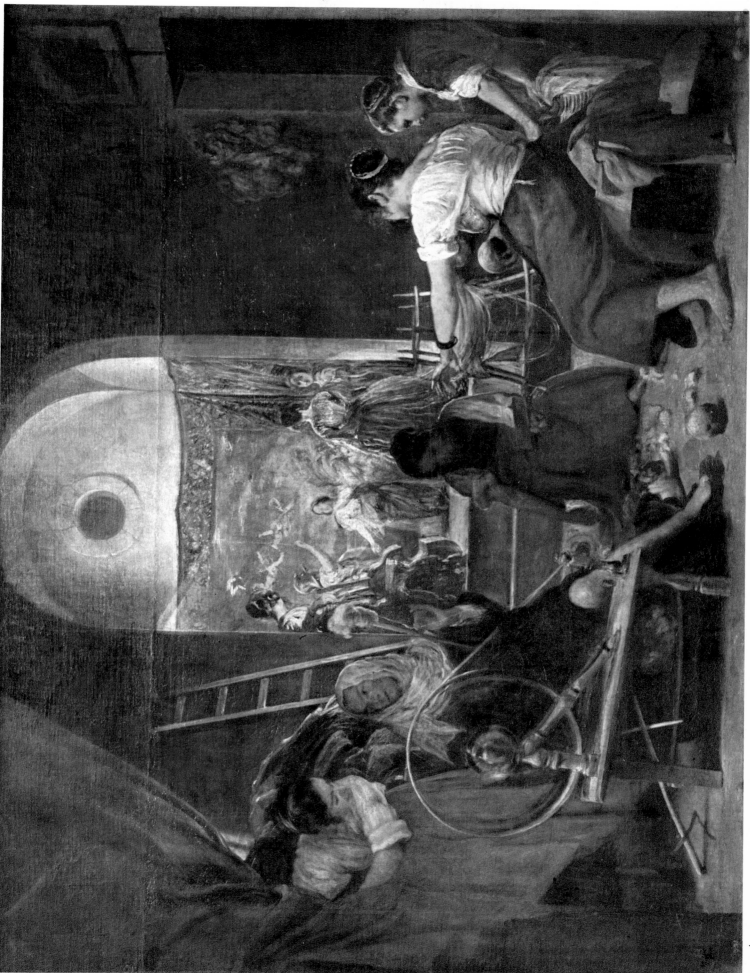

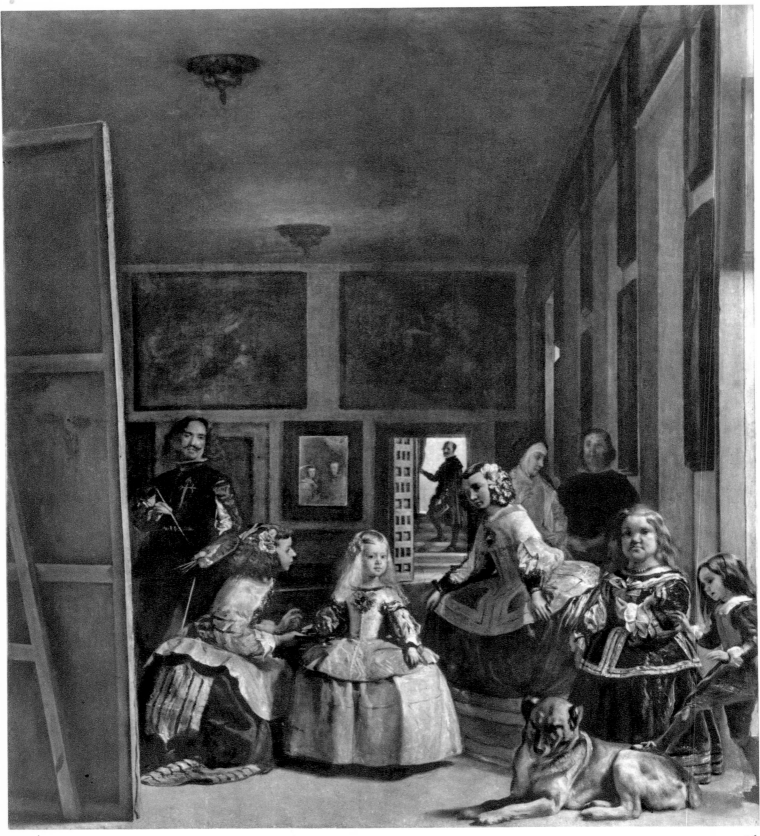

VELÁZQUEZ

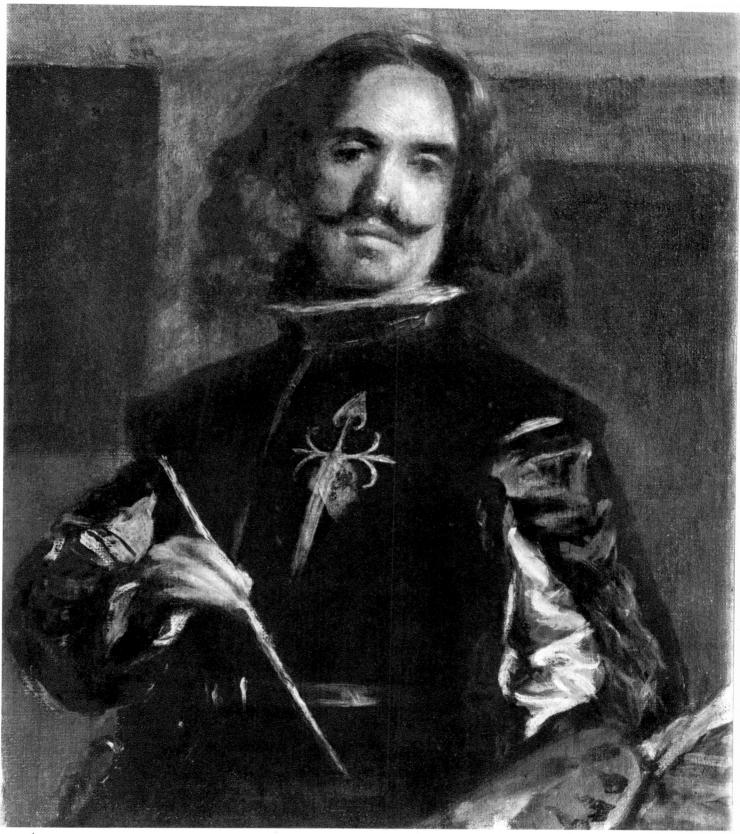

VELÁZQUEZ

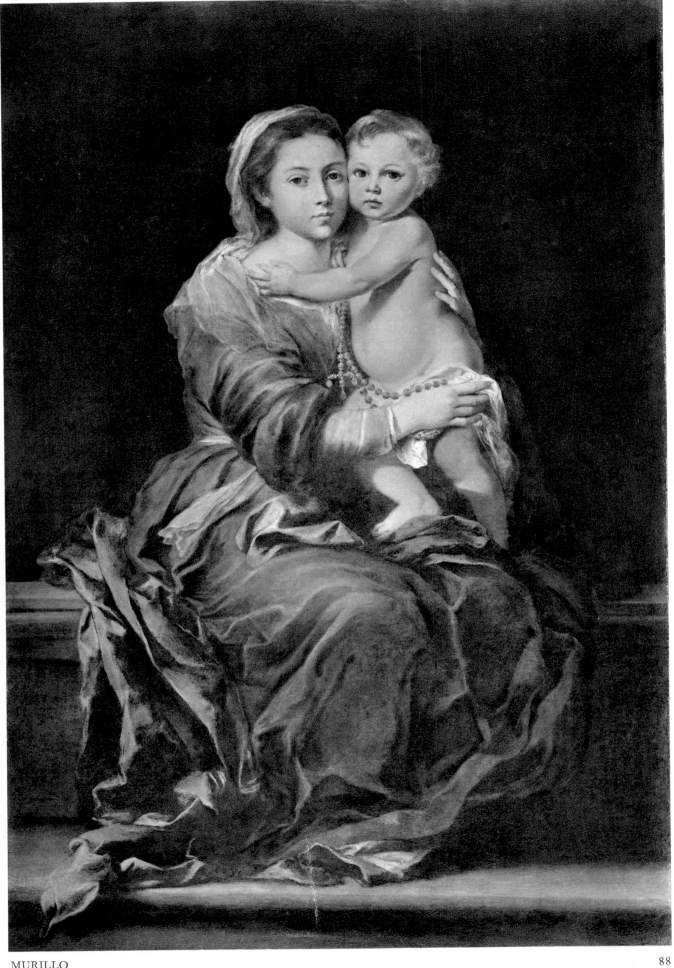

MURILLO

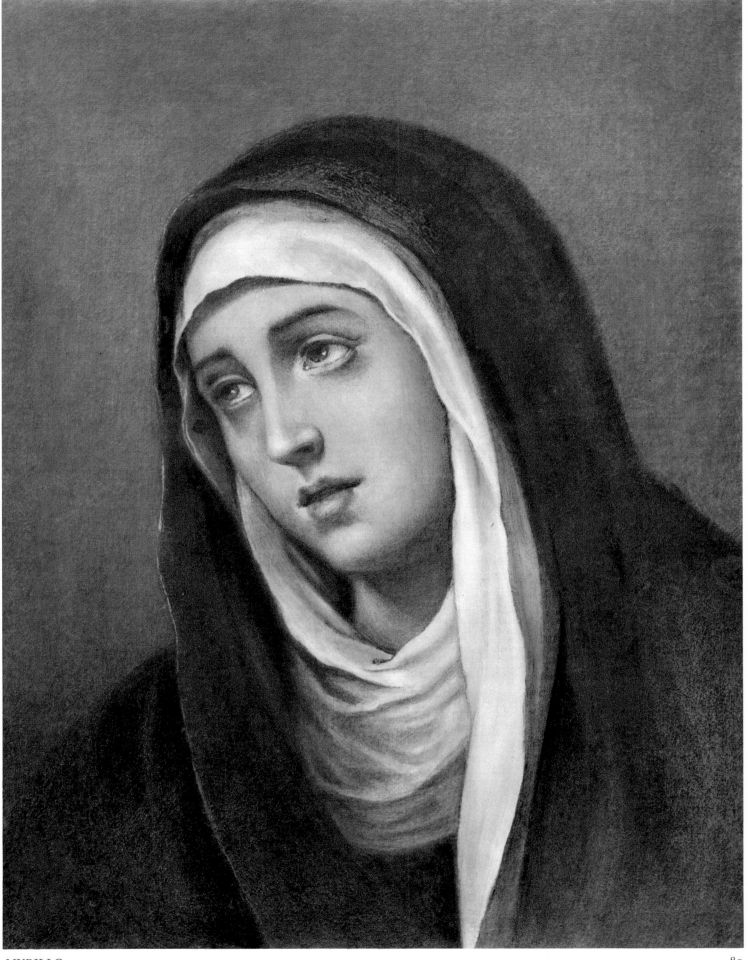

MURILLO

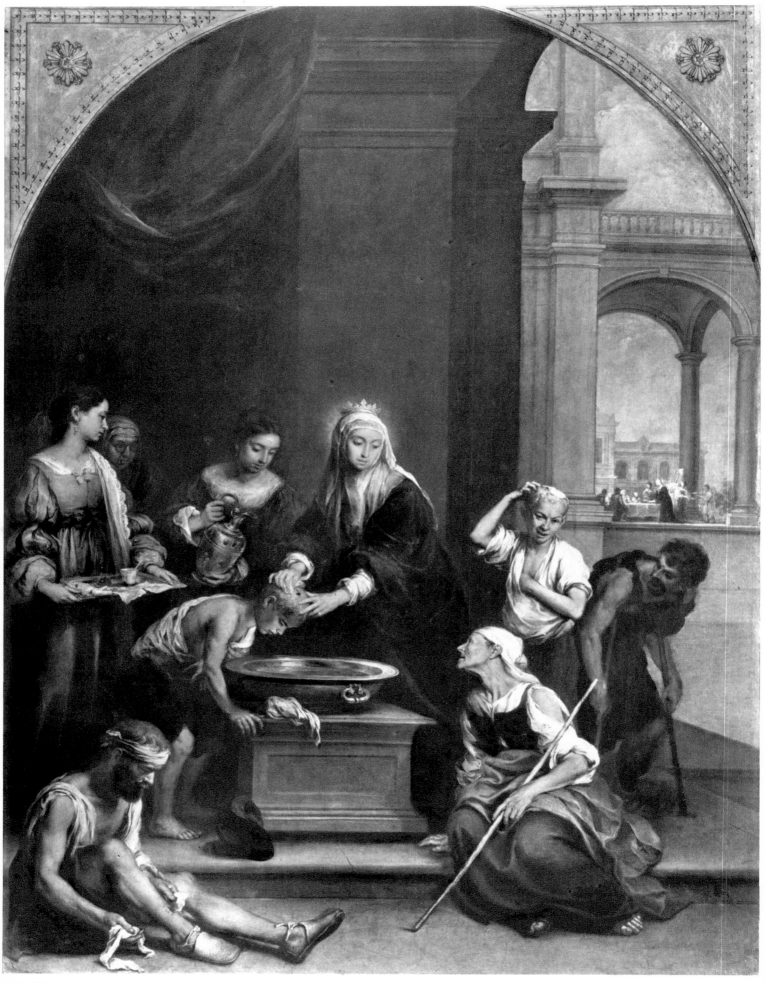

MURILLO

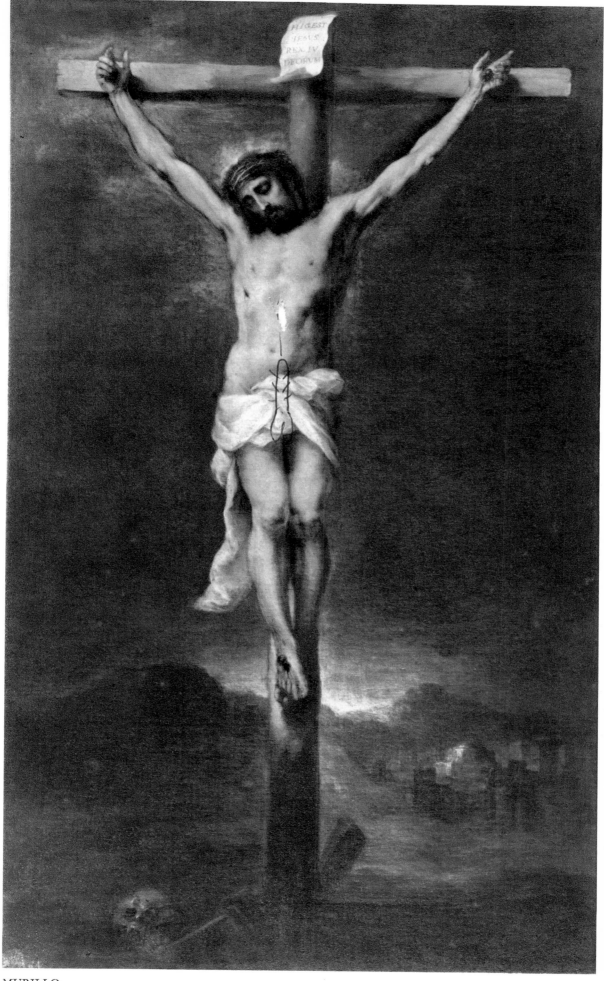

MURILLO

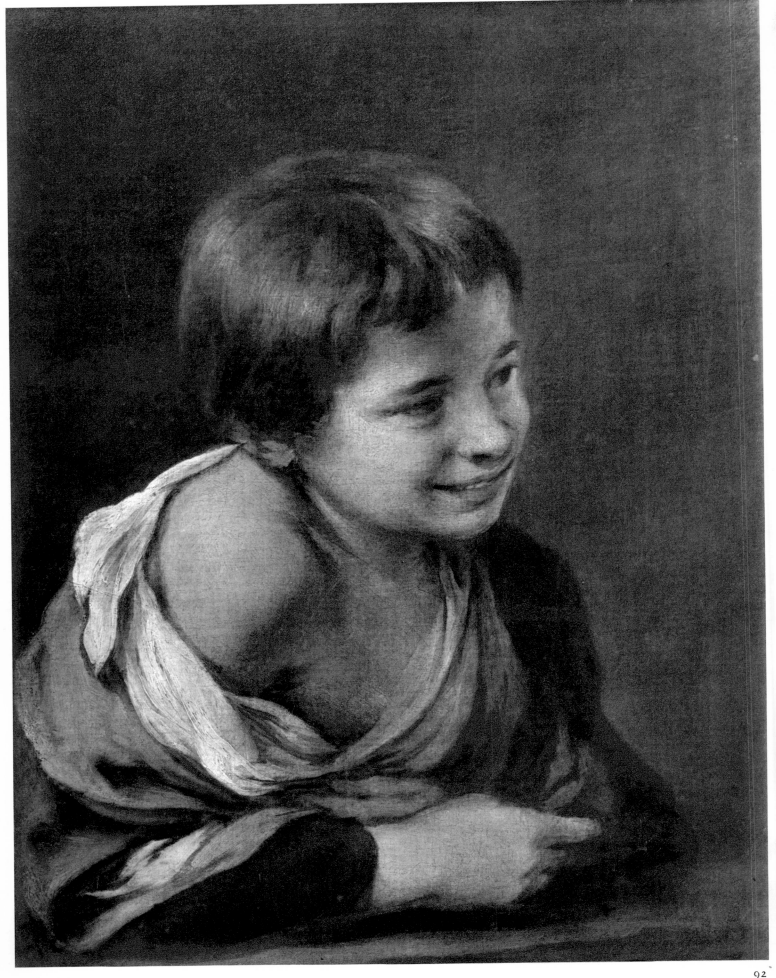

MURILLO

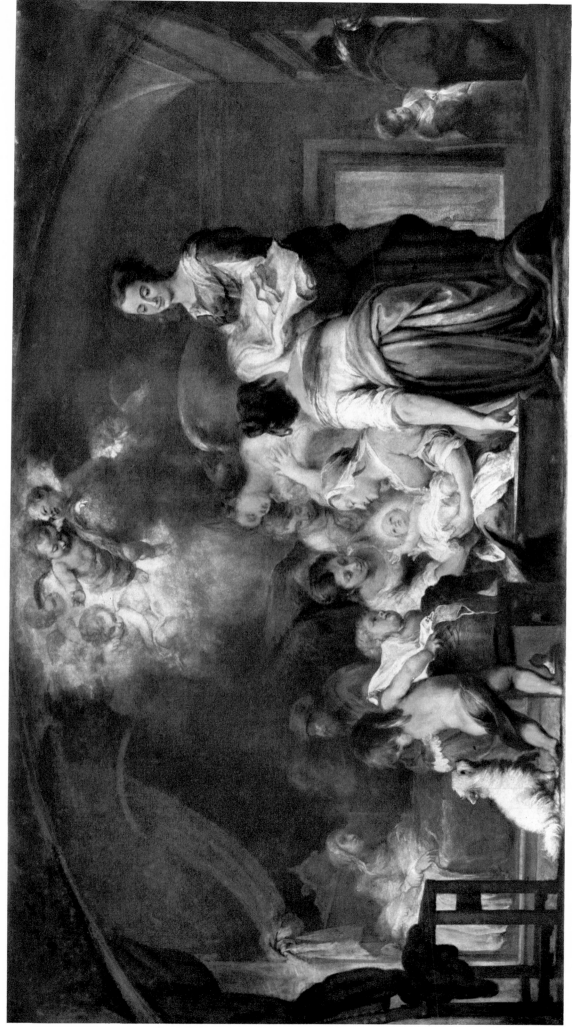

93

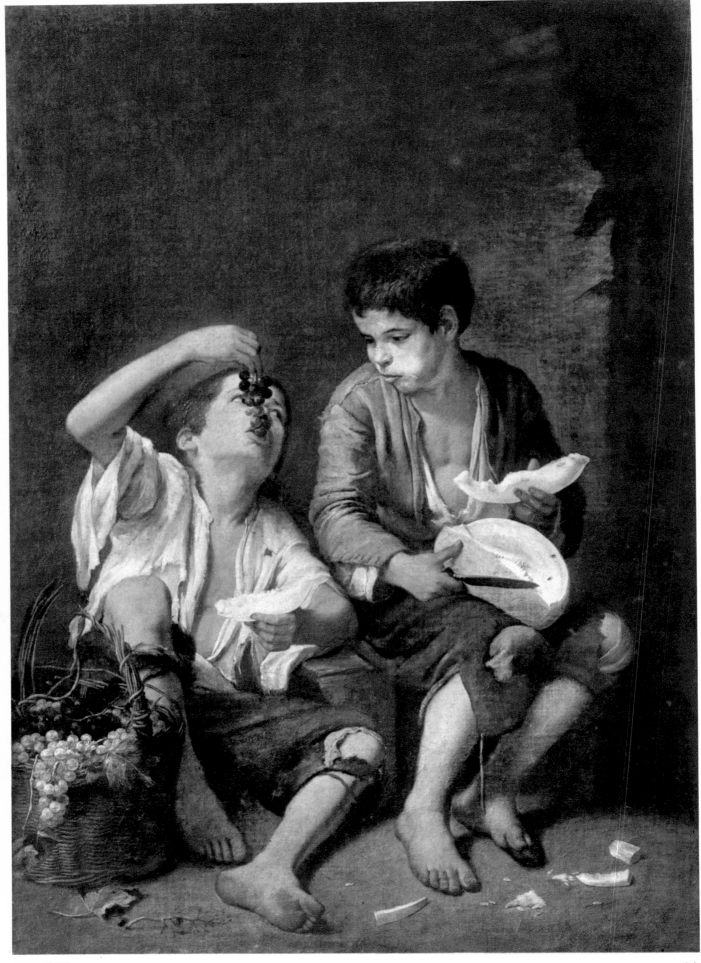

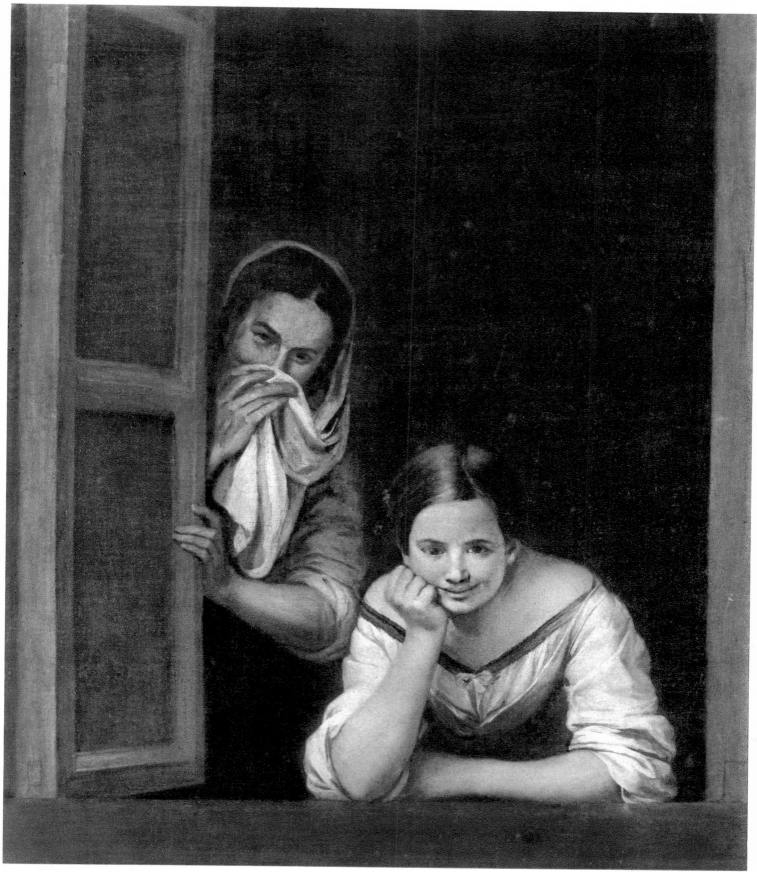

MURILLO

VALDÉS LEAL

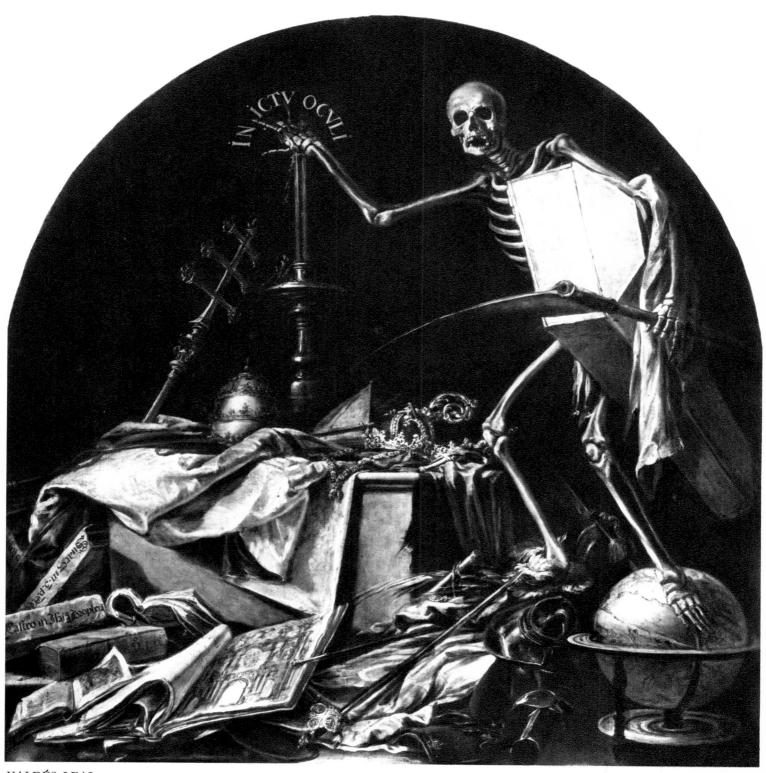

VALDÉS LEAL

98

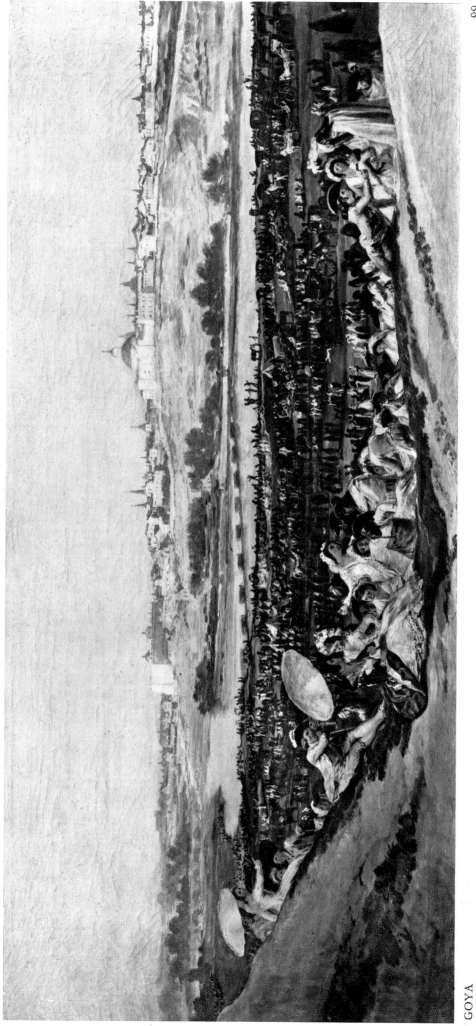

GOYA

99

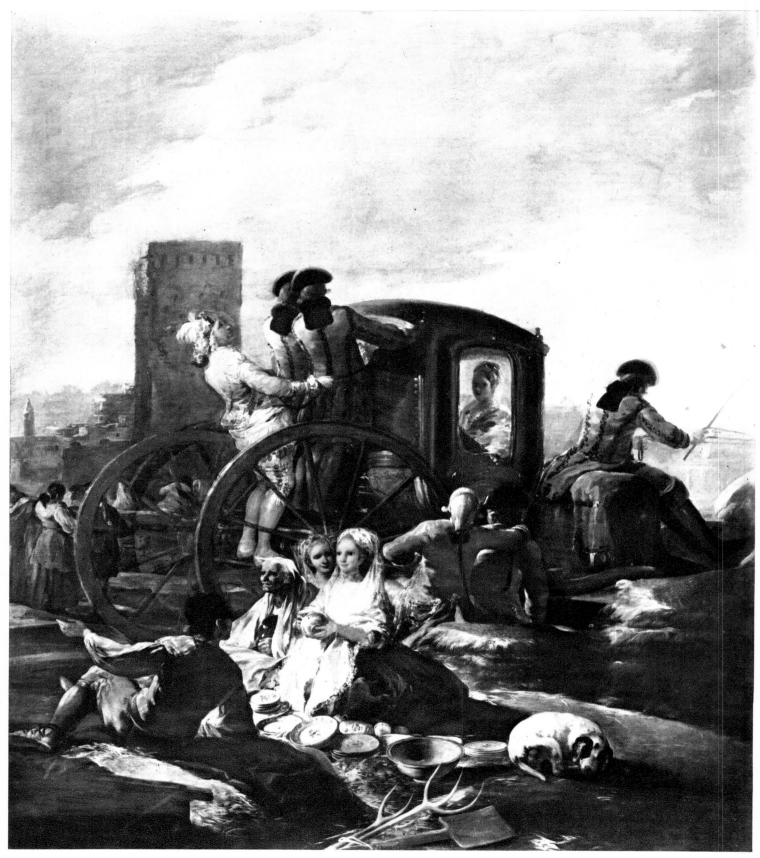

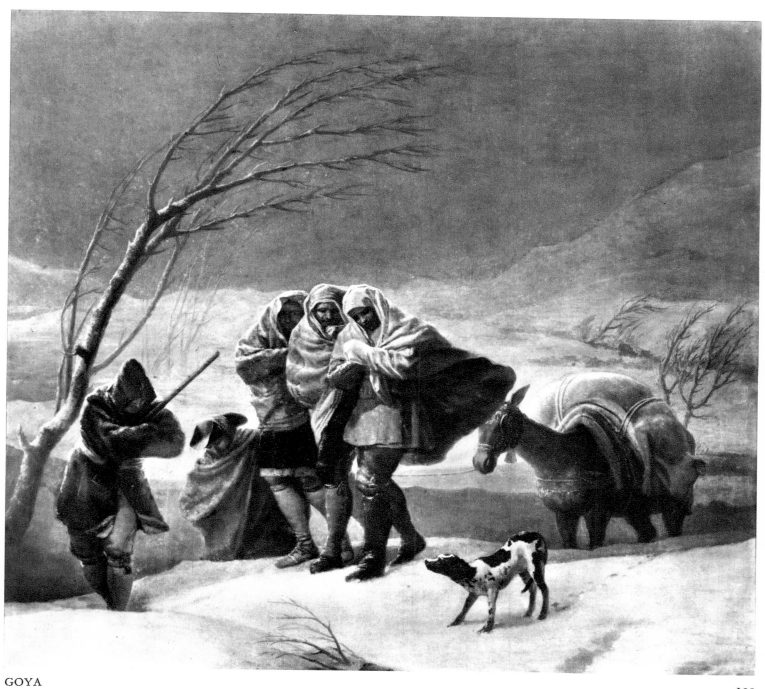

GOYA

101

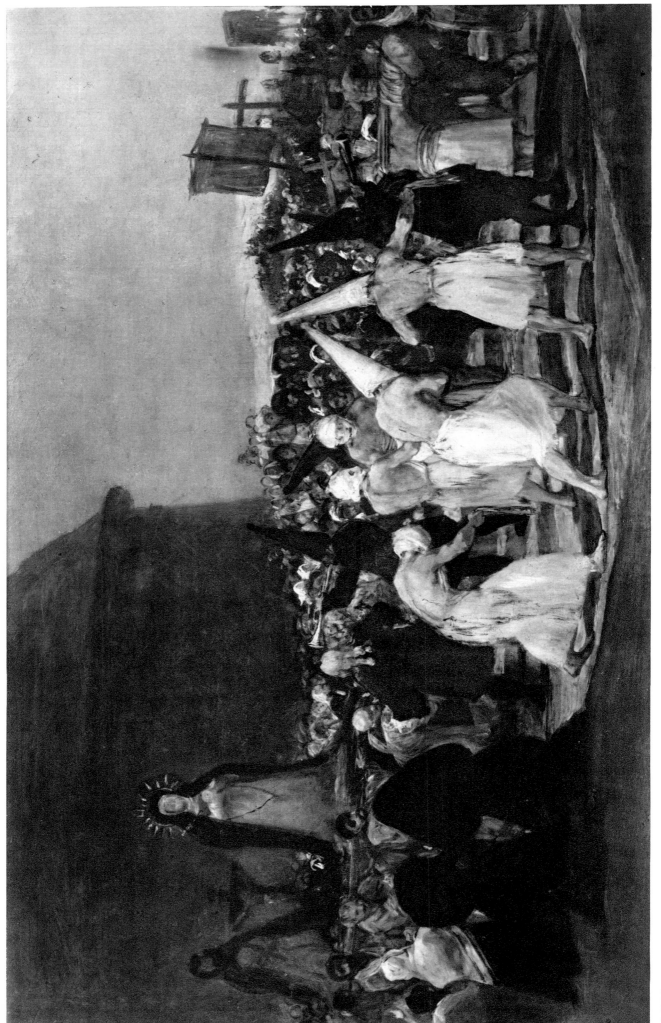

GOYA

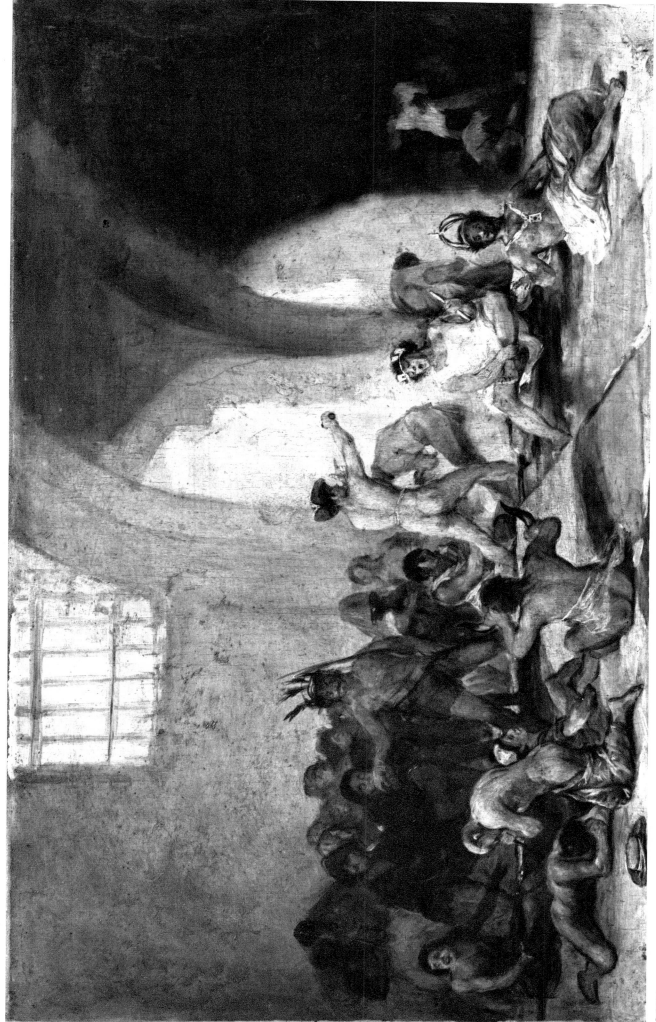

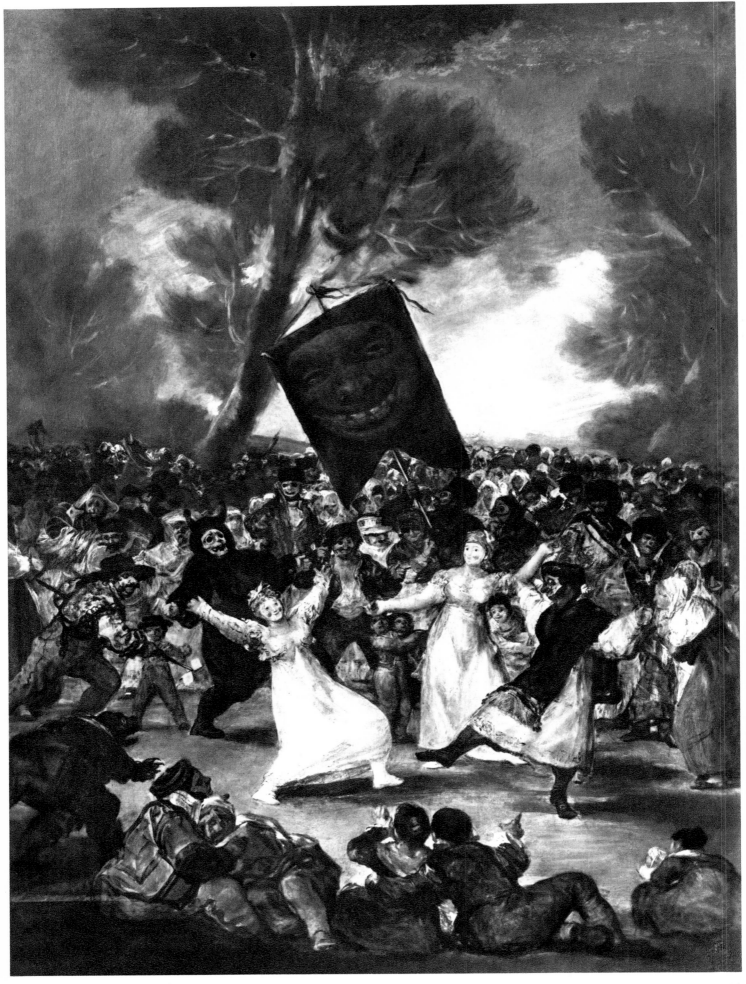

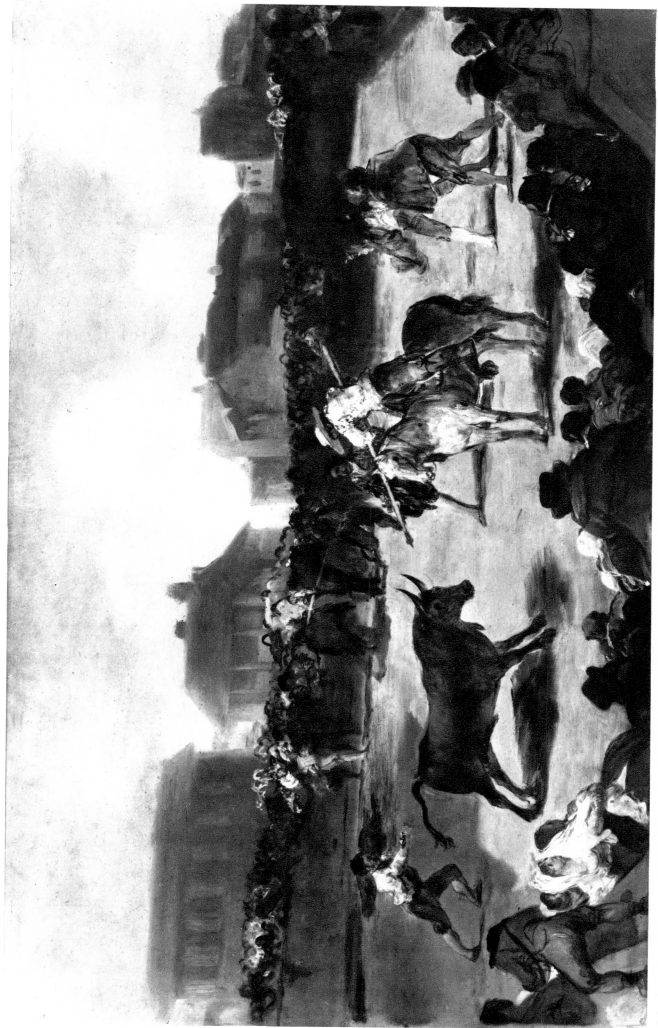

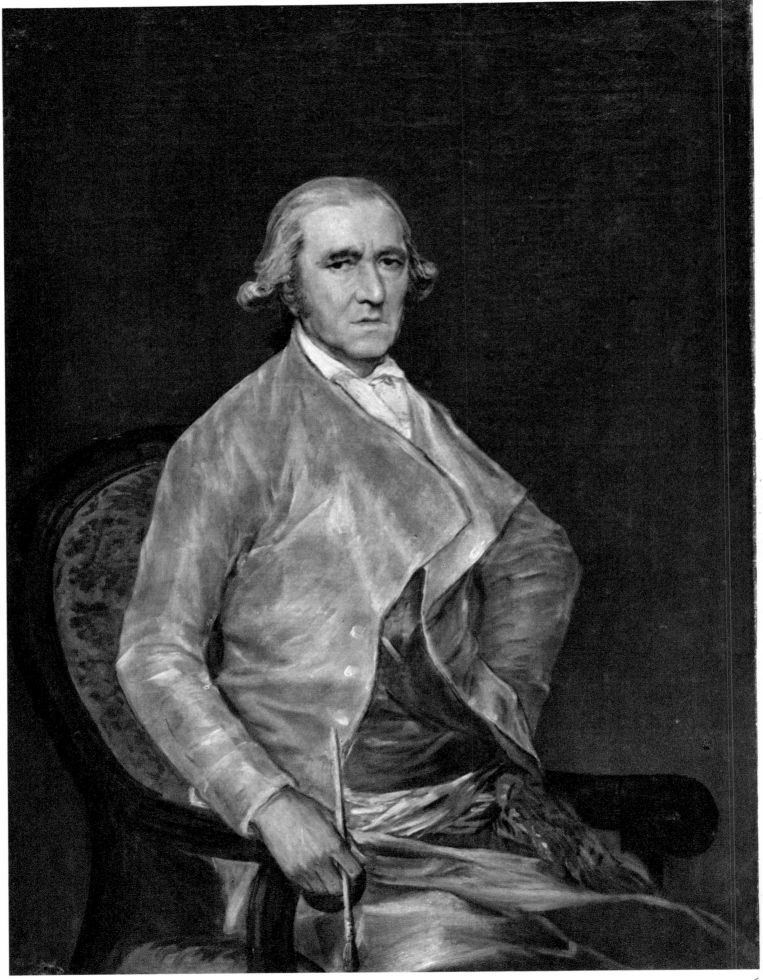

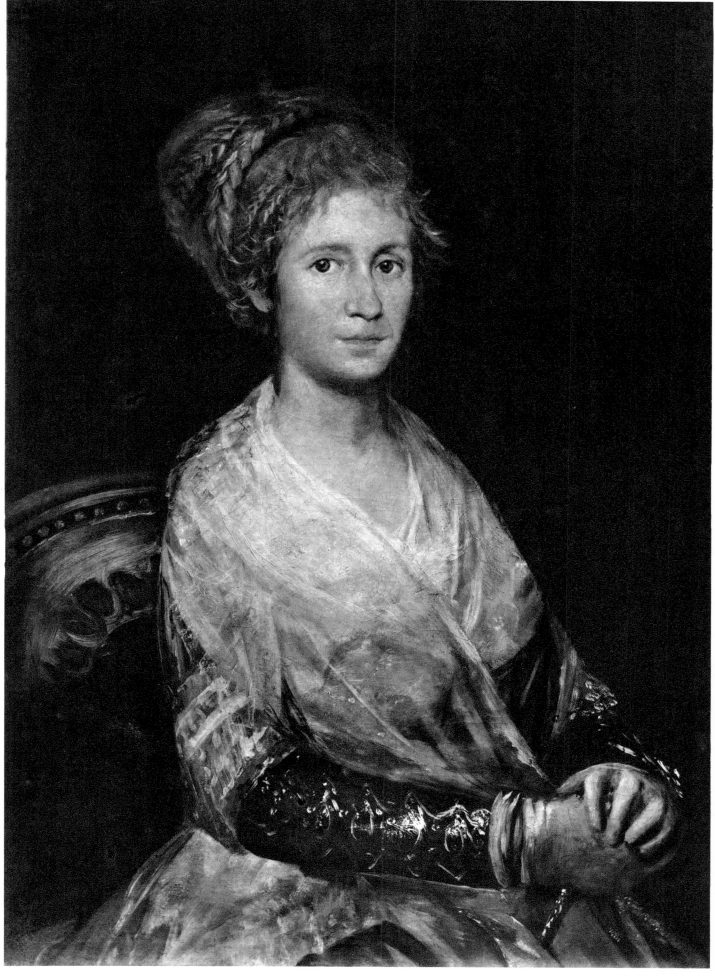

GOYA

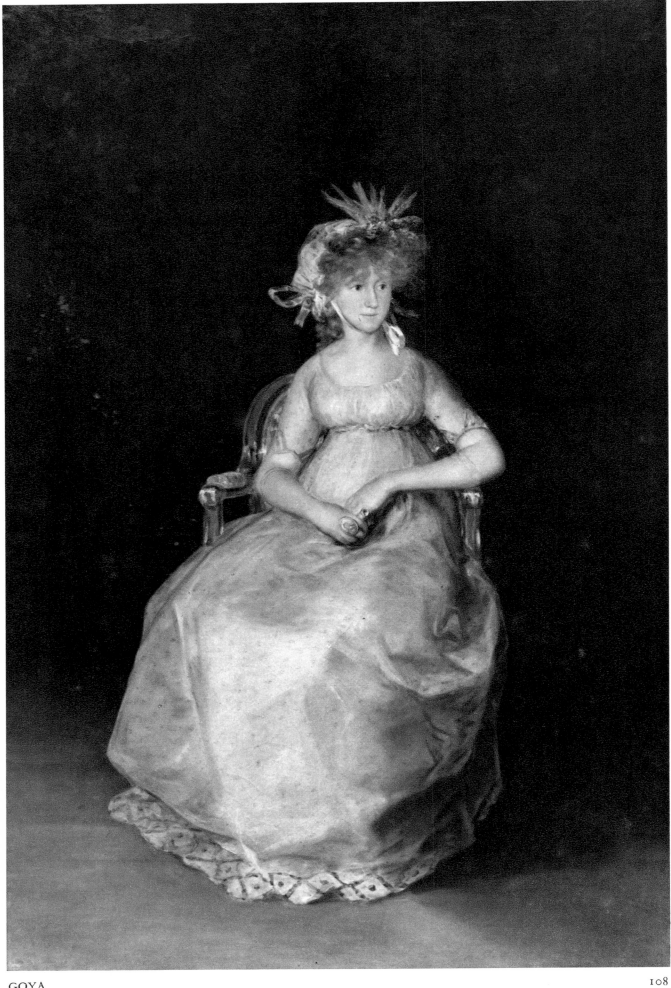

GOYA

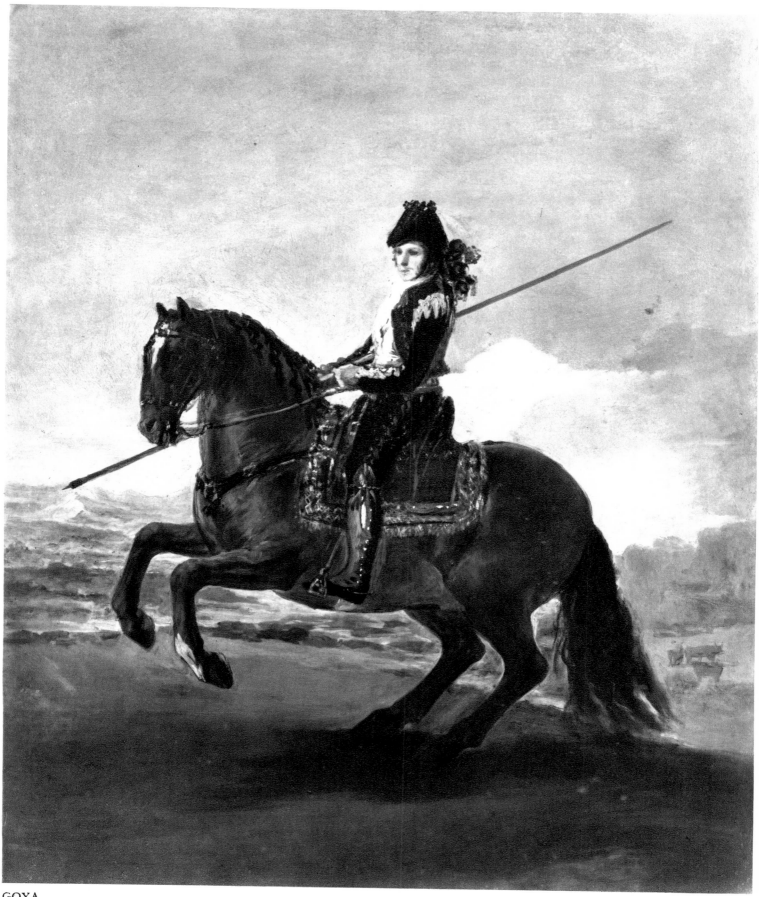

GOYA

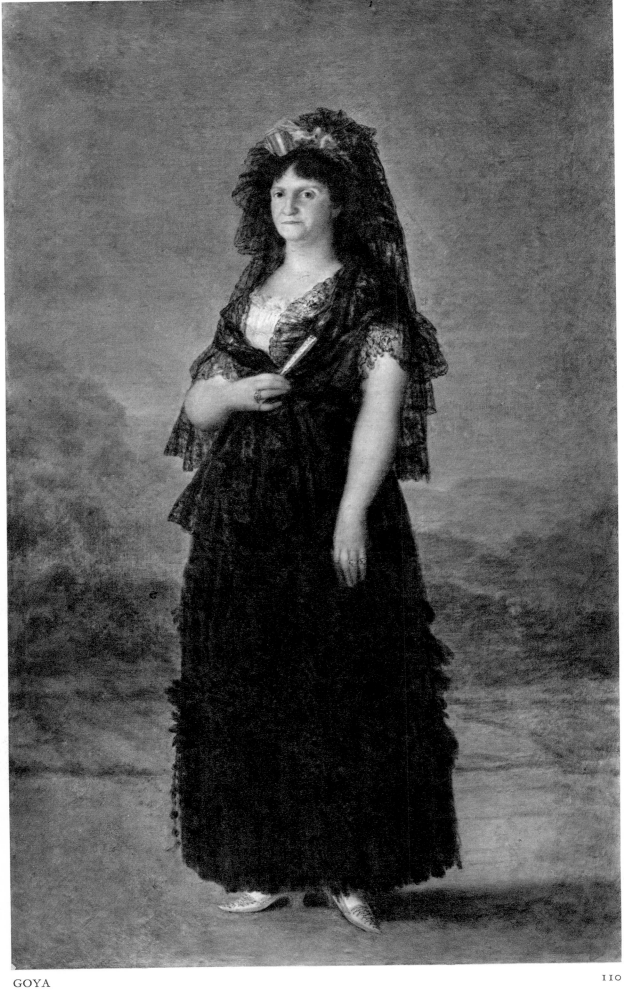

GOYA

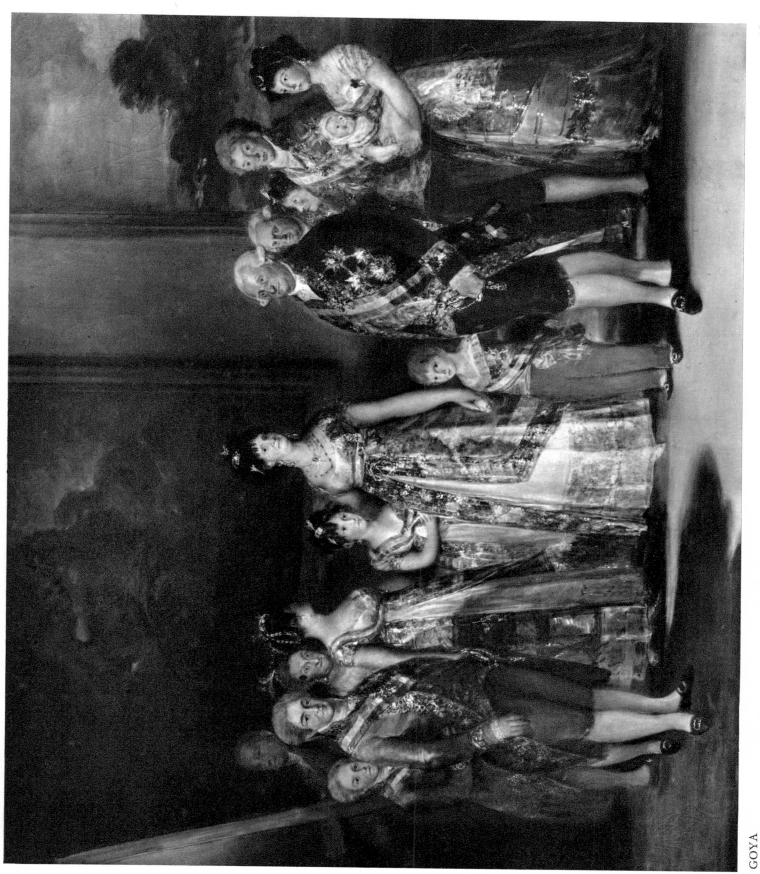

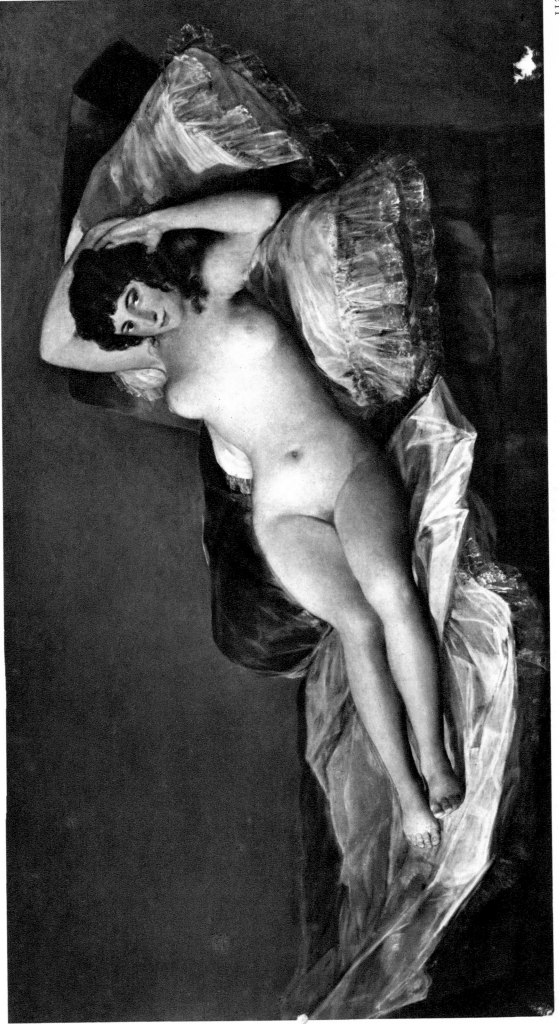

GOYA
114

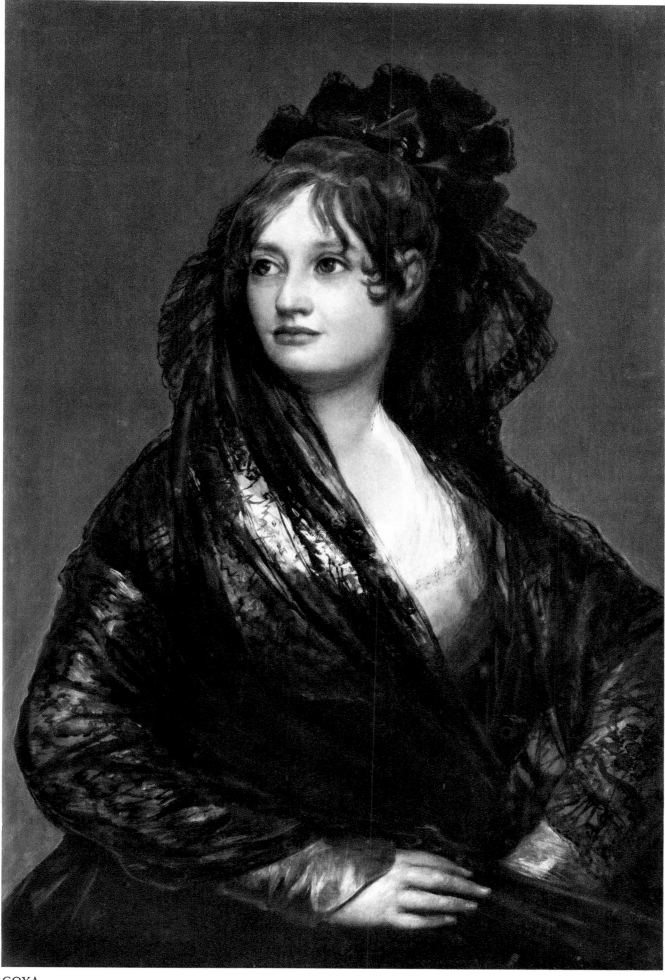

GOYA

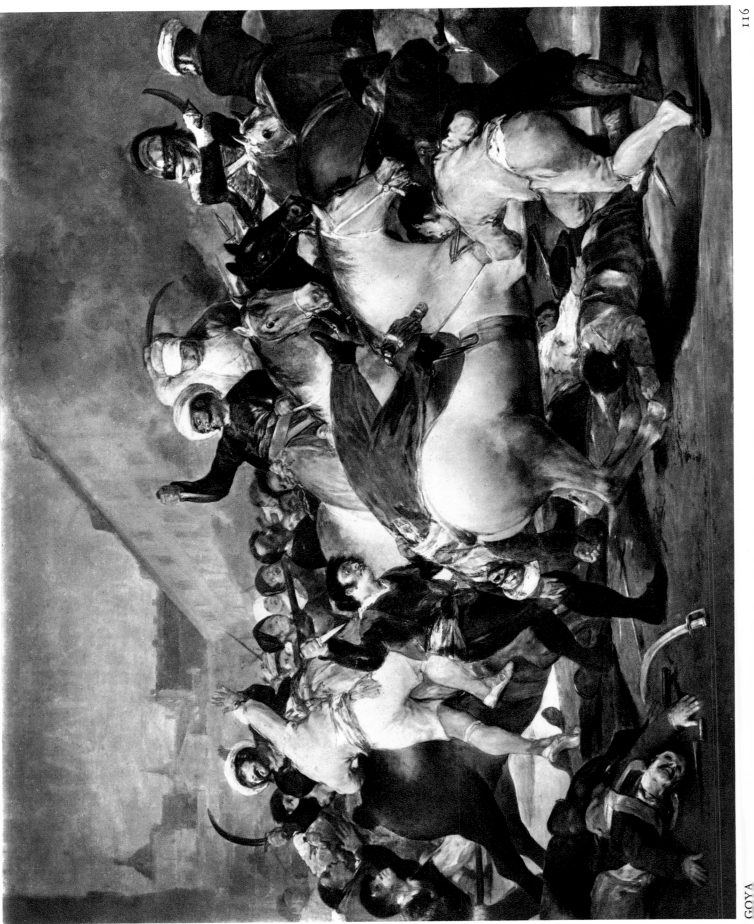

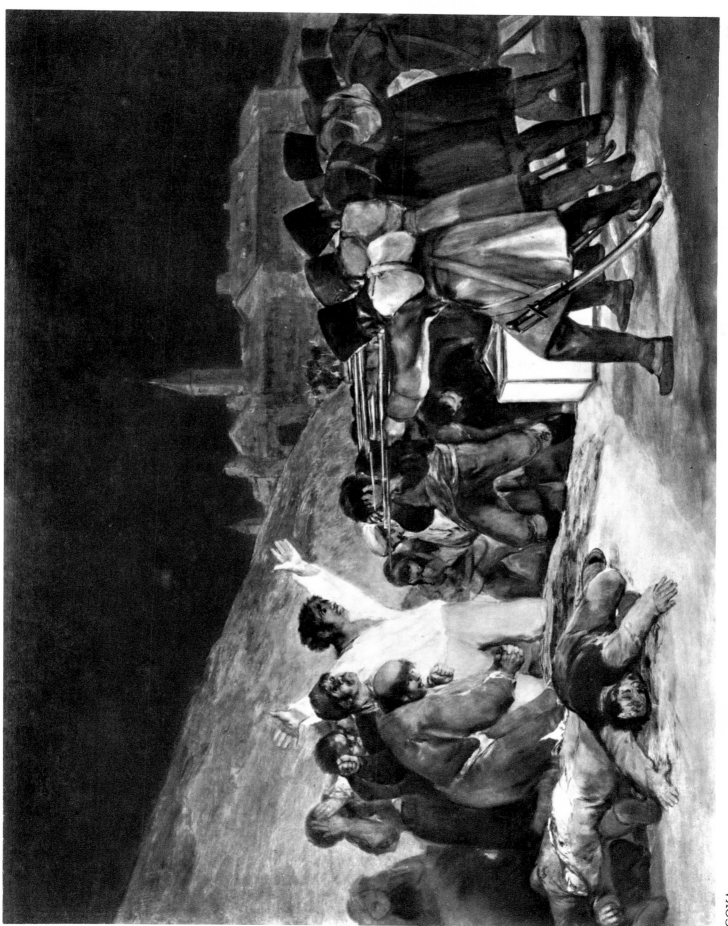

GOYA

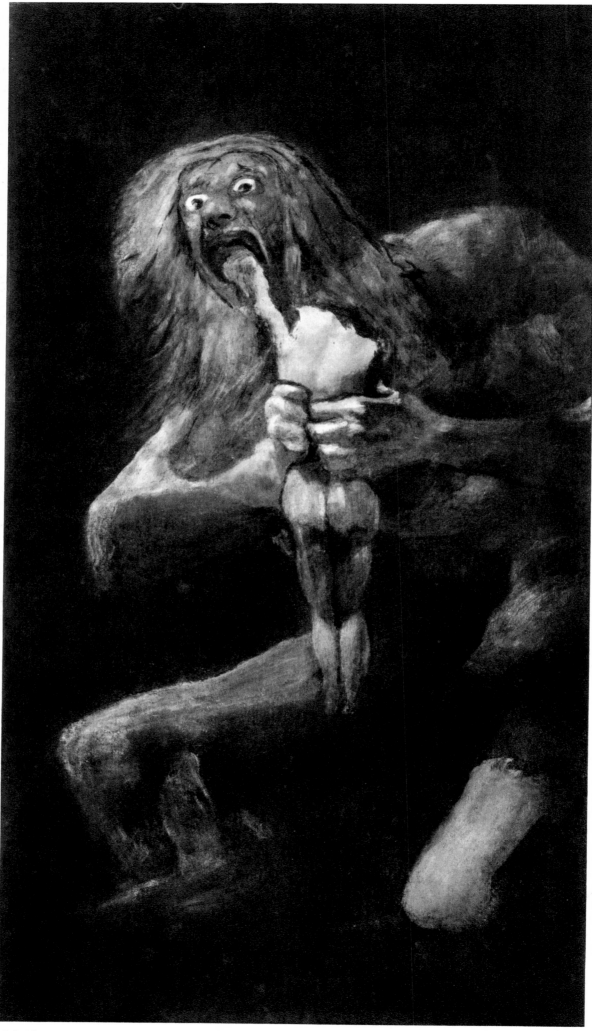

GOYA

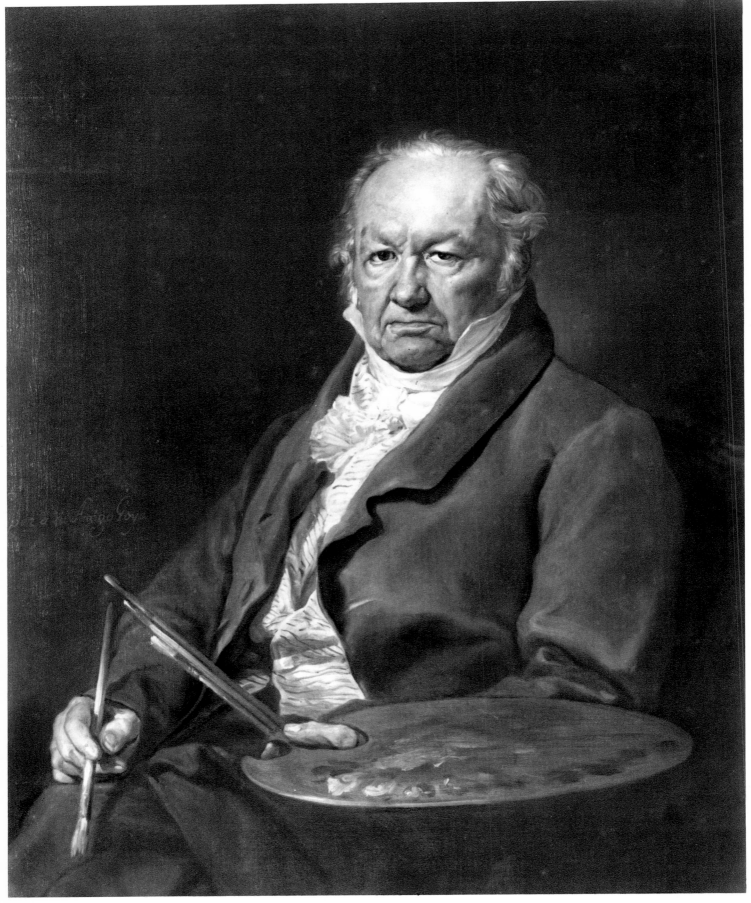

VICENTE LÓPEZ

NOTES ON THE PLATES

Colour Plates

EL GRECO

I

St Martin. Canvas, 105×60 cm. National Gallery, Washington.

II

The Martyrdom of St Maurice. Canvas, 443×302 cm. Escorial, Madrid.

III

The Vision of St Ildefonso. *c*. 1605. Canvas, 112×65 cm. Hospital Church, Illescas.

MURILLO

IV

Two Boys eating Fruit (Detail from plate 94). *c*. 1650–60. Canvas. Alte Pinakothek, Munich.

VELÁZQUEZ

V

Venus and Cupid ('The Rokeby Venus'). *c*. 1642. Canvas, 123×175 cm. National Gallery, London.

VI

The Infanta Margarita. 1660. Canvas, 212×147 cm. Prado, Madrid.

VII

Aesop (Detail from plate 72).

GOYA

VIII

The Clothed Maja. *c*. 1804. Canvas, 95×190 cm. Prado, Madrid.

IX

Charles IV and his Family (Detail from plate 111 showing Don Francisco de Paula).

ANONYMOUS

I

Virgin and Child. Second half of twelfth century. Mural from the church at Sorpe, 234·5×152·5 cm. Barcelona Museum.

FERRER BASSA

2

Descent from the Cross. 1346. Mural from the Chapel of San Miguel in the Franciscan Convent at Pederables, 130×121 cm. Barcelona Museum.

PEDRO SERRA

3

The Holy Spirit. 1394. Part of Whitsun Altar, Manresa Cathedral.

VALENCIAN SCHOOL
(Andrés Marzal de Sas)

4

Altar of St George. c. 1400. 670×486 cm. Victoria and Albert Museum, London.

5

Detail from plate 4.

PEDRO DE CÓRDOBA

6

Annunciation. 1475. Córdoba Cathedral.

PEDRO GONZÁLEZ BERRUGUETE
Born at Paredes de Nava c. 1440 and died there 1503. Court Painter to Archduke Philip of Austria, King of Spain.

7

The Virgin Mary appearing to Bernardine Monks during Mass. Panel, 126×78 cm. Prado, Madrid. From a series of nine panel pictures housed in the famous Convent of San Tomé at Avila until 1836. Probably commissioned for the Convent by the Inquisitor-General, Thomas de Torquemada, during the years 1482–93.

8

The Court of Inquisition. An *auto-da-fé* conducted by San Domingo de Guzmán. Panel, 154×92 cm. Formerly in the Sacristy of the Convent of San Tomé at Avila, now in the Prado, Madrid.

CATALONIAN SCHOOL
(*c.* 1500)

9

Salome bringing John the Baptist's Head to Herod. Panel, 192×108 cm. Dr Richard Strauss Collection, Garmisch.

FERNANDO GALLEGO
Born *c.* 1440 at Salamanca, and active there until 1507.

10

Birth of John the Baptist. Panel, 90×55 cm. Prado, Madrid. Originated, with five further panels, in the Cartuja de Miraflores. (Wrongly captioned 'Campaña' in the plates.)

PEDRO DE CAMPAÑA
(Peter de Kempeneer)

1503–80. Born in Brussels. Architect, sculptor, and painter. Spent some time in Rome, then worked mainly in Seville, visiting Córdoba from time to time. Resident in Brussels from 1562 onwards.

II

Descent from the Cross. Seville Cathedral.

LUIS DE MORALES

c. 1510–86. Worked in Badajóz and for a time at the Court of Philip II in Madrid.

12

Presentation in the Temple. Panel, 146×114 cm. Prado, Madrid.

13

Pietà. Panel, 72×50 cm. Academia de San Fernando, Madrid.

ALONSO SÁNCHEZ COELLO

14

Portrait of Alexander Farnese. 107×79 cm. National Gallery of Ireland, Dublin.

15

Portrait of Joanna of Austria. Canvas, 99×81 cm. Musées Royaux des Beaux-Arts, Brussels.

JUAN PANTOJA DE LA CRUZ

1551–1608, Madrid

16

Portrait of Philip II of Spain (Detail). Canvas, overall dimensions 88×59 cm. Prado, Madrid.

17

Portrait of Doña Margarita. 1606. Canvas, 204×122 cm. Prado, Madrid.

JUAN DE ROELAS

18

The Martyrdom of St Andrew. 1609. 520×346 cm. Seville Museum.

19

Santiago Matamoros ('St James riding over the Moors'). 600×400 cm. Capella de Santiago, Seville Cathedral.

DOMÉNICO THEOTOCÓPULI
called EL GRECO

1541 Crete–1614 Toledo. Studied under Titian in Rome c. 1566, worked in Toledo from 1577 onwards.

20

Portrait of Giulio Clovio. Canvas, 49×95 cm. Pinacoteca del Museo Nazionale, Naples.

21

The Healing of the Blind Man. c. 1571–4. Canvas, 49×61 cm. Gallery, Parma.

22

Coronation of the Virgin. Canvas, 90×100 cm., Prado, Madrid.

23

Dream of Philip II. c. 1594–1604. Canvas, 140×110 cm. Escorial, Madrid.

24

The Burial of Count Orgaz. 1586. Canvas, 480×360 cm. Convent of San Tomé, Toledo.

25

Detail from plate 24 showing heads of St Augustine and Count Orgaz.

26

Portrait of a Nobleman with Hand on Chest. c. 1577–84. Canvas, 81×66 cm. Prado, Madrid.

27

Mater Dolorosa. c. 1594–7. Canvas, 53×37 cm. Strasbourg Museum.

28

Crucifixion. Canvas, 312×169 cm. Prado, Madrid.

29

Portrait of Cardinal Niño de Guevara. c. 1596–1600. Canvas, 194×130 cm. Metropolitan Museum of Art, New York.

30

The Opening of the Fifth Seal ('Vision of the Apocalypse'). Canvas, 224×194 cm. Metropolitan Museum of Art, New York.

31

Portrait of Fray Hortensio Félix Paravicino. Canvas, 110×84 cm. Museum of Fine Arts, Boston.

32

Baptism of Christ. c. 1595–1600. Canvas, 350×144 cm. Prado, Madrid.

33

Pentecost. c. 1604–12. Canvas, 275×127 cm. Prado, Madrid.

34

Laocoon. c. 1610–14. Canvas, 138×177·5 cm. National Gallery, Washington.

35

Presumed Self-portrait. Canvas, 59×46 cm. Metropolitan Museum of Art, New York.

36

View of Toledo. c. 1600–10. Canvas, 121×110 cm. Metropolitan Museum of Art, New York.

37

View and Plan of Toledo. c. 1609. Canvas, 135×228 cm. Greco Museum, Toledo.

FRANCISCO DE ZURBARÁN

1598 Fuente de Cantos, Estremadura–1664 Madrid. Pupil of Diego Perez de Villanueva of Seville, worked there and in Madrid as Court Painter to Philip IV.

38

Vision of St Peter Nolasco. Canvas, 179×223 cm. Prado, Madrid.

39

St Thomas Aquinas visiting St Bonaventure. St. Bonaventure refers St Thomas Aquinas to Christ Crucified as the source of all knowledge. Signed and dated 1629. Canvas, 226×256 cm. Kaiser-Friedrich-Museum, Berlin. From a series of scenes from the Saint's life, formerly in St Bonaventure's at Seville but now distributed between Paris, Dresden, and Genoa.

40

Cloaked Madonna ('Our Lady of the Carthusians'). Canvas, 267×325 cm. Seville Museum.

41

The Miracle of St Hugo. Canvas, 262×318 cm. Seville Museum.

42

The Death of St Bonaventure. 1629. Canvas, 250×225 cm. Louvre, Paris. (From the same series as plate 39).

43

Portrait of Fray Jerónimo Perez. Canvas, 204×122 cm. Academia de San Fernando, Madrid

FRANCISCO HERRERA THE ELDER
1576 Seville–1656 Madrid

44

Vision of St Basil. Canvas, 250×195 cm. Louvre, Paris.

JUSEPE DE RIBÉRA
called SPAGNOLETTO

1588 Xativa, Kingdom of Valencia–1652 Naples. Pupil of Francisco Ribalta of Valencia, worked mainly in Naples.

45

Boy with a Club-foot. 1652. Canvas, 161×92 cm. Louvre, Paris.

46

Martyrdom of St Bartholomew. 1630. Canvas, 234×234 cm. Prado, Madrid.

47

Jacob's Dream. Canvas, 179×233 cm. Prado, Madrid.

48

Archimedes. Canvas, 125×81 cm. Prado, Madrid.

49

The Blind Sculptor of Gambazo. 1632. Canvas, 125×98 cm. Prado, Madrid.

50

St Andrew. Canvas, 123×95 cm. Prado, Madrid.

51

St Sebastian. 1651. Canvas, 124×99 cm. Pinacoteca del Museo Nazionale, Naples.

DIEGO RODRÍGUEZ
DE SILVA Y VELÁZQUEZ

1599 Seville–1660 Madrid. Pupil of Herrera the Elder and Francisco Pacheco, later his father-in-law, of Seville. 1623 Court Painter in Madrid. 1629–31 and 1649–51 visits Venice and Rome. 1652 Marshal of the Court.

52
The Water-carrier of Seville. c. 1618–20. Canvas, 106×83 cm. Duke of Wellington's Collection, Apsley House

53
Adoration of the Kings. 1617. Canvas, 203×125 cm. Prado, Madrid.

54
Portrait of the Infante Don Carlos (1607–32, second son of Philip III). c. 1625. Archbishop's Palace, Seville.

55
Portrait of Philip IV. c. 1628. Canvas, 201×102 cm. Prado, Madrid.

56
Christ in the House of Martha. Canvas, 59×102 cm. National Gallery, London.

57
Los Borrachos ('The Topers'). c. 1624–36. Canvas, 223×290 cm. Prado, Madrid.

58
The Forge of Vulcan. 1630. Canvas, 223×290 cm. Prado, Madrid.

59
Joseph's Coat. 1630 (Rome). Canvas, 223×250 cm. Chapter House, Escorial, Madrid.

60
St Anthony Abbot and St Paul the Hermit. c. 1635(?). Originally an altar-piece in the Chapel of San Antonio in the Buenretiro Palace. Canvas, 257×188 cm. Prado, Madrid.

61
Coronation of the Virgin. c. 1642–3(?). Painted for 'the Queen's Oratory'. Canvas, 176×134 cm. Prado, Madrid.

62
Equestrian Portrait of Don Baltasar Carlos (1629–46, eldest son of Philip IV's first marriage.) Canvas, 209×173 cm. Prado, Madrid.

63
Equestrian Portrait of Don Gaspar de Guzmán (Count Olivárez and Duke of San Lucar, Minister to Philip IV of Spain.) Prior to 1634. Canvas, 313×239 cm. Prado, Madrid.

64
Portrait of Don Fernando in Hunting Costume. Canvas, 191×107 cm. Prado, Madrid.

65
Portrait of the Court Dwarf 'Don John of Austria'. Canvas, 210×123 cm. Prado, Madrid.

66
El Bobo de Coria. Canvas, 106×83 cm. Prado, Madrid.

67
Portrait of the Court Dwarf 'Don Antonio el Ingles'. Canvas, 142×107 cm. Prado, Madrid.

68
El Niño de Vallecas. 1638–42. Canvas, 107×83 cm. Prado, Madrid.

69
Lady with a Fan (According to Beruete, the artist's daughter, Francisca.) c. 1640(?). Canvas, 92×68 cm. Wallace Collection, London.

70
The Surrender of Breda ('Las Lanzas'). Painted after 1637 for the Sala de los Reinos in the Buenretiro Palace. Canvas, 307×367 cm. Prado, Madrid.

71
Detail from plate 70 showing self-portrait of the artist.

72
Aesop. c. 1639–40. Formerly in the Torre de la Parada, Philip IV's hunting-lodge, probably in company with Rubens's *Heraclitus* and *Democritus*. Canvas, 197×94 cm. Prado, Madrid.

73
Mars. c. 1640–58. Canvas, 179×95 cm. Prado, Madrid.

74
Portrait of the Court Dwarf Sebastian de Morra. c. 1643–4. Canvas, 106×81 cm. Prado, Madrid.

75
Portrait of the Court Dwarf Don Luis de Aedo (or Hacedo) christened 'el Primo' (cousin) by Philip IV, painted at Fraga in 1644, in the same year as the King. Canvas, 107×82 cm. Prado, Madrid.

76
Landscape (View of the Villa Medici, Rome). 1650. Canvas, 44×40 cm. Prado, Madrid.

77
Landscape (View of the Villa Medici, Rome). 1650. Canvas, 46×40 cm. Prado, Madrid.

78
Portrait of Pope Innocent X. 1650. Canvas, 140×120 cm. Palazzo Doria, Rome.

79
Detail from plate 78.

80
Portrait of Philip IV (1605–65). *c.* 1628. Canvas, 57×44 cm. Prado, Madrid.

81
Portrait of Philip IV. *c.* 1655. Canvas, 69×56 cm. Prado, Madrid.

82
Portrait of the Infante Don Philip Prosper. c. 1659. Canvas, 128×99 cm., Kunsthistorisches Museum, Vienna.

83
Portrait of the Infanta Margarita Maria of Austria (b. 1651). Canvas, 128·5×100 cm. Kunsthistorisches Museum, Vienna.

84
Queen Maria Anna of Austria (second wife of Philip IV of Spain). *c.* 1652. Canvas, 231×131 cm. Prado, Madrid.

85
Las Hilanderas ('The Spinners'). *c.* 1657. Canvas, 220×289 cm. Prado, Madrid.

86
Las Meninas ('Maids of Honour'). This picture shows the Infanta Margarita Maria (1651–73) with her ladies-in-waiting Maria Agostina Sarmiento and Isabel de Velasco. Her personal dwarfs Maria Barbola and Nicolasico Pertusato are on the right and her royal parents reflected in the mirror behind her. 1656. Canvas, 318×276 cm. Prado, Madrid.

87
Detail from plate 86 showing self-portrait of Velázquez.

BARTOLOMÉ ESTEBAN MURILLO
1618–82, Seville

88
The Virgin of the Rosary. c. 1650–60. Canvas, 164×110 cm. Prado, Madrid.

89
Mater Dolorosa. c. 1655–70. Canvas, 52×41 cm. Prado, Madrid.

90
St Isabel of Hungary tending the Sick ('El Tiñoso'). Painted *c.* 1671–4 for the Hospital de la Caridad in Seville. Canvas, 325×245 cm. Prado, Madrid.

91
Crucifixion. c. 1675–82. Canvas, 183×107 cm. Prado, Madrid.

92
Spanish Peasant Boy. Canvas, 52×385 cm. National Gallery, London.

93
Birth of the Virgin. Painted 1655 for the Church of Seville. Canvas, 185×360 cm. Louvre, Paris.

94
Two Boys eating Fruit. c. 1650–60. Canvas, 145×105 cm. Alte Pinakothek, Munich.

95
Las Galegas ('Girls at the Window'). *c.* 1665–75. Canvas, 125·5×105·5 cm. Widener Collection, Philadelphia.

JUAN DE VALDÉS LEAL
1622–91, Seville

96
Portrait of Canon Bonaventure. Cook Collection, Richmond.

97
Death. Hospital de la Caridad, Seville.

LUIS MENÉNDEZ
(or MELÉNDEZ)
1716 Naples–1780 Madrid

98
Still-life. Canvas, 60×80 cm. Provinzial-Museum, Bonn.

FRANCISCO JOSÉ DE GOYA Y LUCIENTES

Born 1746 at Fuendetodos, Aragón—died 1828 at Bordeaux. Pupil of Don José Luzán y Martínez of Zaragoza and Francisco Bayeu y Subias of Madrid. Appointed Painter to the Spanish Court 1789. Worked in Zaragoza, Madrid, Italy (1771), and France.

99
The Fiesta of San Isidro ('La Pradera de San Isidro'). Canvas, 44×94 cm. Prado Madrid.

100
The Crockery Vendor ('El Cacharrero'). Originated in 1778 as a tapestry cartoon. Canvas, 259×220 cm. Prado, Madrid.

101
Winter Scene ('La Nevada'). Originated in 1786 as a tapestry cartoon. Canvas, 275×293 cm. Prado, Madrid.

102
Procession of Flagellants. 1794. Panel, 45×73 cm. Academia de San Fernando, Madrid.

103
Madhouse. Panel, 45×72 cm. Academia de San Fernando, Madrid.

104
Carnival Scene ('El Entierro de la Sardina'). Panel, 82×60 cm. Academia de San Fernando, Madrid.

105
The Village Bullfight. Panel, 45×73 cm. Academia de San Fernando, Madrid.

106
Portrait of Francisco Bayeu y Subias (1734–95, teacher and brother-in-law of Goya). 1796. Canvas, 112×84 cm. Prado, Madrid.

107
Portrait of Josefa Bayeu (the painter's wife). Canvas, 81×56 cm. Prado, Madrid.

108
Portrait of the Condesa de Chinchón. Canvas, 216×144 cm. Duque de Sueca Collection, Madrid.

109
A Mounted Picador. Canvas, 56×47 cm. Prado, Madrid.

110
Portrait of Queen Maria Luisa (wife of Charles IV of Spain). Canvas, 209×126 cm. Prado, Madrid.

111
Charles IV and his Family. 1799–1800 at Aranjuez. Canvas, 280×336 cm. Prado, Madrid.

112
The Naked Maja. Canvas, 97×190 cm. Prado, Madrid.

113
Two Old Men eating Porridge. c. 1819–23. Mural, transferred to canvas, 53×85 cm. Prado, Madrid.

114
Portrait of the Actor Isidoro Maiquez (1768–1820). Canvas, 77×58 cm. Prado, Madrid.

115
Portrait of Doña Isabel Cobos de Porcel. c. 1806. Canvas, 81×54 cm. National Gallery, London.

116
Charge of the Mamelukes ('The Second of May, 1808'). Canvas, 266×345 cm. Prado, Madrid.

117
Execution of the Defenders of Madrid (The Third of May, 1808). Canvas, 266×345 cm. Prado, Madrid.

118
Saturn devouring one of his Children. Mural, transferred to canvas, 146×83 cm. Prado, Madrid.

119
Self-portrait. c. 1819. Canvas, 46×85 cm. Prado, Madrid.

VICENTE LÓPEZ

120
Portrait of Goya. 1826. Canvas, 93×77 cm. Prado, Madrid.

INDEX OF PHOTOGRAPHERS

A.C.L., Brussels: 15

Alinari, Florence: 42, 44, 78, 79

Anderson, Rome: 7, 8, 10, 11, 12, 13, 18, 20, 21, 24, 25, 28, 32, 37, 40, 41, 43, 46, 47, 48, 49, 50, 53, 54, 59, 60, 64, 66, 67, 68, 69, 70, 71, 75, 77, 81, 84, 86, 87, 88, 89, 90, 91, 92, 96, 97, 100, 101, 102, 104, 105, 106, 107, 109, 110, 111, 115, 116, 117, 118, 119

Archives Photographiques, Paris: 1

Bayerische Staatsgemäldesammlungen, Munich: 94

J. Blauel, Munich: IV

Braun et Cie, Mulhouse: 23, 27, 38, 45, 51, 52, 55, 56, 57, 58, 65, 73, 74, 82, 93

Conzett & Huber, Zurich: I, V, VI

Hauser y Menet, Madrid: 17

Hinz, Basle: II, III, VIII, IX, 113

Dr M. Hürlimann: 16, 22, 26, 33, 61, 62, 63, 72, 76, 80, 85, 99, 103, 108, 112, 114

Prof. G. Jedlicka: 120

Kunsthistorisches Museum, Vienna: 83

Kunstmuseum, Düsseldorf: 98

Foto Mas, Barcelona: 2, 3, 6, 19

Metropolitan Museum of Art, New York, 29, 30, 35, 36

Museum of Fine Arts, Boston: 31

National Gallery of Art, Washington: 34, 95

National Gallery of Ireland, Dublin: 14

G. Schwarz, Berlin: 39

Schwitter AG, Basle: VII

Dr Franz Strauss, Garmisch: 9

Victoria and Albert Museum, London: 4, 5